For Connie & Richard Harrier

With devoted

MEDIEVAL STUDIES
IN HONOR OF
LILLIAN HERLANDS HORNSTEIN

MEDIEVAL STUDIES
In Honor of
LILLIAN HERLANDS HORNSTEIN

EDITED BY

JESS B. BESSINGER, JR.

AND

ROBERT R. RAYMO

New York: NEW YORK UNIVERSITY PRESS · 1976

Copyright © 1976 by New York University

Library of Congress Catalog Card Number: 75-27168
ISBN: 0-8147-7367-2

Library of Congress Cataloging in Publication Data

Main entry under title:

Medieval studies for Lillian Herlands Hornstein.

 Includes bibliographical references.
 Contents: Hubbell, A. F. Lillian Herlands Hornstein.—Ackerman, R. W. Madden's
Gawain anthology.—Benson, L. F. The date of the alliterative Morte Arthure. [etc.]
 1. English literature—Middle English, 1100-1500—History and criticism—Addresses,
essays, lectures. 2. Hornstein, Lillian Herlands, 1909-3. Art, Medieval—Addresses, essays,
lectures.
I. Hornstein, Lillian Herlands, 1909-
II. Raymo, Robert R. III. Bessinger, Jess B., Jr.

Library of Congress Cataloging in Publication Data
PR251.M4 820′.9′001 75-27168
ISBN 0-8147-7367-2
Manufactured in the United Sates of America

A Note from the Editors

Because the teacher and scholar for whom this book was made belongs to New York University, even in honored retirement, the editors could well omit a note of dedication, referring the reader to the departmental memoir that follows. As members of the same institution, our testimony is redundant; but who minds yet another greeting on a festal occasion?

Gathering these essays, happy reminders of her own broad and special medieval interests, was made still pleasanter by the lively cooperation of Professor Hornstein's colleagues, former students, and distant friends. We beg leave to tell her so on our own page, and we invoke for her—which she would never do for herself—a proud speech of Chaucer's Lady Fortune: "Richesses, honours, and swiche othere thinges ben of my right. My servauntz knowen me for hir lady." Loyally we sign ourselves her servants.

J. B. B., Jr.
R. R. R.

CONTENTS

MEDIEVAL STUDIES
IN HONOR OF
LILLIAN HERLANDS HORNSTEIN

Lillian Herlands Hornstein:
A Departmental Memoir

Allan F. Hubbell
New York University

There are the wandering scholars and there are those who stay put. Lillian Hornstein has been one of the latter sort, having adorned New York University as a brilliant student, teacher, and scholar for just half a century. A native New Yorker, she was born in Brooklyn in 1909 (she's my *landsman*—or does one now say *landsperson?*) and came to Washington Square College in 1925. She graduated four years later (summa, of course, and ΦBK) and entered the graduate school, taking the M.A. in 1930 and the Ph.D. with distinction in 1940. She began her teaching career in her own college as an instructor, passed through the usual ranks, and was appointed a full professor in 1959.

First and last, Professor Hornstein's primary interest has been in medieval literature. Stimulated by another of this university's distinguished medievalists, Margaret Schlauch, she presented as her doctoral dissertation a study of the sources of *The King of Tars,* which displayed a wide-ranging knowledge of the relevant literature and linguistic abilities of a sort now growing rarer. In the three and a half decades since this beginning, she has continued to do valuable work on the literature of the Middle Ages. She has published a considerable number of articles and notes in *PMLA,* the *Modern Language Review, Modern Language Notes,* the *Chaucer Review,* and elsewhere, all of them characterized by solid scholarship and a clean and graceful style. When the Middle English Group of the Modern Language Association undertook to bring the Wells *Manual* up to date, she served on the editorial and advisory committee and produced the sections of the first volume entitled "Eustace-Constance-Florence-Griselda Legends" and "Miscellaneous Romances."

But if medieval literature was her first love, it was not her only one. In 1942 in *PMLA* she published an article "Analysis of Imagery: A Critique of Literary Method," a polite but rather devastating

examination of *Shakespeare's Imagery* by Caroline Spurgeon. Sixteen years later, this was judged one of the three best articles on literary criticism that had appeared in the first seventy-five years of that journal. I, who read the article when it first came out and have recently reread it, agree with the referee's characterization of it as "concrete, witty, pointed, convincing." Professor Hornstein was also the main editor of that excellent compendium, *The Reader's Companion to World Literature,* a work which reflects the extent of her interests and knowledge—and which, not perhaps incidentally, has been a longtime best seller.

When I came to the University in the early 1950s, I was from the first aware of and attracted by my colleague's enthusiasm and conscientiousness as a teacher. She was never an easy taskmaster, but one who demanded from her students, and not infrequently got, the best work of which they were capable. As an oral examiner she could be formidable, making no bones about her dissatisfaction with fuzzy or equivocating responses. And she was a splendid reader of dissertations that were the primary responsibility of others in the department. She was willing, whenever asked, to read preliminary drafts and would return them with pages of detailed comment on matters of substance and matters of form. One recent candidate told me that he had spent the better part of two days reading through his dissertation sentence by sentence against critical comments she had made. And he agreed that the final draft was much improved as a result.

This deep concern for students was also exhibited in other ways —in serving as advisor to the undergraduate English honorary society, as director of the book club, and as secretary and president of the English Graduate Association, whose newsletter she also edited for some thirteen years. These are perhaps works of supererogation that many are loath to undertake, but they add greatly to the sense a university has of itself as a community and they are particularly to be valued at New York University, most of whose students are not resident on campus.

It would be tedious to enumerate Professor Hornstein's other services to the department and the University, her painstaking, time-consuming work on committees and her involvement with the alumni associations. But, loving libraries as I do, there is one further service I would like to single out. She and her husband, Professor George Hornstein of the Law School, have long been prime movers

in the Society for the Libraries and have successively been chosen as its president. Through the Society five years ago they gave three very valuable items to the University's growing Joyce collection: twenty consecutive numbers of the *Little Review* in their original wrappers which represented the first publication of any part of *Ulysses,* a largely uncut copy of the first edition, and the first printing, fourth edition (1924), with a four-page table of author's corrections.

Lillian Hornstein has now formally retired from the never-ending task of attempting to civilize the students, both undergraduate and graduate. But she is certainly not retiring from the life of scholarship. At present she is busily at work on a volume for the Chaucer Variorum, an anthology of fifteenth-century literature, and an extensive study of legal imagery and legal references in late medieval poetry. We wish her good health and happiness in the years ahead as she works away at these projects.

Madden's Gawain Anthology

Robert W. Ackerman
Stanford University

The publication in 1839 of Madden's *Syr Gawayne; A Collection of Ancient Romance-Poems* [1] was a notable event in the history both of Arthurian studies and editorial scholarship. The primary concern here is not with the *editio princeps* of *Sir Gawain and the Green Knight* [*GGK*], the nucleus of the collection, but rather with the inception, the development, and the significance of the entire group of poems and, incidentally, with Madden's emergence as the foremost Arthurian of the nineteenth century. The splendid edition of *GGK* is followed by the texts of ten other romances and ballads, all of later date and obviously of less sophisticated craftsmanship—namely, *The Awntyrs off Arthure at the Terne Wathelyne, Golagrus and Gawain, Syre Gawene and the Carle of Carelyle, The Jeaste of Syr Gawayne, The Grene Knight, The Turke and Gowin, The Carle off Carlile, King Arthur and King Cornwall, The Marriage of Sir Gawaine,* and *The Weddynge of Sir Gawen and Dame Ragnell.* Some of these titles were supplied by Madden just as he provided *GGK* with its title. [2]

The great poetic merit of *GGK* began to attract the attention of literary historians and critics shortly after the appearance of Jessie L. Weston's *The Legend of Sir Gawain* in 1897, and today the accumulated volume of scholarship devoted to this one romance has itself legendary proportions. [3] In contrast, the other ten Gawain poems have aroused comparatively little interest. Of course, source investigations, of which George Lyman Kittredge's *A Study of Sir Gawain and the Green Knight* [4] is an early example, tend to draw on the whole range of Gawain literature in all languages, as do the surprisingly numerous appraisals of the hero's shifting popularity rating, from B. J. Whiting's "Gawain: His Reputation, His Courtesy, and His Appearance in Chaucer's *Squire's Tale*" in 1947 to W. O. Evans's "The Case for Gawain Re-Opened" in 1973. [5] In very recent years, a number of the lesser poems have been reedited by scholars who almost invariably attest to the excellence of the original editions in Madden's book. [6] To discuss here the accuracy and the other

5

virtues of the texts in *Syr Gawayne* would be to belabor the obvious. As already suggested, the intention is rather to inquire into Madden's motives and procedures in assembling his collection for the insights they yield as to the nature and value of the Gawain romances and ballads. Such an investigation is feasible largely because of the preservation of Sir Frederic Madden's immense and still unpublished Diary in the Bodleian Library,[7] although his correspondence files and other papers in the British Museum are also of use. We have, indeed, such a wealth of fascinatingly detailed information about Madden the scholar, the distinguished Keeper of Manuscripts, and the man himself that the temptation to admit an inordinate amount of tangential biographical material into even so limited a study as the present one is almost irresistible.[8]

Madden's Arthurianism did not begin abruptly with his labors on his 1839 *Syr Gawayne* or even on that momentous day ten years before when his eyes first alighted on "the very curious romance of Gawayn and the Green Knight" in MS Cotton Nero A. X. (D, 9 July 1829). For as early as 1823, on his maiden visit to the British Museum, and also his first to London, he records reading the romance of *Sir Launfal* in manuscript (D, 6 December 1823). A few months thereafter, he began his duties as manuscript copyist and general assistant to Henry Petrie who, as Keeper of Records at the Tower of London, had been entrusted by a committee of Parliament with the compilation of historical materials. Young Madden's several years' experience of transcribing medieval manuscripts, Latin and vernacular, at the rate of 5 pence per foolscap (D, 31 March 1824) in the great libraries and muniment rooms of the kingdom laid the groundwork for his paleographical expertness, probably unmatched in his own century. This, coupled with his ambitious program of self-improvement in his command of history and languages, medieval and modern, transformed the boy antiquarian of Portsmouth into a scholar and opened up for him the doors to a career.

In the course of his work for Petrie, he read the still unpublished *Brut* of Layamon in MS Cotton Caligula A. IX., drawing up a synopsis of the chronicle for his personal use (D, 18 August 1824). With this addition to his knowledge of the British past, he was moved to commit to his Diary a critique of "the attempt to trace King Arthur's life with precision" which he found in Sharon Turner's recent *History of the Anglo-Saxons* (D, 21 August 1824). During the same period he recorded his reading, or rereading, of

much medieval literature, including the small body of Arthuriana then in print. His continuing preoccupation with the *Brut* of Layamon—"a glorious old fellow," he once called him (D, 22 November 1835)—soon led him to study Wace's *Roman de Brut* in two manuscripts (D, 17 February 1825). Observing his assistant's zeal, Petrie urged him to undertake the editing of Layamon just as he suggested that he edit the romance of *Havelok,* the manuscript of which Madden had fortuitously discovered in the Bodleian Library the preceding year (D, 12 August 1825; 14 August 1826).

Petrie's encouragement and the even earlier interest in his proclivities and talents expressed by the Reverend J. J. Conybeare and two Oxford librarians, Philip Bliss and J. B. Bandinel, were of the greatest significance for Madden's future. For example, it was only as the result of the aid, direct and indirect, of these men, and especially of Bliss, that he was able to realize his boyhood dream of studying at Oxford. Under their auspices, he matriculated at Magdalen Hall in 1825, at age twenty-four. Because of his need for earning his way, he kept terms there as a most irregular basis and, although he passed his responsions in 1827, he abandoned the pursuit of a degree a few years later (D, 9 July 1825; 23 June 1827; 6 January 1831).

For some time, Madden supplemented his income by toiling as a cataloguer in the British Museum, and finally in 1828, the year of the publication of his *Havelok,*[9] he was appointed Assistant Keeper of Manuscripts at that institution (D, 11 February 1828). In his new post, he could feel that he had at last attained reasonable security and also unequaled facilities for his scholarly work in the time left over from his official duties. The death of his wife and newborn son in 1830, after less than a year of marriage, unsettled him a good deal, and he seems to have found solace only in unremitting work. Indeed, a kind of frenzy for committing himself to lengthy and arduous tasks overtook him at this juncture. The proposal made to him in 1831 by the Society of Antiquaries for the editing of Layamon's *Brut* in both texts was a fitting and probably expected recognition of the attention he was known to have given that work, and he accepted at once (D, 20 May, 16 September 1831).[10] But at very nearly the same time, he acceded to Lord Cawdor's request that he put out *William and the Werewolf* (D, 3 September 1830), a task which he completed in a year.[11] Furthermore, he entered into an agreement with the delegates of the Oxford University Press for preparing the Wyckliffite

Bible for publication in collaboration with Josiah Forshall, even though he was aware of the huge labor of collation of the numerous copies that would be involved (D, 26 March 1831). He did not, however, allow his early interest in *GGK* to pass out of mind, especially since his initial correspondence about the "old Scotch romance" with Sir Walter Scott was followed by two interviews with the great old man in October 1831 (D, 6, 17 October 1831). He had already experimented with transcribing the text, and now he read more deeply in the Arthurian field. His original plan was to publish the work by subscription, and it was not until 1836 that he received an offer to issue it in the Bannatyne Club series (D, 25 August 1836).[12]

Concurrently with toiling over these several very large projects, which would constitute a full schedule for most people, let alone one carrying the responsibilities of an officer of the British Museum, often under difficult conditions, Madden edited a number of smaller works, translated a French treatise on paleography, contributed many corrections and notes to the 1840 edition of Thomas Warton's *History of English Poetry,* and wrote articles on a variety of topics for the *Gentleman's Magazine, Archaeologia,* and the like.[13] His three principal commitments occupied him for fully two decades, for the *Holy Bible . . . by John Wyckliffe and his Followers* in four volumes did not appear until 1850.[14] His knighthood, conferred in 1833, his promotion to Keeper of Manuscripts in 1837, his second marriage in the same year, his sense of satisfaction in the restoring of many of the mutilated manuscripts of the Cottonian Collection,[15] and several honors that came to him were all sources of comfort, yet he maintained much the same heavy program of scholarly activity. In 1843 he wrote: "Every week day, to say nothing of Sundays, am I occupied at my desk from ten to twelve hours" (D, 31 December 1843), and on other occasions he was inclined to complain about his self-imposed bondage. Throughout these years, as the reader of the Diary is likely to conclude, he was sustained most by absorption in his two Arthurian projects, if we may refer to Layamon's *Brut* under that heading. In contrast to *Syr Gawayne* and the *Brut,* he found the collating of biblical texts sheer drudgery. He speaks, in fact, of spending night after night on Layamon and *Syr Gawayne,* as if simultaneously, and at one point remarks that these two "are now in harness and at about the same pace" (D, 26 January 1839).

Appearing at the end of October 1839, *Syr Gawayne* stood in strong

contrast to the collections and single editions of Middle English literature produced by what may be called the first generation of literary scholars—chiefly, Bishop Thomas Percy, Joseph Ritson, John Pinkerton, George Ellis, C. H. Hartshorne, David Laing, H. W. Weber, and, of course, Sir Walter Scott. In his nearly impeccable manuscript transcriptions and the fact that he gave each of his texts in toto and with a minimum of emendation, to say nothing of the learning and judgment reflected in his commentaries and glossary, Madden in the new book left far behind the "selections," "specimens," and "remains" school of the late eighteenth- and early nineteenth-century literary antiquarians.

Still another feature was destined to influence future Arthurian scholarship, for this anthology constitutes the first recognition that a significant number of separate Gawain poems exist in Middle English. Since not one of them may be regarded as an immediate rendering of a known French antecedent, in the sense that the English *Ywain and Gawain* and *Guy of Warwick*, for example, are translations or close adaptations of French works, these romances and ballads as a group stand apart from most other English romance literature. Although beginning, no doubt, with the intention of issuing *GGK* singly, as he had published *Havelok* and *William and the Werewolf*, Madden presently adopted the plan advanced by Scott in response to his first announcement of his uncovering the "Scotch" romance in MS Cotton Nero A. X. Scott's suggestion was that the new romance be printed together with two other works of northern provenance, *The Awntyrs off Arthure* and *Golagrus and Gawain*, both of them already well known.[16] Very soon thereafter, as will be explained, he was inspired to augment the collection still more by including all the Gawain pieces he could find.

A version of *The Awntyrs* occurring in a manuscript belonging to Francis Douce had been miserably edited by Pinkerton in 1792,[17] and a second copy in the Thornton MS had been accorded better treatment in Laing's *Select Remains* of 1822.[18] Madden improved greatly on his predecessors by basing his text on fresh transcriptions of both manuscripts.[19] To present-day habitués of the manuscript rooms of libraries, it is interesting to note that the authorities of Lincoln Cathedral sent their precious Thornton MS to London at Madden's request, and during the summer of 1832 he was able to copy out not only *The Awntyrs* but also the *Alliterative Morte Arthure* and other pieces in which he had an interest (D, 8 June, etc., 1832).

Of the two additional copies of *The Awntyrs* now known to us, one, found in the Ireland MS just too late for inclusion in *Syr Gawayne,* was published by John Robson in 1842.[20] From the beginning to the end of his work on his book, Robson, as he acknowledges in his Preface, collaborated closely with Madden.[21] In fact, the Ireland MS was sent to the British Museum, like the Thornton, to facilitate Madden's oversight of the entire work, and he was even involved in negotiations with the Camden Society for the publication of the finished product (D, 22 January, 5 February, etc., 1842).

Golagrus and Gawain has a less complicated history since it was known, and still is, in only a single form—the Chepman and Myllar print of 1508, prized as the earliest example of printing in Scotland. It too was included in Pinkerton's book, but Laing in 1827 produced a facsimile edition, and on the latter Madden based his text.[22]

That *GGK, The Awntyrs,* and *Golagrus* are printed in this order at the beginning of *Syr Gawayne* commemorates Scott's original proposal. Yet, since the transcribing of the first and by far the longest and most difficult of the three was completed in April 1832 (D, 24 April 1832), we may wonder why, in view of the fact that *The Awntyrs* and *Golagrus* called for relatively little textual work, Madden did not round off his collection of "Scotch" romances at this point and publish it forthwith. That seven years elapsed before actual publication could be explained in part, perhaps, by the many activities competing for his time and energy. But the really compelling factor in the delay, as suggested before, was that he developed before the end of 1832 a new and more spacious conception of his project.

That is, in consequence of his immersion in the chronicle tradition underlying Layamon's *Brut,* the whole of the pseudo-history of Britain, and particularly the reign of Arthur, was vividly in his mind. Behind the hero of the several Gawain poems, who is called upon to vindicate his renown for prowess, chivalric honor, and virtue in many exploits and tests, Madden was inclined to see the towering eminence of the chronicle warrior, battle-scarred and valiant to the end in the service of his king. That Gawain as a national hero lingered long in the English folk memory was to him demonstrated by the poems composed in his honor over a span of centuries. The inclusion of all such poems in his anthology thus struck him as natural and altogether appropriate.[23] In the book as printed, the eight romances and ballads following *Golagrus* are grouped in what is labeled an Appendix. This designation implies that they share some

characteristics not found in the first three poems. In addition to their relative brevity and the fact that they were not identified with Scotland, for example, they are in metrical rather than alliterative verse. Moreover, all of them, with two exceptions, were here edited for the first time.[24] The chief objective of the anthology is formulated in these terms: "to examine critically the sources whence the history of his [Gawain's] exploits has been derived." [25] As is made clear in the Preface and notes, these "sources" are French romances containing more or less convincing analogues to episodes in some of the English poems.

Much of the Preface is devoted to a survey of Arthurian backgrounds with emphasis on Gawain's career. Although indebted to and in general agreement with such writers on this subject as Scott, Ellis, and Richard Price,[26] Madden's rationale represents a distinct advance chiefly as the result of his schooling in the chronicles and his somewhat more systematic knowledge of French romance. He knew also certain more recent literary historians, among them Algernon Herbert, whose rather eccentric *Brittania after the Romans* presents the Arthurian reign as largely myth in which Arthur figures as Hercules,[27] and the Abbé de la Rue, who wrote a learned, prolix study of Norman and Anglo-Norman bards, *jongleurs,* and *trouvères.*[28] He found further aid and support in Robert Southey's edition of Malory.[29] Only in 1838 did Part I of Lady Charlotte Guest's *Mabinogion* become available to him (D, 7 November 1838), and on the basis of what he could learn from this and elsewhere he concluded that the old Welsh bards offered little of value in demonstrating the antiquity of Gawain, beyond allusions to Gwalchmai son of Gwyar in the Triads.[30]

For Madden, the classical account of the age of Arthur, and the proper point of departure for dealing with Arthurian literature, was to be found in Geoffrey of Monmouth's *Historia,* and he notes that this story is carried forward rather faithfully by Wace and Layamon and that the outlines are adhered to in the alliterative *Morte Arthure.* In such works, he says, Gawain's adventures "contain so small a share of the marvellous, that they might easily have been accepted as grave matter of history." [31] At this point, he provides a brief outline of the hero's parentage, his knighting by the pope, his dominant role in Arthur's Roman war, his desperate valor in the battle with the forces of the rebel, Mordred, his death, and burial. But, prior to Geoffrey and persisting long thereafter, a rich stock of

legend embodying much supernatural material about Arthur and his knights was orally transmitted from generation to generation. Such popular traditions absorbed into the chronicle account were, in Madden's words, "circulated first by native bards and afterwards by Anglo-Norman minstrels." [32] These formed the matrix out of which the French prose and metrical romances developed, including the poems of Chrétien de Troyes. It is mainly to the prose romances, which Madden knew only in sixteenth-century printed versions, "that we must look for the invention or preservation of those numerous romantic narratives which record the exploits of Gawayne and his fellows on a more ample canvass, and clothe them with a character purely imaginative." [33] With the introduction of new themes and their heroes, such as the story of the Holy Grail, Gawain surrendered his leading role to competitors such as Lancelot and Galahad. It is in the prose *Tristan,* however, that the exalting of a rival brings about his degradation. The fact that "the character of Gawayne is traduced and his history misrepresented" in parts of the *Morte Darthur* is explained in terms of Malory's supposed source, identified by Madden as an abridgement of the *Tristan* by Rusticien de Pise.[34]

His general background thus established, Madden proceeds to comment on individual romances. He takes the author of *GGK* at his word—"With lel letteres loken" (v. 35)—in stating that he worked from earlier romances. The beheading episode finds analogues in the story of Carados in the *Roman de Perceval* and *Le Chevalier à l'Épée,* which he had read only in late printed versions, and also in *La Mule sans Frein.*[35] Of interest in this connection is the recent edition of *Le Chavalier à l'Épée,* and *La Mule sans Frein,* which is accompanied by an essay supporting the view that these two French romances are the immediate source of *GGK,* or at least of a lost intermediate work.[36] With respect to the temptation motif in *GGK,* Madden is far-less satisfactory although he speaks as though he had a "source" in mind.[37]

Certain other insights in *Syr Gawayne* have also withstood the test of time. For example, attention is called to the striking similarities between the main action in *Golagrus and Gawain* and the encounter between Gauvain and the Riche Soudoier in the *Roman de Perceval*—that is, the First Continuation of Chrétien's *Perceval.* In both, the hero is so magnanimous as to feign defeat in combat in order that his adversary might save face.[38] Again, in the first portion of *The Awntyrs*

involving the ghost of Guenevere's mother, Madden detects the story told in *The Trental of St. Gregory,* with which he had become familiar in preparing his edition of the English versions of the *Gesta Romanorum.*[39] Finally, the plot of *King Arthur and King Cornwall* seemed to him, as it has to later commentators, to have been taken ultimately from *Le Pèlerinage de Charlegmagne,* a work which his friend Michel had edited in 1836 from a British Museum manuscript.[40]

It is in the highest degree unlikely that any other scholar of the day possessed the learning and the perceptiveness that one finds reflected in Madden's thoroughly well articulated, if now largely superseded, understanding of Arthurian backgrounds and his still valuable and illuminating comments on individual romances. It is also unlikely that a comparable knowledge of manuscripts and of editorial technique had been acquired by any contemporary. Something has already been said about the manuscripts and the early print used in the editions of the first three poems in *Syr Gawayne.* About the texts underlying the remaining poems in the book Madden is more reticent in his notes, and only in the Diary can one learn about the often exasperating obstacles that had to be overcome in locating and then gaining access to certain of the manuscripts.

In this connection, the most serious difficulties were those caused by the owners of the celebrated Percy Folio Manuscript, which contains no fewer than five Gawain poems. The Folio, which Ritson at one time declared did not exist, had in fact been known in part since Bishop Percy published his *Reliques* in 1765. Although *The Marriage of Sir Gawaine* alone of the five was printed in Percy's book, Madden was aware from the description of the manuscript in the *Reliques* of the existence of the other four.[41] Perhaps the first clear indication that he had decided to enlarge his collection is the disclosure in the Diary in 1831 that he had written for permission to examine the Folio to the present owner, Mrs. Samuel Isted, elder daughter of the Bishop (D, 23 September 1831). Having received an apparently favorable reply, Madden traveled by the Liverpool coach to Northampton some weeks later and presented himself at Ecton Hall, where he was politely received. The Folio was handed to him, but wrapped around it was a document stipulating that no use could be made of it without the express permission of Mrs. Isted and her sister. Moreover, it was never to pass out of the possession of the family. The situation improved, however, when the lady understood

that her visitor was for the moment interested in one piece, *The Grene Knight,* for she then produced a transcript of that ballad which Bishop Percy had caused to be made at one time for possible later inclusion in his book. She even allowed Madden to collate the copy with the manuscript, but he was given to understand that he might go no further (D, 2, 3 November 1831).[42]

Somewhat less than five years later, he sought to borrow the Folio for the prolonged work of copying out the remaining poems he needed. On this occasion, he applied to Mr. Ambrose Isted, son of the late owner, only to learn that the family attitude had not altered. Isted would, however, allow him to come to Ecton Hall in the company of George Baker, a neighbor and friend, and also Madden's fellow member in the Society of Antiquaries, in order to make his copies. Such an affront to the Assistant Keeper of Manuscripts was not to be borne, and the offer was declined. Instead, Madden arranged with Baker, who as a serious historian was familiar with manuscripts, to transcribe the required texts. Baker complied and in December 1836 brought to London his copies of *The Turke and Gowin, The Carle off Carlile,* and *King Arthur and King Cornwall* (D, 2 June, 9 September, 23 November, 14 December 1836). The excellent quality of Baker's work becomes evident when compared with the Hales and Furnivall edition of the Folio.[43] Baker also brought word of Isted's hostility toward any suggestion that Madden reedit the *Reliques,* a development that gave rise to some vituperative remarks in the Diary (D, 14 December 1836). Although to record here the later history of the Folio Manuscript is outside the scope of this study, it is revealing to note that in 1865, a sad and troubled year for Madden, a Mr. Meade, grandson of the Bishop, brought the family treasure to the Museum with an offer to sell it to the nation for 300 pounds. With evident satisfaction, the Keeper of Manuscripts sent his caller away with the advice that the Folio was worth no more than 100 guineas at best (D, marginal note added to entry for 3 November 1831).

Madden's grasp of Arthurian origins was inevitably hampered by the undeveloped state of Celtic studies in his day and the unavailability of proper texts of French romance literature. Moreover, certain assumptions since shown to be mistaken occur in his commentaries on various poems. He was wrong, for example, in the belief that *GGK* in its first form was the work of a Scot, probably Huchowne of the Awle Ryale. But, in the assembling and responsi-

ble editing of previously unknown romances and ballads, in the learned notes on armor, the breaking of a deer and the unlacing of a boar, and the like, and in the remarkable glossary, *Syr Gawayne* must be considered a contribution of the first magnitude.

Furthermore, informing the work is a fundamental conception which has all too seldom been noted and given its due weight by modern critics, particularly those who are prone to discourse on *GGK* and sometimes on the other poems, not in their medieval context, but rather as if they were altogether free-standing literary productions. This perception, as already emphasized, is that the Gawain poems were generated by a consciousness of the Arthurian past. These romances and ballads were appreciated, one may assume, in much the way that the Charlemagne romances appealed to French audiences. It is doubtful that the moral flaw, or *felix culpa,* exhibited by the hero of *GGK* or the occasional intrusion of the "degraded" Gawain in such works as *The Jeaste of Syr Gawayne* and parts of Malory loomed importantly in the reactions of the first audiences of these stories. To cite Madden's words: "We shall find the fame of Gawayne in full vigor from the thirteenth to the sixteenth century, . . . his reputation in the popular estimation continued to retain its hold, in spite of the misrepresentations." [44]

NOTES

1. *Syr Gawayne; A Collection of Ancient Romance-Poems, by Scotish and English Authors, Relating to that Celebrated Knight of the Round Table,* with an Introduction, Notes, and a Glossary, by Sir Frederic Madden, K. H., Bannatyne Club, London, 1839.

2. Madden gave to the romance the title that seems to have occurred to him when he first saw the manuscript copy in July 1829 (see below). As he indicates in his notes, however, Richard Price, who had noticed the poem in MS Cotton Nero A. X. several years earlier and who even planned an edition at one time, preferred to entitle it *The Awntyre of Gawane,* on the theory that this was the composition by Huchowne of the Awle Ryale so designated, according to Wyntown. Ibid., pp. 299-303.

3. Summaries of scholarship on *GGK* may be found in Morton W. Bloomfield, *"Sir Gawain and the Green Knight: An Appraisal," PMLA,* LXXVI (1961), 7-19; and Robert W. Ackerman, *"Sir Gawain and the Green Knight* and Its Interpreters," *On Stage and Off: Eight Essays in English*

Literature Dedicated to Emmett L. Avery, ed. John W. Ehrstine (Pullman, Wash.: Washington State University Press, 1968), pp. 66-73. The continuing production of studies year by year is recorded in the annual publication, *Bibliographical Bulletin of the International Arthurian Society.*

4. Cambridge: Harvard University Press, 1916.

5. *MS,* IX (1947), 189-234; *MLR,* LXVIII (1973), 721-33.

6. See, for example, *The Awntyrs off Arthure at the Terne Wathelyne, A Critical Edition,* ed. Robert J. Gates (Philadelphia: University of Pennsylvania Press, 1969). The present writer's experience in reediting Madden's texts is confined to *Syre Gawene and the Carle of Carelyle: An Edition,* "University of Michigan Contributions in Modern Philology," VIII (Ann Arbor, Mich.: University of Michigan Press, 1947).

7. Bodleian Library, MS hist. C. 140-82. References to the Diary are indicated herein by the abbreviation "D," followed by the date of the entry or entries. I wish to express my gratitude to the Keeper of Western MSS. of the Bodleian Library, Oxford, owners of the Madden Diary, for permission to use and to quote from it.

8. A limited amount of published information about Madden's career at the British Museum may be found in Edward Miller, *Prince of Librarians. The Life and Times of Antonio Panizzi* (London: Andre Deutsch, 1967); and the same author's *That Noble Cabinet. A History of the British Museum* (London: Andre Deutsch, 1973). See also the brief note by M. A. F. Borrie, "Sir Frederic Madden," *The British Museum Society Bulletin,* no. 15 (February 1974), 8-9.

9. *The Ancient English Romance of Havelok,* Roxburghe Club, London, 1828.

10. Some remarks about Madden's editing of the *Brut* are to be found in the present writer's "Sir Frederic Madden and Medieval Scholarship," *Neuphilologische Mitteilungen,* LXXIII (1972), 1-14.

11. *The Ancient English Romance of William and the Werewolf,* Roxburghe Club, London, 1832.

12. *Syr Gawayne,* pp. xliv-xlvi.

13. An indication of the wide variety of publications is to be found in "Sir Frederic Madden and Medieval Scholarship," passim. An incomplete and otherwise inadequate bibliography is included in a notice of Sir Frederic's death. *National Register,* new series (1873), 131.

14. Oxford: Oxford University Press, 1850.

15. A short account of Madden's restoration of the Cotton

Manuscripts damaged in the fire of 1731 appears in "Sir Frederic Madden and Medieval Scholarship," pp. 7-9.

16. Madden quotes Scott's first letter to him on this general subject in his Diary, 15 December 1829. See also the Madden Letters, British Museum, vol. for 1830, esp., item nos. 105, 128, and 256.

17. *Scotish Poems Reprinted from Scarse Editions* (London, 1792), III, 197 ff.

18. *Select Remains of the Ancient Popular and Romance Poetry of Scotland* (Edinburgh and London: William Blackwood, 1822), pp. 81-113.

19. *Syr Gawayne,* pp. 326-27.

20. *Three Early English Metrical Romances, with an Introduction and Glossary,* Camden Society, no. 18 (1842), pp. 1-26.

21. "But to Sir Frederick Madden my obligations are more numerous. If the publication has any value, it is in great measure owing to his suggestions, and the Glossary is, in the most important parts, a literal copy of his most excellent one in *Syr Gawayne.*" Ibid., p. xxxvi.

22. *Syr Gawayne,* pp. 336-37.

23. That Madden was intent on incorporating all the English Gawain poems in his book is especially well revealed by his prolonged search for the manuscript preserving *The Weddynge of Sir Gawen and Dame Ragnell,* referred to but incorrectly identified in Warton's *History of English Poetry (Syr Gawayne,* pp. 358-59). Not until late July 1839 was the correct manuscript, MS Rawlinson C. 86, discovered in the Bodleian Library. Madden thereupon went to Oxford to copy the poem in time to insert it at the end of his anthology, but without notes (D, 27 July, 2 September 1839).

24. The late manuscript of *The Jeaste of Syr Gawayne* had been copied from a black-letter edition, in Madden's opinion *(Syr Gawayne,* p. 348). *The Marriage of Sir Gawaine* appeared with emendations in Percy's first edition of *The Reliques of Ancient English Poetry,* in 1764. But, in his edition of 1794, as a result of Ritson's criticisms, he provided a faithful transcript of the manuscript original. *(Syr Gawayne,* p. 358).

25. *Syr Gawayne,* p. ix.

26. *Sir Tristrem; a Metrical Romance of the Thirteenth Century by Thomas of Erceldoune, called the Rhymer,* ed. Walter Scott (Edinburgh and London, 1804), Introduction, esp. pp. xxii-lxxx. *Specimens of Early English Metrical Romances,* ed. George Ellis, 3 vols., London, 1805, the introductory essays, "First Romances merely Metrical Histories" and "Inquiry into the State of Wales during the Eleventh, Twelfth, and

27. *Britannia After the Romans; Being an Attempt to Illustrate the Religious and Political Revolutions of that Province in the Fifth and Succeeding Centuries,* 2 vols. (London: Bohn, 1836). Volume I, Chapter I, deals with the Welsh bards, Arthurian romance, the Triads, Gildas, Nennius, the *Mabinogion,* and the like. Chapter IV concerns the "mythological reign of Arthur" and such other topics as the "pretended battle of Camlan." Volume II, Chapters I and II, likewise concern Arthur.

28. *Essais historiques sur les Bardes, les Jongleurs, et les Trouvères normands et anglo-normands,* 3 vols. (Caen, 1834).

29. *The Byrth, Lyf, and Actes of Kyng Arthur; Of his Noble Knyghtes of the Rounde Table, Theyr Merveyllous Enquestes and Aduentures,* etc., printed from Caxton's edition, 1485, ed. Robert Southey, 2 vols. (London, 1817), I, i-lxiii.

30. *Syr Gawayne,* pp. xi-xii.

31. Ibid., p. xiv.

32. Ibid., p. ix.

33. Ibid., p. xiv.

34. Ibid., pp. xxviii-xxxix.

35. Ibid., pp. 304-8. Madden acknowledges that Southey in his edition of Malory *(ed. cit.,* I, xxxv-xxxviii) gives a précis of the Carados story which, apparently on the basis of William Owen Pugh's *Cambrian Biography* (1803), he believes to have a Welsh or Breton source. Southey knew the *Roman de Perceval* but not the metrical version.

36. *Two Old French Gawain Romances.* Part I, *Le Chevalier à l'Epée,* and *La Mule sans Frein,* ed. R. C. Johnston and D. D. R. Owen; Part II, "Parallel Readings with *Sir Gawain and the Green Knight,*" by D. D. R. Owen (Edinburgh: Clark, 1972). See esp. pp. 203-8.

37. In *Syr Gawayne,* p. 307, Madden suggests that he will have a comment to make about the temptation of Gawain by the Lady of Hautdesert when he takes up the related romance about the Carl of Carlisle, but little on the subject may be found there.

38. Ibid., pp. 337-40.

39. Ibid., pp. 328-29.

40. Ibid., pp. 356-57.

41. He was also acquainted, as he states in *Syr Gawayne* (p. lxiii), with the partial analysis of the contents of the Percy Folio in Thomas F. Dibdin's strange book, *The Bibliographical Decameron,* 3 vols. (London, 1817), III, 340-44.

42. *Syr Gawayne,* p. 352.

43. *Bishop Percy's Folio Manuscript. Ballads and Romances,* ed. John W. Hales and Frederick J. Furnivall, 3 vols. (London, 1868), I, 59-73, 88-102; III, 275-94.

44. *Syr Gawayne,* p. xxxvii.

The Date of the
Alliterative Morte Arthure

Larry D. Benson
Harvard University

The *Alliterative Morte Arthure* is unique among Middle English ro-
mances for its reflection of contemporary affairs. All romancers
translated their supposedly ancient tales into contemporary terms
and, as Shakespeare's Romans are inevitably Elizabethan, so the
Arthurian knights of Middle English romance are almost all recog-
nizably late medieval gentlemen, contemporary with their authors
in manner, speech, and dress. However, in the *Alliterative Morte
Arthure* the modernization extends even to the action, and many of
the episodes seem to have been shaped, at least partially, with an eye
to contemporary events. Arthur himself appears not merely as a
fourteenth-century king but as a reflection of Edward III, the
greatest of fourteenth-century English kings, and his successful
campaign against Lucius in France is reminiscent of Edward's fa-
mous victories. Even some details of his battle with Lucius's army
and his sea-fight with Mordred's fleet have been thought to have
been drawn from the actual battles of Crécy and *Espagnols sur mer*.[1]
Because of such apparent resemblances to the actual details of
Edward's reign, the poem is usually dated in the last years of that
reign, from around 1360 to 1375.[2]

However, recent studies have shown that these resemblances are
not so exact as was once thought. The correspondences between
episodes in the poem and events in Edward's reign may be due, John
Finlayson has argued, to the poet's dependence upon later accounts,
such as the Chandos Herald's *Life of the Black Prince*, which was
written around 1385.[3] Moreover, George R. Keiser has shown that
the supposed resemblance between Arthur's strategy at Sessoines
and Edward's at Crécy is based upon but one detail, which was
probably drawn from Wace, and that the mention of "Spanioles" in
Mordred's fleet (v. 3700) is not necessarily an allusion to the battle of
Espagnols sur mer, for the Spanish fleet was active in the Channel

throughout the fourteenth century.[4] The case for a date between 1360-75 has thus been considerably weakened, and it is time, I believe, to consider the evidence for a much later date, around the year 1400.

This later date does not rule out the possibility that the poet may have patterned his Arthur on Edward III. Though the resemblances between Arthur and Edward are general, they are nonetheless striking.[5] Perhaps by the year 1400 such resemblances would have seemed especially fitting. After Richard's unhappy reign and Henry IV's accession, many Englishmen must have been thinking about the definition of a good king and Edward may have seemed to many, as he did to Froissart, a king whose like had not been seen since the days of King Arthur.[6] As this suggests, a later date of composition increases rather than diminishes the contemporary relevance of the poem. Those who believed the poem was written in the 1360s or early 1370s have found the contemporary allusions mainly in Arthur's French campaign, but that campaign is over long before the poem ends. Much of the second half of the poem is unprecedented in previous accounts of Arthur, and its main concerns —Arthur's expedition to Italy and Mordred's rebellion—are even more obviously colored by contemporary history than the earlier episodes. A recognition of that coloration and of the important dimension of meaning this implies depends upon the establishment of the date of composition, and that is my main concern in the study that follows.

I. ARTHUR'S ITALIAN CAMPAIGN

After Arthur has defeated Lucius and his army, he sets out to conquer Italy. His expedition has some precedent in previous accounts of Arthurian history, but no previous work contains so full and detailed an account of Arthur's conquests and none details Arthur's progress through Europe—his journey to Luxemburg, the siege of Metz, and his progress down the Rhine to Lucerne and thence into Italy. The reason for this is clear enough: In the *Alliterative Morte Arthure* the emperor Lucius is presented as a fourteenth-century Holy Roman Emperor, and Arthur's expedition to Italy is a conquest of the Empire as it was in the fourteenth century, a confederation of German and northern Italian states.[7] Thus, Lucius's army consists, aside from his pagan allies, almost entirely of Ger-

mans (cf. vv. 2030, 2652-57) and Italians, especially Lombards (v. 1972), and Lucius's heir is "Emperour of Almaine and all these este marches" (v. 3210).[8] Hence, too, the fact that the pope and cardinals can offer the crown of the Empire to Arthur, and, judging from his dream, in which Dame Fortune presents him with the Imperial regalia, Arthur dreams of becoming emperor.

This was not an impossible dream for an English king in the fourteenth century; both Edward III and Richard II had been offered the Imperial crown. The image of Arthur conquering the Empire and thus effectively deposing the emperor was also a possible dream, for Wenceslas IV, who reigned in the last years of the fourteenth century, was most unpopular; in the year 1400 the Electors deposed him for drunkenness and incompetence. Finally, an Englishman in the last years of Richard's reign may have taken special pleasure in Arthur's punishment of the Emperor and his supporters. We must return later to the reasons for the poet's animosity toward the Empire. At the moment it is more important that the journey to Italy and the campaign there contain a number of details that indicate a date of composition in the closing years of the fourteenth century.

The poet's concern for drawing a parallel between Lucius and the Holy Roman Emperor probably accounts for the fact that Arthur's route to Italy follows the "German way"—down the Rhine to Lucerne, over the Goddard Pass to Como, and then to Rome.[9] However, all the characters in this poem follow this route. Even the Senator who comes to England to demand tribute from Arthur hastens back to Rome via the "German way," from Flanders to Aachen, over Mt. Goddard, through Lombardy and Tuscany to Sutri and Rome (vv. 495-502). Likewise, when Lucius sets out to encounter Arthur, he goes directly into Germany (v. 618) and ravages the country around Cologne (v. 623). This is obviously not the most direct route into France, but it seems to be the only route the poet knew. Yet, there is not record of any English traveler having known or used this route before the year 1402.

That was the year in which Adam of Usk journeyed to Rome by the route he describes in his *Chronicon.* Like the characters in the *Morte Arthure,* Adam enters Italy by way of the Goddard Pass, and he would have agreed with the poet that this involved "full grevous ways" (v. 497), for Adam was drawn in an ox-cart and was so

terrified that he had to be blindfolded.[10] Once in Lombardy he
traveled (as Arthur does) through Como, Milan, and Piacenza to
Borgo San Donnino (the last city is not mentioned in the poem):

> But thence—instead of continuing to follow the main road to Parma
> and Bologna and onward to Florence and Perugia—he turned to the
> south and made his way over the mountains to Pontremoli, and
> emerging at Ferrara, he followed the coast road through Pietrasanta
> to Pisa. Thence, once more turning inland, he accomplished the rest
> of the journey by way of Sienna and Viterbo.[11]

Adam explains that he turned aside from "Bologna, Florence, and
Perugia on account of the raging wars of the Duke of Milan." [12] By
staying within the Duke's territory as far south as Pisa and Pietra-
santa, Adam was able to avoid Tuscany, where the Duke's armies
were most active.

 Not only do Arthur and his army follow the "German way" into
Italy, they take exactly the same detour as Adam took to avoid
Tuscany. Arthur describes this itinerary when he announces his
plans to conquer Rome:

> I shall at Lamass take leve to lenge at my large (349)
> In Lorraine or Lumbardy, whether me leve thinkes;
> Merk unto Milan and mine down the walles
> Both of Petersand and of Pis and of the Pount Tremble,
> In the Vale of Viterbo vitail my knightes.

Arthur intends to march to Milan and then turn aside, as Adam did,
to Pietrasanta, Pisa, and Pontremoli, and finally turn back to Vi-
terbo, on the direct road to Rome.
 This is apparently the same route that the Welsh king, Sir Val-
iant, took when he went to Rome on a pilgrimage. In the council at
the beginning of the poem, Sir Valiant swears to be avenged on the
Viscount of Rome. He vows not to rest:

> Til that I have vanquisht the Vᵢscount of Rome (326)
> That wrought me at Viterbo a vilany ones
> As I past in pilgrimage by the Pount Tremble.

Sir Valiant apparently goes by way of Pontremoli not merely for

alliterative convenience (Parma or Perugia, on the direct road to Rome, would have done as well), but because this is the only route the poet knows. He is aware that one need not enter Italy through the Goddard Pass, since he has the emperor place guards at St. Bernard as well as the Goddard (v. 566), but Lucius himself assumes that even if one uses the Bernard Pass he will necessarily pass through Pavia, as did Adam of Usk: "In at the portes of Pavia shall no prince pass" (v. 568).

The relation between Adam's itinerary and the poet's knowledge of northern Italy does not indicate that the author of the *Alliterative Morte Arthure* drew upon the *Chronicon* of Adam of Usk. There must have been other travelers to Italy who followed this route, especially in the Jubilee Year of 1400. (Parks, who assumed the poem was written in the 1360s, thought it probable that the poet was one of the English pilgrims to Rome in the previous Jubilee Year of 1350, though there is no evidence that any of those pilgrims followed the "German way.") [13] Probably our poet was not a pilgrim himself but dependent on secondhand knowledge. The absence of the famous Tuscan place names, such as Florence, may be due mainly to the poet's decision to direct Arthur's campaign in Italy mainly against Lombardy, a fief of the Holy Roman Empire, but Valiant's use of the detour through Pontremoli seems to indicate that the poet believed that travelers to Rome ordinarily followed Adam's itinerary to avoid the warfare in late fourteenth-century Tuscany.

The route used by characters in this poem is less significant than the poet's obvious interest in northern Italy. He apparently assumes that his audience shares his interest in Lombardy and can even follow his geographical references. This would not have been the case in the 1360s. It was not until after 1368, when Lionel Duke of Clarence married Violante, the daughter of Galeazzo II of Milan, that many Englishmen knew about northern Italy. As Parks writes, Lionel's wedding brought about a "sudden familiarity with Milan. Before that marriage, travel to Italy was not extensive because the Papal court, the object of most travel from England, was at Avignon." [14] Though Lionel died shortly after the marriage, diplomatic and trade relations with Lombary continued; Chaucer traveled to Milan on an embassy in 1378. Richard II maintained what amounted to an alliance with Milan, and in the 1390s Parliament even discussed the possibility of intervening in the wars Milan was waging in Tuscany. Moreover, the ending of the

Babylonian Captivity in 1378 meant that the pope (at least the one England supported) was again at Rome, and the temporary lull in the Hundred Years' War led many English soldiers, such as Sir John Hawkwood, to seek employment as mercenaries in the Tuscan campaigns. For all these reasons, English knowledge of northern Italy greatly increased in the late fourteenth century. The poet could afford to be vague about the geography of the still fabulous East, but in the case of Italy he apparently dealt with territory familiar to his audience, and he took pains to be accurate.

The poet likewise had a fairly accurate understanding of the political situation in northern Italy. Indeed, if we can take his references seriously, they indicate a date of composition sometime after 1399. When Arthur's troops have conquered Como, we are told:

> The Sire of Milan herde say the citee was wonnen (3134)
> And send to Arthur certain lordes,
> Grete summes of gold, sixty horses charged,
> Besought him as soveraign to succour the pople,
> And said he wolde soothly be subject forever,
> And make him service and suite for his sere landes;
> For Pleasaunce, for Pawnce, and for Pownte Tremble,
> For Pise and for Pavy he proffers full large . . .
> And ilk a yere for Milan a melion of gold.

The poet knows that the "Sire of Milan" is the richest and most powerful prince in northern Italy, overlord of Como, Piacenza, Ponte, Pontremoli, Pisa, and Pavia. Alliteration rather than a desire for accuracy probably accounts for this choice of place names. Nevertheless, all the places the poet names were actually controlled by the Sire of Milan at the end of the fourteenth century.

This was not true earlier in the century. In the Jubilee Year of 1350, when Parks believed the poet himself may have made a trip to Rome, the Sire of Milan was Giovanni Visconti (who ruled 1349-54); he was master of much of northern Italy but he controlled neither Pavia nor Pisa.[15] By the late 1360s, when negotiations for Duke Lionel's marriage began, Pavia had come under the rule of the Viscontis but there were now two Sires of Milan. Giovanni had apportioned his holdings among his three sons—Matteo, Galeazzo II, and Bernabó. Galeazzo II and Bernabó assassinated their brother Matteo in 1355, and for the next thirty years the domain of Milan

was ruled jointly first by the two brothers, and then by Bernabó and Giangaleazzo, son and heir to Galeazzo II. Galeazzo II, as we have noted, was the father of Violante, who married Duke Lionel, and doubtless those whose interest in Lombardy was stirred by this marriage would have known of this peculiar governmental arrangement. That arrangement ended in 1385 when Giangaleazzo murdered his uncle Bernabó and became sole Sire of Milan. Only then did it become possible for the first time since 1354 to speak accurately of a single Sire of Milan who had sole power over all the lands from Como to Pisa and Pontremoli. Even before 1354, one could not speak of a Sire of Milan who controlled Pavia, since that city did not become Milanese possession until 1360. The city of Pisa did not fall into the control of Milan until the year 1399.[16] If we can take the poet's words as a serious reflection of his knowledge of Italian affairs, we must conclude that the poem was written no earlier than 1399. It could not have been written much later than 1402, when Giangaleazzo died, for the Milanese state broke up rapidly after his death. By 1406, Thomas of Walsingham reports, the pope had reconquered almost all the territory he had lost to Milan while Giangaleazzo lived.

However, the poet does call this character the "Sire of Milan," and "Sire" *(Signore)* had ceased being the proper title in 1395, when Giangaleazzo was granted the title of duke (for 100,000 florins) by the Emperor Wenceslas.[17] The poet is therefore inaccurate one way or another; if he wrote between 1365 and 1395 he was correct in using the title "Sire of Milan" but wrong about his possessions (the Sire did not yet control Pisa); if he wrote after 1399 the list of possessions is correct, but Giangaleazzo was no longer the "Sire." However, though travelers to Italy, such as Adam of Usk, knew the proper title, other Englishmen, such as Thomas of Walsingham, apparently did not and continued to refer to the ruler of Milan simply as "Dominus de Mediolano." [18] The political situation in late fourteenth-century Italy was confused enough that a foreigner might well be excused for being a bit out of date in the matter of titles or for not knowing precisely who controlled what and when, especially if (as was probably the case of our poet) his knowledge came at secondhand. Indeed, it may be that our poet did not know exactly who the Sire of Milan was.

This is indicated by the prominent role the poet accords to the "Viscount of Rome." Among the first of the vows of Arthur's knights

is that of the Welsh king, Sir Valiant, who swears (in the passage quoted above) to be avenged on the "Viscount of Rome," and Sir Valiant is the first to fulfill his vow. When the battle between the armies of Arthur and Lucius is about to begin, Valiant spies his old enemy in the vanguard of the Roman army (v. 2024), and he shouts:

> "Viscount of Valence, envious of deedes, (2047)
> The vassalage of Viterbo today shall be revenged!" . . .
> Then the Viscount, valiant, with a voice noble
> Avoided the avauntward, enveround his horse;
> He dressed in a derf sheld endented with sable,
> With a dragon engoushed, dredful to shew,
> Devourand a dolphin with doleful lates,
> In sign that our soveraign sholde be destroyed . . .
> Then the comlich king castes in fewter,
> With a cruel launce coupes full even
> Aboven the spayre a span among the short ribbes,
> That the splent and the spleen on the spere lenges!
> The blood sprent out and spredde as the horse springes,
> And he sproules full spakely but spekes he no more!
> And thus has Sir Valiant holden his vowes,
> And vanquisht the Viscount that victor was holden!

The importance of the Viscount is shown by the extended and gory account of his death. Even Lucius is dispatched more cleanly and quickly (vv. 2252-54). Evidently the poet and his audience took special satisfaction in Valiant's revenge.

There was no "Viscount of Rome" in the fourteenth century, and "viscount" itself is rather a rare title in this period. In England when it was used it meant something like "sheriff," and it did not become a title of nobility until 1440.[19] However, the title was used in the Holy Roman Empire, and the most famous such viscount was the one whose family bore the name *Visconti,* derived from their heredi-tary office of *vice comes* of the emperor: Giangaleazzo Visconti, Sire of Milan. George Neilson first suggested that "Viscount" here is not a title but a family name, Visconti.[20] This is an attractive suggestion, for it helps explain both the shift in name (from "Viscount of Rome" to "Viscount of Valence") and the curious arms borne by this knight. Valence, Neilson explained, is Vallenza, which the Viscontis controlled, and Giangaleazzo was therefore properly both "Vis-count of Rome," by virtue of his office as *vice comes* of the Emperor,

and "Viscount of Valence," by virtue of his overlordship of Vallenza. Parks, who assumed the *Alliterative Morte Arthure* was written in the 1360s, rejected this identification because Vallenza did not become a part of the Visconti domain until 1382.[21] We might also note that the reference to the viscount's power extending from "Venice to Viterbo" (v. 2025) would likewise be inaccurate any time before 1399, when the acquisition of Pisa had extended the Visconti rule as far south as the border of Viterbo. However, if we assume a date around 1400 there is no reason to reject Neilson's thesis.

Neilson's thesis also helps explain the curious arms borne by the Viscount of Rome: They are described twice, first when his banner is lifted before Lucius's army:

> Dresses up dredfully the dragon of gold (2026)
> With egles all over enamelled of sable.

Then, in the passage quoted previously, the dragon is described in more detail:

> A dragon engoushed, dredful to shew, (2053)
> Devourand a dolphin with doleful lates.

Adam of Usk described the "dreaded arms" of the Visconti thus: "a dragon azure, swallowing a naked man gules, on a field argent." [22] The dragon was usually blazoned as a viper (though the serpent is clearly a dragon in some late fourteenth-century representations),[23] and the poet's tinctures differ from those of the Visconti arms. Furthermore, this dragon is swallowing a dolphin rather than a man. Neilson explained that by glossing "dolphin" as Dauphin;[24] there may be something to that, for Giangaleazzo was son-in-law to the King of France and thereby Earl of Vertues. However that may be, the device of a dragon swallowing another creature is rare indeed and lends support to Neilson's conjecture that the poet meant to represent a Visconti as the "Viscount of Rome."

Further support is apparent in the fact that the poet seems to have combined the Visconti device with Imperial eagles. Neilson explained that the dragon of gold with eagles all over enameled of sable is emblematic of the Visconti's association with the Holy Roman Emperors and their device of a black (not always double-headed) eagle on a gold field. Clearly the eagles are meant to

represent Lucius's emblem (his standard is an eagle and his tents are decorated with eagles "all over," v. 1294). They may therefore reflect not just a symbolic association, as Neilson thought, but an actual quartering of the Visconti and Imperial arms: when Giangaleazzo became an Imperial Duke in 1395, he proclaimed that his arms would henceforth be quartered with the Imperial eagle.[25]

Parks rejected this and Neilson's other arguments for the identification of the Visconti with the Viscount of Rome, because "it would hardly be tactful for the poet to refer to a contemporary ruling family as miscreants and rightfully slain by one of Arthur's knights." [26] This would indeed have been the case in the 1360s, when the English court was negotiating for the marriage of a prince of the blood to one of the daughters of Galeazzo II. However, by the end of the century the Viscontis were by no means universally admired. Giangaleazzo's murder of his uncle Bernabó in 1385 was an international scandal. English chroniclers recorded the fact, and Chaucer gave Bernabó a place in his *Monk's Tale* and emphasized Giangaleazzo's perfidy:

> Thy brother sone, that was thy double allye,
> For he that nevewe was and sone-in-lawe,
> Withinne his prison made thee to dye.[27]

Even more scandalous was the part Giangaleazzo apparently played in the defeat and consequent massacre of the Christian army at Nicopolis in 1396. Froissart reports that Giangaleazzo was allied with the Turks and sent them prior warning of the advance of the Christian army. Froissart marvels that a Christian ruler "would seek or require love or alliance with a king miscreant." [28] However, Froissart explains, the Visconti were renowned for evil deeds, especially Giangaleazzo: "He held the error and opinion of his father; that was how one should neither honor nor worship God," and he therefore despoiled the religious orders and "did great despite to Holy Church." Not everyone shared this low opinion of the Visconti; Adam of Usk admired his strong government. However, Froissart's views would have been heartily seconded by the few surviving Christian knights who straggled back from Nicopolis in the closing years of the fourteenth century. Our poet, whose attitude toward Lucius's pagan allies indicates that he shared the crusading

zeal that led to the disaster at Nicopolis, very likely shared Frois-
sart's opinion of the Visconti.

Yet the poet shows no awareness that the Sire of Milan and his
Visconti are the same. Nor is there any apparent reason for his
association of Visconti with Viterbo. Perhaps some English mer-
cenaries in the pay of Florence or the pope had an unfortunate
encounter with Visconti troops near Viterbo.[29] Or perhaps the poet
was simply confused. Even allowing for such confusion, the image of
Italy is generally accurate both in geographical details and in its
representation of the political situation in the very last years of the
fourteenth century. To summarize this evidence: The only route to
Rome known to the poet is one apparently not used by English
travelers until the late fourteenth century and not mentioned by
anyone until Adam of Usk in 1402. The poet refers to a Sire of Milan
who controls Pisa; the ruler of Milan did not control Pisa until 1399.
Only in the later fourteenth century, after Giangaleazzo's murder of
Bernabó in 1385 and, more especially, after his role in the massacre
at Nicopolis, did the Visconti earn international infamy of the sort
that would account for the poet's animosity toward the "Viscount of
Rome." That most infamous of the Viscontis died in 1402, and the
state he established broke up shortly thereafter. How one weighs this
evidence depends on how seriously one takes the poet's words. Ob-
viously one cannot construe them too closely, for a romancer nec-
essarily aims at aesthetic effect rather than historical accuracy. Yet
the date of composition indicated by the Italian references—some-
time between 1399 and 1402—accords closely to that indicated by
the English references, which we must next consider.

II. MORDRED AND RICHARD II

When Arthur and Gawain return to England to conquer the
kingdom from Mordred, they meet and destroy Mordred's fleet off
the coast of Sandwich. Then they sight Mordred with a huge army
waiting on the shore, and they turn their ships toward the land.
However, the tide is out, and Arthur prudently veers back to sea.
The headstrong Gawain will not turn back. With the small troop on
but one ship, he purposely runs aground, wades ashore, and, though
hopelessly outnumbered, he attacks Mordred and his army:

But then Sir Gawain, iwis, he waites him well (3770)
To wreke on this warlaw that this war moved,
And merkes to Sir Mordred among all his bernes,
With the Montagues and other grete lordes.

Of all the personal names in the *Alliterative Morte Arthure,* "Montague" is the only name actually borne by a contemporary English family. The Montagues were one of the most powerful families in fourteenth-century England.[30] They first came to prominence in the service of Edward III, and Edward made Sir William Montague the Earl of Salisbury. Sir William and his successor to the earldom, Sir John Montague, became even more powerful during the reign of Richard II. William was one of Richard's most important supporters; his brother was steward of the king's household; and Sir John, who succeeded to the earldom in 1397, was one of Richard's closest friends and advisors.

The lines quoted above are usually read as if the Montagues were with Gawain marching toward Mordred's army. This is possible, since in Middle English verse the modifier is often separated from the element it modifies. Given a date of composition somewhere between 1360 and 1375, the lines almost have to be read this way, for there would have been no reason for the poet to place Edward's most faithful supporters in Mordred's army. Yet even in Middle English this reading seems forced, for adverbial phrases are not often separated from their verb in this fashion, especially when the construction is not parallel to that of a preceding phrase. Moreover, such a reading violates the sense of the passage. The whole point of the episode is that Gawain is hopelessly outnumbered. He is alone, with a troop of only seven score men (v. 3930), who are apparently his personal retainers, since they carry only Gawain's badges (v. 3730). Mordred, on the other hand, has an army of 60,000 (v. 3717) men including many great lords. We have no choice but to read the passage as it is written: Gawain marches toward Mordred, who is accompanied by the Montagues and other great lords.

Although the poet would have had no reason to enlist the Montagues in Mordred's army if he had been writing earlier in the century, by the year 1400 the head of the Montague family, the Earl of Salisbury, had become infamous for both heresy and treason. Sir John Montague was one of the "Lollard knights," and according to

Walsingham, he was the worst of the lot, scorning the sacraments even at his death:

> Comes Sarum, Johannes de Monte Acuto, qui Lollardorum fautor semper fuerat, et imagine vilipensor, contemptor canonum, Sacramentorumque derisor, expers omnium Sacramentorum vitam finivit, ut fertur.[31]

Sir John was also one of the knights who nailed the "Lollard Manifesto" to the doors of Westminister Hall during the Parliament of 1395.[32] This is all according to hostile chroniclers, such as Knighton and Walsingham, who were unlikely to be fair to any supporter of Richard. However, the most recent student of the problem, K. B. McFarlane, has shown that many of the accusations were probably true and at the very least represent what was commonly believed.[33]

Whoever the author of the *Alliterative Morte Arthure* was, he was no Lollard. His heroes devoutly swear by the veronica, venerate the saints, make pilgrimages, respect the sacraments, and carefully observe the temporal rights of the church. Sometimes the poet seems even to go out of his way to emphasize the orthodoxy of his heroes, as when Arthur invades Italy and announces at length his policy toward church property:

> I give my protection to all the pope landes (2410)
> My rich pensell of pees my pople to shew.
> It is a folly to offend our fader under God
> Other Peter or Paul, the postles of Rome.
> If we spare the spiritual we speed but the better;
> Whiles we have for to speke, spill shall it never!

It is difficult to understand why the poet should have made so much of this point if the question of church property had not been in the air, and the expropriation of church property was indeed an issue in the late fourteenth century. Expropriation had been one of the articles of the "Lollard Manifesto," and in 1404 (and again in 1410) Parliament petitioned Henry to seize church properties, which the devout Henry resolutely refused to do.[34] The poet would clearly have approved Henry's refusal, and so orthodox a writer would have been shocked by Sir John Montague's heresy.

There were, however, even better reasons for enlisting the Montagues in Mordred's army. As we have noted, the Montagues were faithful supporters of Richard II, and Sir John Montague was especially close to the king. He was therefore hated by Henry's supporters, and when Henry seized the throne in 1399, Montague barely escaped with his life:

> The king's council and diverse other noblemen and the Londoners would that his head should have been struck off openly in the Cheap, for they said he well deserved it for bearing letters of credance from Richard of Bordeaux [Richard II] to the French king, and there to report openly that King Henry was a false traitor, which fault they said ought not to be pardoned ... the earl excused him and said that he did was by the king's commandment.... King Henry believed well the earl's words, but his council would not believe it, but said, and so did all the Londoners, that he should die, because he had deserved death.[35]

Nevertheless, Henry did pardon Montague. Thereupon Montague and other great lords proclaimed a tournament to which King Henry was invited. They planned to use the tournament as an excuse for assembling an armed force with which, after killing Henry, they would free Richard, who was still alive and imprisoned. However, the plan was revealed to the king, and the conspirators scattered. Montague went to Cirencester, where he was captured and beheaded (by the townspeople in some accounts). His head was sent to Henry and displayed on London bridge, and he was declared a traitor.[36]

The poet's naming of Montague among Mordred's supporters strongly indicates that the *Alliterative Morte Arthure* was written about 1400, when the memory of Sir John Montague was still fresh in the minds of those who regarded Henry IV as a true king and Richard as an usurper. It is not likely the poem was written much later than 1400, since in 1409 the Montagues were restored to their estates, and the new Earl of Salisbury, Sir John Montague II, began a blameless career in the service of the king.[37]

The most important consequence of Montague's association with Mordred is the suggestion that Mordred is identified in some fashion with Richard II. If indeed the poem was written in the year 1400 or shortly thereafter, it would have been difficult for the poet and his audience to avoid reading contemporary political significance into

the struggle between Arthur and Mordred. In 1399-1400 England in effect had two kings—Richard II and Henry, the "rightful king," who had returned from the continent to conquer the throne, just as Arthur did. It looks as if the poet was aware of this parallel, for he associates Mordred with Ireland and the West Country. Mordred says that he intends to take refuge in Ireland (v. 3909). Richard was closely associated with Ireland and was the first English king to take much interest in Ireland since Henry II. He had just returned from Ireland when Henry landed, and he may indeed have intended to flee there when he was captured.[38] Likewise, Mordred lives in the "wild boundes of the West Marches" (v. 3551), where Henry encountered and captured Richard. This was the part of England where Richard's supporters were most numerous. This is apparently why when Guenevere flees she hastened toward Chester (v. 3914). Richard's supporters were especially numerous there, and he had recently raised the town to the status of a princedom with himself as prince.[39]

Richard's enemies would have recognized a general parallel between Richard's crimes and Mordred's (though these are the standard set of crimes for evil rulers) and a more specific parallel in the doubtful paternity of both "usurpers." Mordred is the "Malbranche," the evilly engendered. Richard was also, so his enemies believed, evilly engendered. According to Froissart, Henry told Richard:

> The common rumor runneth throughout England and in other places that ye were never son to the Prince of Wales but rather son to a priest or canon, for I have heard of certain knights that were in the prince's house, mine uncle, how that he knew well that his wife had not truly kept her marriage. Your mother was cousin-german to king Edward, and the king began to hate her because she could have no generation; also she was the king's gossip of two children at the font; and she that could well keep the prince in her bandon by craft and subtlety, she made the prince to be her husband; and because she could have no child, she doubted that the prince should be divorced from her; she did so much that she was with child with you and another before you. As of the first I cannot tell what to judge; but as for you, because your conditions have been seen contrary from all nobless and prowess of the prince, therefore it is said ye be rather son to a priest or canon; for when you were gotten at Bordeaux, there were many young priests in the prince's household. This is the bruit in this country.[40]

This accusation of bastardy may have been based on the suspected
irregularity of the marriage of Richard's mother to the Black Prince.
His mother was Joan, the Fair Maid of Kent, who was first married
to Sir William Montague. That marriage was annulled by the pope
on the basis of a previous secret engagement to Sir Thomas Holland.
When the annulment was declared, Joan married Holland. When
he died, she married the Black Prince. However, her first husband,
Montague, still lived and provided a basis for those who chose to
gossip about the validity of her later marriage.

Not only does Henry accuse Richard of bastardy, he hints at
incest: Richard's mother was cousin-german to his grandfather and
was godparent to two of Edward III's children. Both relationships
are well within the forbidden range. If modern historians are correct,
there is more to it than that: Joan's first marriage to Montague
made her the Countess of Salisbury, who was Edward's mistress and
in whose honor he founded the Order of the Garter: *Honi soit qui mal
y pense.*[41] At any rate, her reputation was low indeed among Henry's
supporters. As Adam of Usk says, Joan was "given to slippery ways
of life, to say nothing of much that I have heard." [42]

The poet apparently regarded Joan as in some fashion parallel to
Guenevere. When Arthur sees his sword Clarent in Mordred's hands
he exclaims:

> My wardrope at Walingford I wot is destroyed. (4203)
> Wiste no wye of wonne but Waynor herselven;
> Sho had the keeping herself of that kidd wepen.

Guenevere's association with Walingford has been explained as an
allusion to the adulterous liaison between Mortimer and Isabella,
wife of Edward II; they held festive court there at Christmas in
1326.[43] However, the castle of Walingford had much more recently
been associated with Joan of Kent, for it was her residence from the
time of her marriage to the Black Prince in 1361 until her death in
1385.[44] Had the poem been written in the 1360s or 1370s the men-
tion of Walingford would surely have reminded the hearers of Joan
of Kent, wife of the Black Prince. The allusion would have been, to
say the least, tactless. By 1400, when Henry's supporters were busy
reviving gossip about Joan's character, Richard's enemies would
have found a reference to Walingford and the consequent allusion to
Joan appropriate indeed.

Likewise, the poet's animosity toward the Holy Roman Empire, which we noted near the beginning of this study, may also be due to his dislike of Richard. In Edward's reign, relations between England had been cordial. Edward accepted the title of Vicar of the Empire and struck coins by that authority. In the year 1348 Edward had been offered the Imperial crown, and he had negotiated a kind of overlordship of the Imperial fiefs of Luxemburg and Lorraine (perhaps this is why Arthur considers the Duke of Luxemburg a traitor).[45] Richard allied himself even more closely to the Empire. By marriage to Anne of Bohemia he was brother-in-law to the Emperor Wenceslas, and he cultivated close relations with those parts of the Empire, such as Lorraine and Lombardy, that bordered on France. The idea was to isolate and neutralize France,[46] a shrewd policy but one that earned Richard little credit in England, where Richard's peaceful diplomacy was seen as a sign of weakness. The culmination of Richard's policy came in the year 1397, when the German Electors, already intent upon deposing Wenceslas, offered Richard the crown of the Empire. Unfortunately, Richard made this an excuse for raising money, and Richard's enemies saw the offer not as a diplomatic triumph but as further proof of his tyranny:

> In this tyme risen tydingis in this lond that the Kyng was chose emperoure, for whech cause the kyng mad mo gaderingis and taliages than evir he ded before. There was no cite, no town, no prelate, lord, knyte, or marchaunt but thei mote lende the Kyng mony.[47]

A supporter of King Henry might therefore have felt he had good reasons for thinking ill of the Empire, at least in the years 1397-1400. In 1400 Wenceslas was deposed, and a new emperor (actually one of three rival emperors), Rupert of Bavaria, was elected. Henry IV immediately set out to establish good relations with him and to ally England once more with the Empire. In June 1401 Henry signed an agreement with Rupert for the marriage of his daughter Blanche to Rupert's son Henry, and they were married at Cologne on Easter of 1402.[48] After that date an ardent supporter of Henry, as our poet seems to have been, would have had little reason for animosity against the Empire.

Obviously the *Alliterative Morte Arthure* is no roman à clef or political allegory. My point has not been to prove that Richard *is*

Mordred nor that Joan of Kent *is* Guenevere. The characters and episodes of this poem owe far more to Arthurian tradition than to the events of 1399-1400. However, those events did color the poet's handling of his materials, and this allows us to fix a date of composition. The poet's hints of Richard in the characterization of Mordred, the allusions to Walingford, and the presence of the Montagues in Mordred's army all indicate a date of composition after Richard was deposed in 1399 and after the attempted rebellion by Montague and other great lords in 1400. The poem must have been written well before the Montagues were back in favor in 1409, and it was probably written before Henry's daughter married the Emperor in 1402. The English allusions, in short, support the same date as the Italian—in or shortly after the year 1400.

Space does not allow an exploration of the full implications of this later dating. Probably the poet, like many of his contemporaries, looked back on Edward III as the equal of King Arthur, and he may have entertained hopes that Henry would restore Arthurian glory to England. Henry apparently had such hopes, and at Christmas in 1400 he sponsored a tournament in the challenges to which he was compared to Arthur and Alexander.[49] However, the *Alliterative Morte Arthure* ends not in a great Arthurian triumph but in Arthur's tragic death. It may be that the poet, ardent Lancastrian that he was, meant his poem to serve both as a mirror of the virtues of Henry's grandfather and a solemn warning of what the duties of kingship implied. The *Alliterative Morte Arthure* may therefore have a more profound relation to contemporary events than has yet been suspected. To discover that relation we should look not to the last years of Edward's reign but to the first year of Henry's.

NOTES

1. See William Matthews, *The Tragedy of Arthur* (Berkeley and Los Angeles, 1960), esp., pp. 184-92, and George Neilson, "Morte Arthure and the War of Brittany," *Notes and Queries,* 9th series, X (1902), 161, and "Huchown's *Morte Arthure* and the Annals of 1327-1364," *The Antiquary,* XXXVIII (1902), 229-32.

2. J. L. N. O'Laughlin dates the poem at 1360 in his "The English Alliterative Romances," in *Arthurian Literature in the Middle Ages,* ed. R. S. Loomis (Oxford University Press, 1959), p. 521 Mat-

thews, *Tragedy of Arthur,* p. 192, believes the poem may have been composed shortly after 1375.

3. *"Morte Arthure:* The Date and a Source for the Contemporary References," *Speculum,* XLII (1967), 624-38. In his edition, *Morte Arthure,* York Medieval Texts (Evanston, Ill., 1967), p. 33, Finlayson suggests that the poem may date from the last years of the fourteenth century.

4. "Edward III and the Alliterative *Morte Arthure,*" *Speculum,* XLVIII (1973), 37-51. Spanish ships were at Sluys (1340), Winchelsea (1350), and La Rochelle (1372).

5. See Keiser, p. 45. The use of place names, as Keiser notes, is especially important (Finlayson, *"Morte Arthure:* The Date," p. 628). Arthur's use of an armorial device reminiscent of Edward's is also striking; see Matthews, *Tragedy of Arthur,* pp. 186-87.

6. Froissart, *Chronicles,* trans. Geoffrey Brereton (Baltimore, 1968), p. 195. See Keiser, pp. 50-51, for the full quotation and discussion.

7. G. N. Neilson, "The Baulked Coronation of Arthur in 'Morte Arthure,'" *Notes and Queries,* 9th series, X (1902), 381-83, 402-4.

8. This seems to be the import of the line; an alternative possibility is that Arthur himself is aspiring to the title. All quotations are from my edition: *King Arthur's Death: The Middle English Stanzaic Morte Arthur and Alliterative Morte Arthure* (Indianapolis and New York: Bobbs-Merrill, 1974).

9. For a full discussion see George B. Parks, *The English Traveller to Italy, I: The Middle Ages (to 1525)* (Rome, 1954). Neilson (note 7 above) argued for a relation between Arthur's journey and the journey of the Emperor Charles IV to Rome in 1354, but there is little basis for this.

10. *Chronicon Adae de Usk,* ed. and trans. E. N. Thompson, 2d ed. (London, 1904), p. 75.

11. *Chronicon,* pp. xxii-xxiii.

12. *Chronicon,* p. 75.

13. "King Arthur and the Roads to Rome," *Journal of English and Germanic Philology,* XLV (1946), 169.

14. Ibid., p. 169.

15. For a convenient account of the Visconti, see E. R. Chamberlain, *The Count of Virtue: Giangaleazzo Visconti: Duke of Milan* (London, 1965), pp. 11-74.

16. Ibid., p. 196.

17. Ibid., p. 163.

18. *Ypodigma Neustria,* ed. H. T. Riley, Rolls Series (London, 1876), p. 419.

19. OED, s.v. "viscount." The earliest recorded use is in John of Trevisa, 1387, the second in our poem, which the OED dated "?1400."

20. "The Viscount of Rome in the 'Morte Arthure,'" *Athenaeum* (1902), pt. II, 652-53.
21. "King Arthur and the Roads to Rome," p. 165.
22. *Chronicon,* p. 75.
23. For a good reproduction see the plate in Geoffrey Trease, *The Condottieri: Soldiers of Fortune* (London, 1970), opp. p. 80.
24. "The Viscount of Rome," p. 653. On Giangaleazzo's relations with France and the Dauphiné, see Chamberlain, *Count of Virtue,* pp. 33-34.
25. Chamberlain, *Count of Virtue,* p. 163. In Trease, *Condottieri,* opp. p. 128, is a reproduction of manuscript painting of Giangaleazzo's coronation as duke; the imperial arms appear (a single-headed eagle, sable, on a field of gold) next to Visconti's arms, which are quartered (though whether or not with eagles is not clear from the reproduction).
26. "King Arthur and the Roads to Rome," p. 165.
27. *Monk's Tale,* vv. 2403-5, in F. N. Robinson, *The Works of Geoffrey Chaucer,* 2d ed. (Boston, 1957). See the note on these lines for a reference in a contemporary English chronicle.
28. Froissart, *Chronicles,* trans. Lord Berners, ed. G. C. Macaulay (London, 1895), p. 439. The other quotations are from pp. 439-40.
29. The poet's references to Viterbo are puzzling; see n. 12 on p. 213 of Matthews, *The Tragedy of Arthur,* for the possible explanation that the poet had in mind the murder of Henry of Almaine in 1271. The country around Viterbo was frequently a scene of warfare in the late fourteenth century as well as a stopping place on the normal pilgrim route to Rome, and possibly some now forgotten incident aroused the poet's ire.
30. For a brief account with references, see May McKisack, *The Fourteenth Century: 1307-99,* Oxford History of England (Oxford University Press, 1949).
31. *Ypodigma Neustria,* p. 390; see also pp. 348, 368. There are similar remarks in Walsingham's *Historia Anglicana* II, 149 and in the chronicles of Knighton, St. Albans, and Capgrave.
32. The "manifesto" is printed in *English Historical Documents, IV: 1327-1485,* ed. A. R. Myers (London, 1969).
33. K. B. McFarlane, *Lancastrian Kings and Lollard Knights* (Oxford, 1972), esp. pp. 221-26.
34. The petition of 1410 is printed in *English Historical Documents,* ed. Myers, pp. 669-70.
35. Froissart, *Chronicles,* p. 471.
36. Almost all the chronicles mention this. Adam of Usk

successfully prevented the expropriation of the Montague estates by arguing that since Montague was already dead his possessions had already passed to his heirs and therefore could not be alienated. Though Usk thus proves himself a skilfull lawyer, it is worth noting that he made his journey to Rome to escape a charge of horse theft.

37. McFarlane, *Lancastrian Kings,* p. 76.

38. McKisack, *The Fourteenth Century,* pp. 491-92.

39. *Ypodigma Neustria,* p. 378. See also Johannis de Treklowe et Henrici de Blaneford, *Chronica et annales,* ed. Henry T. Riley, Rolls Series (London, 1866), p. 237. For a full discussion, see R. R. Davies, "Richard II and the Principality of Chester: 1397-99," in *The Reign of Richard II,* ed. F. R. H. DuBoulay and Caroline M. Barron (London, 1971), pp. 256-79.

40. Froissart, *Chronicles,* p. 468.

41. See McKisack, *The Fourteenth Century,* p. 474, and Margaret Galway, "Joan of Kent and the Order of the Garter," *University of Birmingham Historical Journal,* I (1947), 13-50.

42. *Chronicon,* p. 181. Finlayson (n. 3) suggests that Guenevere's farewell to Arthur is based on Joan's farewell to the Black Prince in the Chandos Herald's *Life of the Black Prince;* if so, that passage is even more ironic than we thought.

43. Matthews, *The Tragedy of Arthur,* p. 184.

44. Richard II also used Walingford as a residence. He left his queen (Isabella of France) there when he departed for Ireland and in the closing years of his reign, letters under the Great Seal were dated from Walingford. See J. L. Kirby, *The Reign of Henry IV* (London, 1970), pp. 60, 119-20.

45. See Fritz Trautz, *Die Könige von England und das Reich 1272-1377*(Heidelberg, 1961), pp. 345-408. Edward's Imperial coins are depicted in the plates in Friedrich Heer's *The Holy Roman Empire,* trans. Janet Sondheimer (New York, 1968).

46. J. J. N. Palmer, "English Foreign Policy, 1388-99," in *The Reign of Richard II,* pp. 75-107.

47. *Capgrave's Chronicle of England,* ed. Francis G. Kingeston, Rolls Series (London, 1858), p. 264. Walsingham says this was only an idle rumor which Richard turned to his advantage (*Ypodigma Neustria,* p. 374), but the *Annales Ricardi Secundi* (in Treklowe, n. 39 above), pp. 199-200, give supporting particulars.

48. Kirby, *Henry IV,* p. 138.

49. Mary A. E. Green, *Lives of the Princesses of England* (London, 1857), III, 315. Green quotes from the still unpublished Arundel MSS in the College of Arms. It is interesting to note that the tournament was held in honor of Manuel Palaeologus, the Emperor of Constantinpole, who was in England seeking to inspire a crusade against the Turks. His presence and the discussion his proposal inspired may have lent a special interest to the poet's treatment of Lucius's Saracen allies.

Patience and the *Mashal*

Morton W. Bloomfield
Harvard University

*To Lillian, who herself best exemplifies patience
and all the other virtues.*

After many years of neglect, recent criticism and scholarship are beginning to turn to *Patience,* the shortest of the poems found in the *Gawain* Manuscript (BM. Cotton Nero A.x) and have raised a number of interesting questions about it which have contributed to an enriched understanding of it. For the first time one feels that some progress in comprehending it is being made although much yet remains to be done.[1]

My concern in this article is with the question of genre, for I believe that it is a complex issue on which for good reason the commentators are divided. I hope to contribute to its elucidation in the hope of a better understanding of the poem.

When the subject has been broached at all, the poem has usually been seen as a homily. If we are to define a homily as the handbooks of rhetoric do or as common sense dictates, it is quite clear that *Patience,* although didactic and moralistic, is not a homily. It is a wisdom poem giving a tropological and psychological interpretation of a biblical tale. Moralizing does not make a literary work a sermon.[2] The sermon form no doubt had some influence on *Patience,* but it is hard to imagine it as belonging to that genre.

We have in world literature, and in particular medieval literature, a number of narratives whose focus is on the story but in which moralizing plays a clear but subsidiary role. What we have in these works is not an exemplum or exempla buried in a sermon or moralized tract but just the opposite: a sermon or sermonic elements buried in an exemplum. A perfect example of this upside-down sermon may be seen in Chaucer's *Pardoner's Tale* (which incidentally is also frequently mistermed a sermon). Here the exemplum, the

41

story of the three thieves who seek death, takes over the work and the moralizing and sermonizing part is embedded in it.

The decisive point is the amount of moralizing and teaching present.[3] A sermon is fundamentally an exhortation to right action and right understanding which makes use of authority (especially the Bible and the Fathers), an explanation (or explanations) of the moral demands, exempla, allegorizing, and so forth. A moralized exemplum or *mashal* is fundamentally a narrative with a small amount of moralizing, sometimes in an explicit moral, sometimes in the words of the speaker directed to his audience, sometimes primarily at the beginning and end (as in *Patience*), and sometimes as interruptions in the story. But the story is the center of the work and is meant to be fairly self-explanatory. It is to the *mashal* category that *Patience* belongs.

The *mashal* (plural *meshalim*) is a type of wisdom literature found among the writings of the ancient Hebrews comprising what other civilizations called in their various languages fables, allegories, extended proverbs, parables and so forth. Jesus' parables are *meshalim*. All these items are short narratives which are either self-explanatory or with explicit moralizations. Jesus explains many of his parables in explicit language. Fables are similar to parables but usually with talking animals or plants as the characters. They repeat, as other *meshalim* do, like a narrative, something that presumably happened in the past in direct and forceful language, with a minimum of static description and with little or no character development. Characters are static, representative, and exemplary.

Although made-up stories were always in the past at least subject to suspicion by most men, fables and parables which were ostensibly and obviously made-up (and hence could fool no one) and written for an express moral purpose were more palatable than most fictions.[4] They were at least permitted. Since they were even used by the Bible itself, the defensive stand of composers of *ficta* was less needed. A *mashal* using the Bible itself would be especially above suspicion.

The parable, fable, and exemplum were the terms used by the ancient classical world to indicate what was covered by the Hebrew word *mashal*. At the same time in the ancient world another related genre flourished, the *epyllion*, which is described by Crump [5] as a short narrative poem of various lengths but no longer than one book. Its subject is an incident in (or occasionally a complete story of) the

life of an epic hero [6] or heroine. Dramatic narrative form was favored and at least one long speech is found in them. Digressions from the main story are not unknown.

The *mashal* and to a lesser extent the *epyllion* traditions account, I believe, for the form of *Patience* and indeed other moralistic short medieval narrative poems. *Jonah* itself as it appears in the Bible is a *mashal* so that reading the tale could suggest such a form to the modern reteller. The characterization, however, is probably due to the *epyllion* tradition.

There is, however, one very important difference between the *mashal* and the form of *Patience:* the presence in the latter of a narrator. Normally the *mashal* does not have a persona or narrator. However, in the *epyllion* such a figure is not unknown. But even more significant in explaining its presence in *Patience* I believe is the rise of the author-persona in Western literature from the late twelfth century on. The use of a commentator in literature belongs to the growth of literature itself. Literature in early societies had goals and social purposes—exhortation, healing, cursing enemies, praise, reciting of genealogies, and so forth. In order to succeed they had to be true. Magic only works if it reflects the truth. The truth includes the presence of the author or the circumstances giving rise to the tale when not an oral narrative. This involved in most written literature the presence of the author as a major part of the circumstances which made the literary work. However, his role was strictly circumscribed. As written literature became more sophisticated, the persona-figure became more important, and we find elaborate examples in classical literature.

In the West, however, the persona does not become a major actor in the literary work until the high medieval period, when stimulated by a new urban civilization, by certain classical works like those by Horace and Ovid, a reading audience, and the rise of the psychological point of view. The persona then becomes an important element in Alain de Lille, Jean de Meung, and Guillaume de Lorris. The rise of allegory and self-conscious individualism all helped to develop the persona.

Hence it is not surprising that the *Patience mashal* should give a major role to the commentator. Moralized stories or *meshalim* with the strong presence of a commentator are quite common in the fourteenth century. To confine one's self to English literature, one can point to numerous stories and events moralized or willfully

misunderstood by the persona in *Piers Plowman*. The author of *Patience* may himself have written another example in *Purity*. Chaucer's *Canterbury Tales* offer examples other than the *Pardoner's Tale:* the *Nun's Priest's Tale,* the *Manciple's Tale,* the *Physician's Tale,* the *Clerk's Tale,* and others. Gower's *Confessio Amantis* offers many examples.

Leaving the form aside for the moment, one must turn to the tradition of the virtue of patience and the exegetical tradition of Jonah. Needless to say, these need lengthy investigations which I cannot embark on here, but I think something illuminating (from the point of view of the understanding of *Patience*) may be said.

Traditionally patience has various links with other virtues: obedience, fortitude, temperance, and humility. The tradition wavers as to how to classify this virtue. Aquinas links it basically with fortitude. A history of its complexities would be a study in itself. Augustine wrote a *De patientia* and in the first book praised this virtue and associated it with Christ himself. In practicing patience, we imitate Christ and God.[8] In the practice of patience, we become godlike. Gregory the Great makes it the root and safeguard of all the virtues.[9] The poem is hence not only about the acquired patience of Jonah but also and even more important about the patience of God and of the persona who bears the worst of afflictions patiently —poverty. As Diekstra says, we must not take a narrow view of patience (p. 206). It is in fact the virtue of the acceptance of God's will. We must face both His favors and His punishment. Patience is needed in success as well as adversity. This is well seen in the two vices frequently opposed to patience—impatience (in the face of adversity) and insensibility (in the face of success).

Although I can't prove it, I suspect patience became strongly emphasized in the later part of the Middle Ages just because the nominalist and other philosophers became more and more emphatic about the power and irrationality of God. With such a God one needs all the patience one can bring to bear. A. C. Spearing [10] is the only scholar I believe who has seen the power manifested in God as He appears in *Patience*. But even he does not see its relation to the notion of *potestas inordinata* (or *absoluta*) which was a popular topic in fourteenth- and fifteenth-century philosophy, especially among the nominalists. God's power was both *ordinata* and *inordinata:* the former comprised the laws and regularities of nature and were in principal predictable: the latter comprised the extranatural and hence unpredictable and awesome power of God.[11]

Jonah is a figure of great ambiguity and the new book on the history of the interpretation of *Jonah* bears this out.[12] He is both a querulous, unpleasant man and at the same time a prophet capable of a beautiful prayer from the belly of the whale. Jonah asks to be thrown into the sea and yet complains about petty inconveniences. His book carries a message of universalism, and it is referred to, rather ambiguously, too, by Jesus himself. Furthermore, in the exegetical tradition, Jonah is often considered the prototype or figure of Jesus or, in the Kabbalistic mystical tradition, the symbol of the soul incarnated in this world who descends only to rise again.[13] Diekstra points to the alternation of joy and sorrow in Jonah's makeup as "the chief source of his characterization" (p. 209) in *Patience*.

Sendal's recent analysis of the narrative structure of our poem also bears out this point. He sees the poem built around prayer to God in despair and God's answers. When a man can pray, he has accepted God's providence and is aware of His power. The poem dramatizes Jonah's alternations between rebellion and acceptance. He is as it were forced to do good or establish the foundations of God's mercy by his deeds. The action is to stress also the fact of Jonah's chosenness. He has been chosen by God and his fate is determined. He cannot escape it. As Schleusener writes: "The poem rests on a conception of the way God works in the world and how men find themselves turned to his will." [14] The central topic, Spearing says, is "the confrontation between the human and more than human." [15]

These insightful comments help us to understand the poem, but they do not help us to understand its generic structure. There are, as I have implied above, three focal points in *Patience:* God, the persona, and Jonah. They all manifest different levels of the spiritual virtue of patience [16] so that we may learn that it is "a perfection of the concupiscible appetite that disposes it to submit to the control of reason. . . ." [17] We see contemporary patience manifested by the persona; past impatience manifested by Jonah; and past, present, and especially future patience manifested by God. God's patience is partly mercy,[18] but it also is partly His humility in assuming the form of a man in Jesus's life and again at His promised return. *Patience* has an eschatological level—the level of its applicability to the fourteenth century and the future. The representative of the present, the persona, unites with the future in the form of God and joins him in a special way by manifesting patience. He and God are both examples of patience. Jonah is the exemplar of impatience.

The persona speaks out at the beginning of the virtue of patience in the face of suffering and refers to the beatitudes in Matthew,[19] which he heard read on a "halyday" at high mass. They speak of the blessed beginning with the poor and ending with those who hold their peace, both beginning and end linked by being promised the same reward. These two are in a team.[20] This association thus connects patience and poverty, which were frequent companions in the later Middle Ages, especially as a result of the poverty issue, which was dividing the fraternal orders. In this period, the true test of patience was found supremely in voluntary poverty.

Jonah then comes into the persona's mind and he proceeds with a psychological elaboration of the story stressing, even at the occasional cost of consistency, Jonah's impatience with God's decrees. Jonah has the potentiality of patience, but he perpetually needs evidence of God's support to manifest such a virtue.

The voice of the persona is strong throughout and becomes closest to God when he addresses the humbled Jonah at the end (lines 524-31) telling him not to be angry, "bot to go forth thy wayes." Be patient, He says, in both sorrow and joy. As befits a *mashal* this sage apostrophe is followed by a closing proverb:

> For he þat is to rakel to renden his cloþeȝ
> mot efte sitte with more vnsounde to sewe hem to-geder.

One must not be overhasty and react too quickly. One must face both sorrow and joy. But the real test is poverty and when poverty oppresses the speaker ("pouerte me enpreceȝ"), he rises to the occasion.

The voice of the persona resounds throughout. His presence is not forgotten, or only rarely, and we are aware of a patient man who in lively fashion is contemplating the story of Jonah and retelling it with bite and power. The struggles of the protagonist appear through the voice of the speaker and guarantee the victory of patience over impatience and restlessness from the very beginning. The earthly then finds its final answer in the voice of the divine and its assurance of divine mercy at the end.

NOTES

1. The most important event in *Patience* scholarship in recent years has been the J. J. Anderson edition of *Patience* in the series "Old and Middle English Texts," published by the Manchester University Press (New York: Barnes & Noble), which appeared in 1969. Its bibliography, pp. 24-29, is almost complete to about 1968. Since then we can point to the following major contributions: Charles Moorman, *The "Pearl" Poet*, Twayne's English Authors Series 64 (New York: Twayne, 1968) esp. pp. 64 ff.; Jay Schleusener, *"Patience,"* lines 35-40, *MP*, 67 (1969-70), 64-66; "History and Action in *Patience*," *PMLA*, 86 (1971), 959-65; William Vantuono, *"Patience, Cleanness, Pearl* and *Gawain:* The Case for Common Authorship," *An Med*, 12 (1971), 37-69; "The Question of Quatrains in *Patience*," *Manuscripta*, 16 (1972), 24-30; "The Structure and Sources of *Patience*," *MS*, 34 (1972), 401-21; R. H. Bowers, *The Legend of Jonah* (the Hague: Nijhoff, 1971), esp., pp. 60 ff.; R. J. Sendal, "The Narrative Structure of Patience," *Michigan Academician*, 5 (1972), 107-14; and F. N. M. Diekstra, "Jonah and *Patience:* The Psychology of a Prophet," *English Studies,* 55 (1974), 205-17. See also next note.

2. Needless to say, I am not persuaded by Vantuono's arguments in *MS*, 34 (1972) that *Patience* is a sermon. The rhetorical outline of a sermon corresponds in general to any moralized argument through narrative, such as *Patience* is. The rhetoric of true sermonic persuasion and moralizing is not in the poem. David Williams, "The Point of *Patience*," *MP*, 68 (1970-71), 127-36 shares my belief that the genre of the poem is not a sermon and emphasizes as I do the large narrative element in the poem. I do not, however, agree with his attempt to find a *consolatio* in the poem.

3. Yet even the amount in *Patience* eliminates the possibility that it is a simple biblical paraphrase, as Diekstra, op. cit., p. 205 suggests.

4. See William Nelson, "The Boundaries of Fiction in the Renaissance: A Treaty between Truth and Falsehood," *ELH*, 36 (1969), 30-58, esp. pp. 36, 48; and Stephen Manning, "The Nun's Priest's Morality and the Medieval Attitude toward Fables," *JEGP*, 59 (1960), 403-16.

5. See M. Marjorie Crump, *The*

Epyllion from Theocritus to Ovid, Thesis, University of London (Oxford: Blackwell, 1931), p. 22.

6. In this connection it may be pointed out that the prophet Jonah, the son of Amittai, is independently mentioned in 2 Kings 14:25. To the ancient Hebrews a prophet would be the equivalent of an epic hero, a man touched by God.

7. Chaucer does, of course, deepen and undercut some of these tales from a variety of perspectives, but their central form is that of the *mashal* or parable.

8. See Martin Skibbe, *Die ethische Forderung der Patientia in der patristischen Literatur von Tertullian bis Pelagius,* Inaugural-Dissertation ... der Westfälischen Wilhelms-Universität zu Münster/Westf. (Privately Printed, 1964), passim. Tertullian, Cyprian, Marius Victorinus, Hilarius, Ambrose, Ambrosiaster, Jerome and Pelagius all connect this virtue with Christ Himself.

9. *Hom. 35 in Ev.* However, other virtues claim that distinction in the tradition.

10. *The Gawain-Poet: A Critical Study* (Cambridge: Cambridge University Press, 1970), pp. 90 ff.

11. On *potestas inordinata* or *absoluta,* see Heiko Augustinus Oberman, *The Harvest of Medieval Theology: Gabriel Biel and Late Medieval Nominalism* (Cambridge: Harvard University Press, 1963), pp. 30-56, et passim.

12. Yves-Marie Duval, *Le Livre de Jonas dans la littérature chrétienne, grecque et latine* (Paris: Etudes Augustiniennes, 1973), 2 vols.

13. See Uwe Steffen, *Das Mysterium von Tod und Auferstehung, Formen und Wandlungen des Jona-Motivs* (Göttingen: Vandenhoeck & Ruprecht, 1963).

14. *PMLA,* 86 (1971), 964. However Schleusener insists that *Patience* is a homily (p. 961).

15. P. 74.

16. Diekstra comes close to this argument when he writes (p. 210) "there are two protagonists in the poem, God and Jonah, and they are compared in terms of their patience." He ignores the third member of the triumvirate: the persona.

17. R. Doherty in *New Catholic Encyclopedia* 10: 1086.

18. Diekstra p. 210 says it is "nothing else but mercy."

19. Found in the form used here in Matthew 5: 3-12. Another form of them appears in Luke 6: 20-26, belonging to another literary genre. On a comparison of these two, see C. H. Dodd, "The Beatitudes: a Form-critical Study," *Mélanges bibliques rédigés en l'honneur de André Robert* (Paris: Blond & Gay, 1955), reprinted in *More New*

Testament Studies (Manchester: Manchester University Press, 1968), pp. 1-10. The Matthew form is paralleled in Wisdom 25: 7-15 (and some of the Psalms)—lists of makarisms as Dodd puts it.

20. Anderson does not make clear the pun on "teme" in line 37 which links together *theme* with *team,* the team being the two beatitudes which are envisaged as horses pulling together. See *Piers Plowman* A 8.2 (= B 7.2 and C 10.2), B 19.256 (= C 22.261) and B 19. 266 (= C 22.271) give examples of *teme* as *team* but not necessarily limited to two. (I am indebted to Professor Sherman Kuhn and the files of the MED for this information). These two are traditionally linked because the reward is the same in both cases. Schleusener (1969-70), 64-66 discusses perceptively these lines and refers to the widespread Patristic linkage of these two beatitudes. To Augustine, each beatitude was a rung on the ladder of perfection, and he makes clear the eschatological significance of the beatitudes (PL 39: 1231-35). Their presence at the beginning of *Patience* suggests its eschatological dimension. See Williams, p. 132, especially: "Without the beatitudes, the message of *Patience* might seem only a rather baffled stoicism."

I have not been able to look at W. M. Grant's dissertation: *"Purity" and "Patience": A History of Scholarship and a Critical Analysis, DA* 30A (1969-70), 280.

St.-Savin and the Parthenon: A Study of Prosper Mérimée's Medievalism

Harry Bober

New York University

The frescoes in the church of St.-Savin constitute the finest and most famous single complex of mural paintings of medieval France, as well as one of the most important of the Romanesque period in western Europe (Figs. 1, 2). To anyone familiar with these paintings, especially the Genesis series on the nave vaults, it will seem odd that they could ever have been thought to show any kinship at all with ancient Roman painting of Pompeii and Herculaneum. That they should further have been likened to the sculptures of the Parthenon as well as Greek vase painting seems absurd. And yet these are not the observations of some confused inglorious critic, best ignored, nor of some benighted and incompetent antiquarian, best forgotten. They are the considered remarks of one of the great figures of nineteenth-century literature, the articulate and sensitive Prosper Mérimée, as thoughtful and deliberate in his expression as he was learned in history and the arts. He knew St.-Savin well, as none other in his day and a rare few since. His remarks are drawn from his book on the church and its paintings,[1] a monument whose rescue from threatening ruin and loss, and whose preservation by judicious restoration, were entirely due to his efforts in his capacity as In-specteur-Général des Monuments historiques.

The Parthenon and St.-Savin—what to the twentieth-century historian of art could serve only to typify an esthetic antithesis tells in swift strokes the central issue in Mérimée's views on art. Such was his authority that we must seriously ponder the question of how he was able to relate classical antiquity to Romanesque France, and how to read the factors in the balance between the classical and medieval aspects of his esthetics.

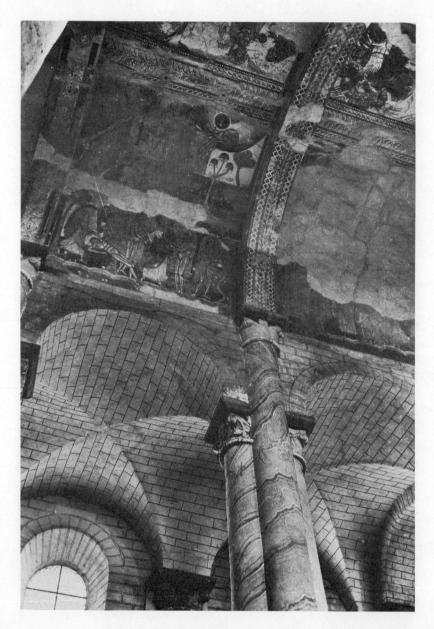

Fig. 1. St.-Savin, nave. Genesis scenes in vaults.

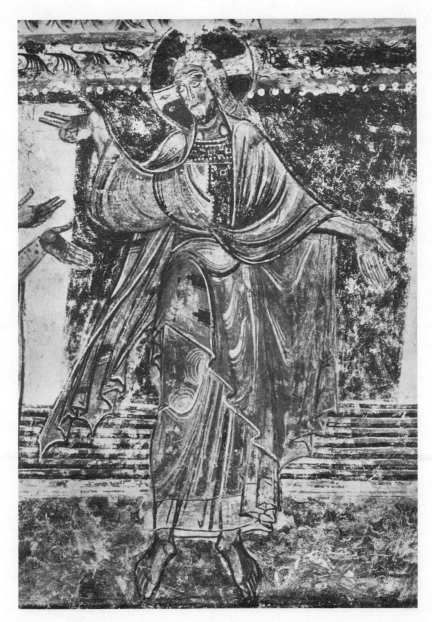

Fig. 2. St.-Savin, nave. Noah leaving the Ark (detail).

Fig. 3. St.-Lazare, Autun. Devil and the Rich Man, capital (detail).

Fig. 4. St.-Lazare, Autun. Adoration of the Magi, capital (detail).

Fig. 5. Church of Chauvigny. View of choir capitals.

Fig. 6. Church of Chauvigny. Magi capital with signature of the sculptor,
"Gofridus."

57

Outside his native France, very little attention has been given to Mérimée's interests and views on the arts.[2] In archaeological and historical studies of the monuments of medieval France, recourse to his official reports and surveys is almost unavoidable. But apart from this afterlife in footnotes, and sporadic incidental reference, he has been almost entirely forgotten among English-speaking historians of art.

For historians of literature, on the other hand, the author of *Carmen* has ever loomed large; his voluminous writings, the novels, plays, short stories, historical works, translations, and enormous correspondence, have all been systematically collected and studied.[3] If a brief statement on the position of his literary critics is possible, it would be that they discern through the complexities and paradoxes in his life and works "a member of the great Romantic generation" who was never quite a convinced Romantic.[4] In short, that Mérimée was a classicist at heart.

To some extent, literary critics in appraising his esthetics in general have also ventured to touch upon his views on art.[5] Not surprisingly, their conclusions favor the picture of Mérimée the classicist, albeit with touches, tinges, and toning of Romantic coloration. The rare historian of art who has considered this question also finds Mérimée's critical and historical orientation to be essentially classical.[6] Although his official involvement with medieval monuments is acknowledged to have occasioned hesitation and even vacillation, it was never sufficiently strong or lasting to deflect the allegedly basic classicism.

Classical components of his writing and criticism are so evident in his reports, essays, and correspondence that it would almost seem as if such conclusions leave no possibility of doubt. But it is this very position, that Mérimée remained the classicist at the expense of and to the exclusion of medievalism, that must be challenged and reversed. I believe that Mérimée was primarily a medievalist. His classicism may be redefined and understood as the "fossil index" of the nascent medievalism of his age, and in the birth of which he proves to be one of the most important figures. Mérimée, in this view, is the Romantic after all, and his perceptions about medieval art make for the peculiarly individual stamp of his Romanticism within that movement.

In that capacity, and in that light, his place for the historian of art has consequences that have not been recognizable from the working

conclusions of previous criticism. He now becomes a figure of major significance in the history of taste, criticism, and the historiography of medieval art. For those students of literary criticism who find merit in this interpretation of his position in relation to medieval art, the implications for his place in literature invite a challenging revision. For the present paper, however, I propose to consider the nature of his classicism as it affected his approach to medieval art, and the seeming paradox that has inhibited modern criticism of Mérimée.

* * *

Of the many possible factors in this situation, one in particular seems to have been most telling in its pervasive effect, namely, the concept that sets medievalism and classicism in antithetical if not mutually exclusive relation to each other. Upon examination of his relevant writings, however, I find that these were not at all opposite poles for Mérimée, neither were they divergent centers of a conflicted system, for he does not treat them as mutually contradictory. On the contrary, for him they served different but related aspects of a single esthetic. Mérimée integrated these seeming opposites through an ingenious historical rationalization of their interrelationship, supported by his archaeological and stylistic observations.

His classicism, it must be said, was decidedly Greek, and as nearly pure as he could make it. In a quipping aside he once lamented that "Homer stole" from him "a great many of the finest things that I might have invented, had he not said them before me." [7] That he was thoroughly imbued with Greek spirit should not be surprising in one who saw that spirit as "something expansive, that acts upon everything that approaches it." [8] When he declared that "the Greeks are our masters in everything," [9] it had to follow that their works of art were the ultimate achievement of mankind, "the most beautiful monuments that the spirit could conceive." [10]

Of all the references to classical art, his use of the term "antique" is predictably the most frequent. Ordinarily, in the literature of art, this is the omnibus term for classical antiquity and may refer to any or several of the classical cultures, or as a characterization of forms of any period where specific or general classical qualities are found. Mérimée is rather consistent in his avoidance of such catch-all usage, preferring to develop his own particular shade of meaning to the term. He tries to separate out the Greek component in his

stylistic characterizations, and to use the explicit designation of Greek for such cases. For the rest, that is, for non-Greek classicism, he reserves the term antique. Greek art for him is the quintessence of antiquity; the rest of classical antiquity draws upon that essence in one way or another, emulating its principles or imitating its forms at best as derivatives or imitations might.

Antique and Greek, for Mérimée, relate in an esthetic hierarchy, in which Greek stands at the apex of the classical pyramid followed, with downward gradations, by the rest. By virtue of their grasp of something of the Greek spirit and tradition, monuments or styles may qualify as antique since, at the very least, they express or preserve some element of the higher esthetic; at their very best, such works may be found to be most admirable.

Hellenist as this classicism may appear, Mérimée's reactions in the face of monuments of non-classical periods betrays another dimension of this esthetic, one which threatens the purity of classical principle and eventually transforms it into something essentially different. In praise of medieval monuments that he esteems, alluding to their antique qualities, he writes of their nobility, grace, elegance, and beauty, the same words that he had for the authentic Greek monuments. This extension of "antique" to the Middle Ages opened the way for what was to become a new life for medieval art in art criticism.

Roman art, in his system, follows the universal formula according to which it is derivative, emulating Greek principles and models. Unfortunately, his position has been simplified to distortion, with the claim that he categorically deprecated Roman art. Against the report that Greek art could bring a shining tear of love for its beauty to the eyes of Mérimée is juxtaposed his own words that Roman art stirred in him "a violent desire to demolish" certain offensive monuments.[11] This hardly does justice to Mérimée's subtlety, much less to his authority as a historian of Rome.[12] While he recognized Roman art in a subordinate relation to Greek, he found in Roman art as much to admire as to condemn. It was not, in fact, against Roman monuments that he took that violent offense, but against two particular monuments situated in Athens and near the Acropolis; in that specific context he found them an offensive intrusion.[13] His judgments on Roman art abound in delicate observations, responsive to the individual monuments and the particulars of those

monuments, but even his more general views can hardly be reduced to a simplified negative reaction.

When, as on one occasion, he remarks that the Romans were "a little less scrupulous than their masters," [14] he seems wistful rather than reproachful. Indeed, it becomes something of a formula for Mérimée to couple praise of Roman art with indications of fault, as if to assure the audience of his day that the favorable observation is not uninformed. The effect of these balanced statements of praise and blame is to weight the balance on the side of the former. "Although incorrect," he says of the reliefs on the triumphal arch in Orange, "they are impressive," and he adds, "I do not know of a single work of the Romans that does not have a character of grandeur that effectively redeems their faults of taste." [15]

If he was never "ecstatic" over Roman monuments, as he was at the Athenian Acropolis,[16] it is sufficient that the Pont du Gard of Nîmes awed him for minutes of mute admiration of its imposing grandeur.[17] Among some Roman sculptures in Avalon he singles out some as graceful but others he found mediocre.[18] Thus there appears to be something of a dualism in Mérimée's classical posture. On the one hand, we have his articulate statements of an orderly intellectual classicism. On the other, and in the face of the monuments, we have his critical observations that blur and obscure that classicism.

Mérimée's romanticism and medievalism have been understood, in any case, as necessarily split away from his classicism, its irreconcilable opposite. Thus, even those critics otherwise alert to the difficulty of excluding the one or the other, have tried to resolve the question by separating them chronologically, that is, to see them as alternating phases but never integral. One critic discerns in Mérimée's trip to Greece in 1841 the pivotal turn from romanticism to the deciding preponderance of his true classicism. "The erstwhile Romantic," he writes, "now stood revealed as an unashamed devotee of classicism." [19] Another, admittedly with primary reference to literature, sees the same resolution although in terms of a shift in emphasis, and believes that "after 1853, the spirit of Mérimée was impregnated with the Greek spirit." [20]

Such arguments for the resolution of what is taken as a dualism, by a kind of esthetic stratigraphy, strike me as forcing the separation of both factors. I believe that the peculiar classicism that underlies Mérimée's critical and historical views on art was present right

along,[21] and that it is apparent from his earliest reports on the monuments in 1834. Among the notes on his first tour of inspection in 1834, upon assuming office as Inspecteur-Général of the historic monuments of France, we find such statements as that alluding to the Greek "ideal of absolute beauty," [22] and another explaining how even the Romans "always idealized their models." [23] Or, again, he enthuses about medieval sculptures "so perfectly rendered" in certain respects, and "with so much grace," that "it makes one think of those in the Parthenon frieze." [24]

For the historian of art, Prosper Mérimée has stood in a somewhat anomalous position. Although he wrote a number of studies on the history of art and on individual monuments,[25] these are almost unknown outside of France. Where known, among English-speaking historians, they have attracted little attention except perhaps for the fascination of finding that the author of *Carmen* also had this interesting antiquarian side line. Another aspect of Mérimée's activity in the arts was his work as Inspecteur-Général des Monuments historiques de France for eighteen years, beginning in 1834.[26] Rather like Henri Rousseau's Sunday painting, Mérimée was the summer archaeologist, for it was during the summers that he conducted his official campaigns. His reports on the monuments are fine examples of analytical description, and give particular attention to their condition, with recommendations for their rescue from the impending ruin that faced so many of them. Thanks to his official representations, more and more funds were found for the work that was needed. Not only did he alert officialdom to the "vandalism" of such uninformed restoration that had been the practice, but it was Mérimée who "discovered" Viollet-le-Duc for the service of the scrupulous archeological restorations that were actually carried out.

It might be said of the classical antiquities of France that they needed no Mérimée to insure their preservation since, by the time he had come upon the scene, classical monuments had been valued and appreciated for a long time, and treasured by enthusiastic historians and antiquarians. Private collections of antiquities were to be found everywhere, and Mérimée in fact reports on his visits to many of them, as well as the municipal collections that had been established in the towns and cities. Many of the classical monuments had not only been restored, but had also become famous tourist attractions. The Maison Carée in Nîmes, among the most admired of these, had even been turned into a museum, housing local classical

antiquities.[27] Far from the protective ministrations of the Inspec-
teur-Général, such monuments often occasioned Mérimée's com-
plaints about their restoration. "They have gone too far in their
restorations," he protests, writing about Roman monuments in
Nîmes, "especially in the amphitheatre." [28]

The medieval monuments of France had not enjoyed comparable
attentions, and it was mainly in this area that his accomplishment
was so remarkable. Whatever else might be debatable about his
importance for the history of art, this one thing is not, namely, that
it was primarily and often exclusively to his vigorous intervention
that we owe the preservation of countless hundreds of monuments of
the Middle Ages in France. This much, at least, is amply recognized
today even if not as widely known as it deserves.

On the other hand, there is an important qualification with re-
spect to his activities in behalf of the medieval monuments that has
not been noticed. It is not sufficient, in crediting his rescue of the
medieval monuments, to treat them as an undifferentiated aggre-
gate, but this is usually the case. Indeed, it is essential, for a proper
understanding of his accomplishment and his views on art, to dis-
tinguish between the Gothic monuments on the one hand and those
of the Romanesque and pre-Romanesque period on the other. The
point of that distinction is that by 1834 the position in enlightened
official and public circles with respect to Gothic art was not very
different from the attitude toward classical monuments. Gothic art,
especially architecture, had not only been found acceptable and
admired, it had even arrived at the status of a highly fashionable
cult. Mérimée could say of Chartres, in his report, that it was
already too well known from published monographs to require
description.[29] Similarly "trop connu par de nombreuses publica-
tions" was the cathedral of Bourges, acknowledged among the most
beautiful churches in France. The people of Bourges were very
proud of their cathedral and the Gothic house of Jacques Coeur.[30]
As in the case of the classical monuments, enthusiasm for Gothic
architecture had already reached the point of attracting extensive
activity in the restoration of many of the most admired monuments
well before Mérimée assumed office.

The situation was quite different for Romanesque monuments.
Far from being in vogue at the time, Romanesque and pre-
Romanesque monuments were viewed with indifference, contempt,
or both; the buildings, neglected and in various states of delapida-

tion, were often in hopeless ruin.[31] With some minor exceptions and qualifications, all of the arts of the span between the end of Roman antiquity and the beginning of Gothic were still classed as barbarous works from the darkest period in the Middle Ages.

Worse than neglect, there was authorized and deliberate destruction of Romanesque and earlier monuments in the late years of the eighteenth and on into the first decades of the nineteenth century. It would be inconceivable that the cathedral of Paris or of Chartres could ever have been sold "for scrap" during that same period, without violent opposition; there would have been uprisings of the people to prevent it. And yet, in 1790, the largest church in Christendom, before the building of St. Peter's in Rome, was sold by the State to a contractor for its building materials. This was the abbey church of Cluny, the St. Peter's of Romanesque architecture, and by 1823, its systematic demolition had been virtually completed. Not even the masterful protest by one of the pioneer medievalists, Alexandre Lenoir, addressed to the Ministry of Interior in 1800, could save the greatest single masterpiece of Romanesque monastic architecture. [32]

Small wonder, then, that by 1834 Mérimée found the Romanesque monuments generally in the worst possible states of disfigurement and disintegration. The vaulting of the abbey church of Vézelay was split and threatening collapse, and pieces of stone were breaking off and falling about him as he made his notes and sketches for the young Inspecteur-Général on his first tour of inspection in mutilation, and the incompetent efforts to prevent the collapse of the vaults before Mérimée's arrival brought on the greater danger that the building "se serait écroulé infailliblement." [34] His report on Vézelay, remarkable under any circumstances, was all the more so for the young Inspector-General on his first tour of inspection in 1834. It combines physical and material description, statistics, historical, iconographic and stylistic analysis, and a final survey of its condition, with the warning wonder that the vault was still standing. He urged action to save "this magnificent church," not only one of the oldest but "finest in the department of Yonne." [35] Mérimée discovered this masterpiece of Romanesque architecture and sculpture for us, and saved it.

Allegedly the classicist, Mérimée could scarcely have been a more zealous medievalist. His espousal of the cause of Vézelay was but part of a formidable quest and sustained crusade in behalf of an

abandoned, undiscovered, and unappreciated Middle Ages, its Ro-
manesque and pre-Romanesque art. He was not alone in this, for
there were the archeologists and antiquarians [36]—the "profession-
als"—from whom he learned quickly and gratefully, without pre-
tention. But this single non-professional may have wrought more in
his work of rescue and preservation of Romanesque monuments,
and the nascent science of historical conservation, than all of his
academic fellows together. Autun, St.-Gilles, St.-Savin, Chauvigny,
St.-Nectaire, and Conques are but some few names from the roster of
Romanesque masterpieces that have become bywords for all me-
dievalists since, whose preservation we owe largely if not entirely to
Mérimée.

A corollary of this official activity, equally important for the
history of art, was his considerable share in beginning to turn the
whole trend of taste and historical studies deeper into the Middle
Ages, back from the accepted Gothic, into the unloved Romanesque
and pre-Romanesque periods. The shift might be epitomized in the
contrast between Bourges and Vézelay as Mérimée encountered and
reported them. In Bourges, the cathedral was but one of two cele-
brated Gothic monuments, pointed out by the inhabitants "avec le
plus de plaisir et de fierté." [37] For several years it had been the object
"d'une grande restauration," entailing "des travaux consider-
ables." [38] For the abbey church of Vézelay, where he observed that
"il n'est aucune partie de ce monument qui n'ait besoin de répara-
tions," the poor inhabitants found it impossible to raise even such
funds as were required simply "d'empêcher le progrès de la de-
struction," let alone for all the other necessary repairs.[39]

Ever present in Mérimée's notes on the Romanesque monuments
is the abundant evidence of his appreciation of their esthetic, and
recognition of other special qualities. The sculptured capitals of
St.-Lazare in Autun for him "attire forcément l'attention et la
captive par la variété et la fini des détails," and he finds some of the
capitals of Ste.-Foy in Conques to be "parfaitement sculptés" and
"d'un merveilleux fini." [40]

That Romanesque was not yet generally understood might have
surprised Mérimée and he takes pains to characterize the style and
explain its difference from Gothic in his reports to the Ministry as
well as the public, in the published *Notes* containing those reports.
But he was amazed to incredulity that the architect of the restora-
tions of St.-Savin was so confused and ignorant of the difference as to

think that St.-Savin was Gothic.[41] He would have been far more astonished if he could have known that not only ignorance, but worse, ignorant deprecation of the Romanesque continued to be widespread to the very end of the nineteenth century and beyond.

One historian of a standard handbook published in 1865 quips that: "If Romanesque is to be applied to our Norman architecture, the Parthenon ought to be called Egyptianesque, and the Temple of Ephesus Assyrianesque." He adds that there is still "no universally received definition of the term." [42] To the author of a "Dictionary of Art and Archaeology" published in 1883, Romanesque is still "a degenerated and hybrid style of architecture and ornament transitional from the classical Roman to the introduction of the Gothic"; he finds its method of construction "incongruous," and in its decoration a "dissonance of natural and conventional or fanciful objects." [43]

For Mérimée, the Romanesque period brought a rebirth of all the arts in a new and beautiful harmony. Architecture was now monumental and solid, with clearly definable characteristics, and sculpture, reappearing after a long absence, now played a considerable role in the decoration of churches. Painting in this period became united with sculpture, and color was now important to the whole effect. "You might say," he concludes in this eloquent and still valid synthesis, "that the artists had ever before their eyes a picture of the heavenly Jerusalem, all resplendent with gold and rubies." [44]

From these writings Mérimée the medievalist emerges as clearly as had Mérimée the classicist. In oblique recognition of the fact, critics and biographers have at least paused in passing tribute to some aspect of his medieval interests, before offering the judgment that declared him to be nevertheless the classicist. His medievalism, in such appraisals, would affect the allegedly basic classicism no more than might a commendable hobby.

On this question in general, the most instructive of critics, best informed of all with respect to Mérimée's involvement in the arts, has been Paul Léon, himself a member of the Service des Monuments Historiques as early as 1905, and heir to the living memory of Mérimée in that service. In a splendid book on *La vie des monuments français, destructions, restaurations,* published in 1951, he tries, at least, to see a balance between Mérimée's medieval and his classical interests. As with all the critics, however, he sees this as an issue to be resolved, if possible, in favor of one side or the other. The way out is

found by attributing the difficulty to Mérimée himself, to his hesitation: "Hésitation du coeur, hésitation de l'esprit."[45] Mérimée is supposedly torn between classicism and romanticism, "sans cesse tiraillé entre classiques et romantiques, entre le siècle qui finit et le siècle qui commence."[46] While acknowledging Mérimée as "sans rival" in all that concerns the Middle Ages, he concludes, softly however, that "au fond, Mérimée par ses origines et sa culture, reste proche de l'Antiquité."[47]

Shorn of qualifications, Léon's opinion comes into sharp focus in his study of *Mérimée et son Temps,* which appeared eleven years later. Neither in the face of the romantics, he says, nor in the face of the Gothic, is there ever doubt but that Mérimée "reste fidèle à l'antique"; Greece, finally, was Mérimée's home, and there, ecstasy.[48]

Evidently, for the historian of art, the issue could thus be more neatly resolved than it was for the literary critic, whose nagging doubts were not always so equivocating and who could ask more bluntly, if only intermittently: "Est-il classique? Est-il romantique?"[49] Mérimée's positive opinions of medieval art, far from impressing the art scholar, were taken as the simplest proof of his classicism. The line of such reasoning may be explained quite simply. It rests on the fact that in the very act of enthusing about those works of medieval art that he admired—and especially those he admired most—Mérimée not only characterized them in classical terms, but also appraised their qualities on a comparative scale of their approximation and evocation of classical monuments.

That Mérimée's analytical comments on art abound in such characterizations is, of course, true. The architects of Chartres are comparable to the architects of the Parthenon,[50] a Romanesque sculpture of Christ reminds him of an antique Jupiter,[51] and a Romanesque relief in some of its finer details makes him think of the Parthenon frieze.[52] His juxtaposition of the Romanesque paintings in St.-Savin and both Greek and Roman painting has already been mentioned. He even goes so far as to state that the technique and technical methods of painting at St.-Savin derive drom the Greeks, and that the compositional principles of the same Romanesque paintings follow those of the ancient Greek masters.[53]

To see in such classical comparisons and terminology proof of classicism in refutation of those very medieval subjects to which their service is addressed, is rather like claiming that the early Christians were not essentially Christian since their language,

grammar, rhetoric, metaphors and figures were so completely those of their pagan Roman antecedents. Even in a most superficial sense, Mérimée's classical formulae in their medieval context could hardly be taken as sufficient evidence to neutralize, much less reverse, the positive charge of his primary field, the medieval. For one thing, such terminology and comparisons are simply part and parcel of a stock rhetoric that was by then age-old. These are the stylized conventions and formulae of the literature of art since the Renaissance. Such usage is especially prevalent in the seventeenth and eighteenth centuries, virtually fixed in the high style criticism which was formalized in the *Académies* and inherited by the nineteenth-century *Instituts*.[54] Ludovic Vitet, for instance, first Inspecteur-Général (1830-1834) and Mérimée's predecessor, had called the cathedral of Reims the Parthenon of French architecture, and the thirteenth century "the golden age of our national sculpture." [55] But such rhetoric was not, of course, merely formalistic. The invocation of classical antiquity was a stylized formula which signified a high standard of quality or achievement. Applied to medieval art, it expressed the rightful claim to the honor of restoration among the worthy styles of history—for Vitet, the claim for Gothic art; for Mérimée, Romanesque.

The matter of Mérimée's medievalism is demonstrable on more substantial grounds than might be inferred from this nominal classicism. Across the pages of his *Notes* it emerges that he is able to treat medieval art as an esthetic complex with its own full range of quality, like any other sophisticated art style of history. And, quite apart from his judgment of that quality in one work or another, they afford a rich range of other interest such as might be found in other great periods. Among those aspects that he develops along with the esthetic are the historical, iconographic, and technical significance of the medieval monuments. Of one capital in the nave of the church at Issoire, he says that it is so very fine that "it will surprise even those persons who have seen the finest sculptures of the Middle Ages." However, concerning the capitals in the upper galleries of the same church, he does not hesitate to judge them "des plus grossiers et des plus laids que j'aie vus." [56]

A telling note, attesting to his critical acumen in qualitative judgments of Romanesque art while adding another significant corrective to the claim for his classicism, may be illustrated in the instance of the famous classicizing portal of St.-Trophime in Arles.

The fact of its evident relationship to antiquity, however, does not automatically trigger from Mérimée the enthusiastic endorsement that might be projected from the formula of the true classicists who found medieval art tolerable in direct proportion to its approximation of antiquity. Not only does he judge these sculptures to be simply "grossièrement sculptées" as art, but distinctly inferior to the comparable works of St.-Gilles.[57] He proves himself not only alert to the inhibiting prejudices of academic classicism, but also capable of transcending—even if only for a brilliant moment—the supposed absolute of the classical ideal. For the capitals of St.-Martin of Nevers, he advises us that to be able to really see this admirable art, we must be prepared to forget our prejudices, meaning, of course, of schooling in classical taste. "Si l'on veut bien oublier pour un instant les scrupules de l'école, on avouera que ce dernier chapiteau peut rivaliser en élégance, en beauté, avec tout ce que l'antiquité nous a laissé de plus correct." [58]

The paintings of St.-Savin are another interesting case in point (Fig. 1). We have his report after inspection of the monument in 1836, and his monograph on the church and its art published in 1845. At first he sees the painting as originating in an art in its infancy, barbarous works in which you could hardly expect perspective or landscape. He finds its colors crude, its anatomical rendering "very bizarre and very incorrect as one might expect." [59] Even these views, we may safely surmise, were charitably stated relative to current opinions of his day, especially since he was also trying to persuade the Ministry to preserve the church.

He must nevertheless have been more intrigued by the paintings than he may have realized from his first visit, or could fully explain at the time. In the course of four further trips to study them, he arrived at a profound recognition of the positive character and the sophistication of this great series of Romanesque paintings. Although they gave the impression, at first, of "ignorance and ineptitude," he wrote in his book, "un examen plus attentif" revealed "un certain caractère de grandeur tout à fait étranger aux ouvrages qui datent d'une époque plus récente " (see Fig. 2).[60] Astonishingly for the nineteenth century, or even now, Mérimée sets these Romanesque paintings above those of Jan van Eyck. "No doubt," he says, those of Jan van Eyck are "much more correct, more exact, and closer to nature," but the grandeur of the Romanesque paintings simply is not there. With their thousand faults, as he concedes, the

frescoes of St.-Savin even have "quelque chose de cette noblesse" that is so noteworthy in works of art from antiquity.[61]

The formula of balancing the virtues in a work of medieval art against concessions of its faults is not one of literary rhetoric for Mérimée. It is, rather, indicative of the fact that in his taste for the Romanesque he belongs to that very first generation in the discovery of Romanesque art and its nomination for acceptance as a distinctive style worthy to stand and hold a place in the history of art along with Greek, Roman, Renaissance, and the most recently admitted Gothic. Thus, when he writes of the church of St.-Lazare in Autun, he says that while it may lack that "imposante sévérité qui distingue l'architecture antique," it is striking in its own way, and "attire forcément l'attention et la captive par la variété et le fini des détails." [62] This is an extraordinary concession and recognition, in that it claims and discovers in Romanesque architecture the esthetic validity of an emotional force in the effect of its visual impact. Critical to the weight of this factor in the balance of its medieval relevance is Mérimée's recognition that through such appeal a work of medieval art could be found not only acceptable, but irresistible, even at the expense of a requisite quality of the canon of classicism.

Less strong and explicit in its invocation of this argument is the reference in his discussion of the tympanum of Ste.-Foy in Conques. It is, however, no less interesting since he cites emotional appeal as one of the esthetic attractions except that this time it more than compensates for "barbaric" qualities. Although the work on the tympanum "soit barbare," he sees in its composition more art and "je dirai plus de sentiment, qu'on n'en attendrait d'une époque grossière." [63]

From Mérimée's observations concerning the sculptured capitals in the interior of St.-Lazare in Autun (see Figs. 3, 4), may be added still further ramifications of what has been emerging as his evidently broad and comprehensive medievalism. After the familiar opening pattern of conciliatory negative concession, he admits that the Autun capitals may lack the classical qualities of nobility, simplicity, and grace of the Doric and Corinthian. However, he is quick to counterpose, once you get past "l'étrangeté des formes, il est impossible de ne pas s'arrêter avec plaisir devant ces compositions capricieuses qui avaient tant de charmes pour nos ancêtres." [64] With his other medievalist arguments, such statements as this may serve to suggest his responsive approach in the characterization of aspects

of Romanesque style that remained especially difficult for people to grasp not only in his day, but for the rest of the nineteenth century.

Mérimée was able to see and feel the immense appeal of precisely those un-classical characteristics that we find distinctive of the Romanesque today, namely, its fertile and capricious inventiveness, its fantasy, and its expressiveness. By the time he had completed his second regional circuit of inspection of monuments, in 1836, he was often able to see and understand Romanesque monuments entirely in their own terms, and to lose himself completely in enthusiasm and in the "feeling" of Romanesque art. Such, for instance, is the case in his report on the church in Chauvigny and its decoration (Figs. 5, 6).[65] One could hardly ask, even to this day, for a more spirited or accurate characterization which is at the same time so completely evocative of Romanesque form and iconography. For its bearing on the theme of this study, it must be noted that in his analysis he finds or needs no recourse—whether by way of comparison or the usual concession of faults—to that old haunting classicism.

He found the richly decorated Chauvigny a church that "peut passer pour l'une des plus intéressantes d'un pays qui renferme tant de monuments remarquables," and nothing "de plus élégant, de plus riche" than the exterior decoration of the apses.[66] Even the archivolts of the windows, he marvels, are carved "avec un art merveilleux" and "présentent une multitude de charmantes fantaisies qui rachtent leur bizarrerie par la perfection du travail." Inside the church he found columns "chargé d'ornements d'une délicatesse véritablement extraordinaire" but it was above all in the execution of the choir capitals (Fig. 5) that the artist lavished "sa capricieuse fécondité d'invention." His description of the capitals is more than an inventory of the range and diversity of fantastic and historiated Romanesque subjects; it is eloquent of that fascination which they had for him, as they still do for us. Here it is sufficient to suggest that quality in some few excerpts: "Ici sont des espèces de sirenes avec des faces humaines, des ailes et une queue de poisson; là, des monstres composés de trois ou quatre animaux différents, dévorant des hommes ou combattant les uns contre les autres; puis des oiseaux énormes, des serpents immenses. . . ." It is interesting to mention here another descriptive inventory of Romanesque sculptured capitals with animal subjects, which refers, in part, to "those fierce lions, those monstrous centaurs, those half-men, those striped tigers, those fighting knights. . . . Here is a four-footed beast with a serpent's tail;

there, a fish with a beast's head. . . . In short, so many and so marvelous are the varieties of divers shapes on every hand, that we are more tempted to read in the marble than in our books. . . ." This excerpt is not from another report by Mérimée but from a letter written by St. Bernard of Clairvaux.[68] There is nothing to show that Mérimée even knew this text, which makes his description of Chauvigny all the more remarkable for a quality of seeing and writing which may so closely approximate that of a twelfth-century witness of such sculptures.

<p style="text-align:center">* * *</p>

The main purpose of this essay has been to reconsider the prevailing verdict that, even taking into account his links with romanticism, Prosper Mérimée must be finally adjudged a classicist. In refutation of that position I have offered arguments to show that in his views on art, he is clearly a medievalist. Moreover, I see him as a major figure in the movement that was first discovering medieval art, for which interest had been virtually eclipsed by the antipathetic taste and historiography of the Renaissance that lasted well into the nineteenth century. He was among those who first began to shape what I have been calling "medievalism," a loose aggregate of positive interpretations and characterizations, sometimes approximating principles of criticism, favorable to the Middle Ages and its art. By its nature, medievalism was in opposition to neoclassicism. Without release from the conditions and rules of the formalized classicistic esthetic, it would have remained impossible for medievalism to come into being. Given the un-classical and even anti-classical premises of medieval art, efforts to interpret it from a classical base would be like trying to translate a text using the dictionary of a different language, however similar seeming, and doomed to essential failure.

I have chosen to place emphasis entirely on Mérimée's approach to Romanesque art, leaving aside Gothic except by way of justifying that choice. I did so to show that it was in his espousal of the cause of Romanesque art that his contribution to medievalism is so especially remarkable. Beyond those of his contemporaries who were still freshly enthusiastic over the Gothic, no longer *terra incognita* by then, Mérimée was venturing to probe new mysteries of medieval

art, not alone to be sure, but side by side with the great pioneers of medievalism. His instincts and sensibilities had led him to the vanguard of taste and history, to share in and contribute fundamental insights into the discovery of the marvels of the Romanesque. For this, along with the rest, he must be given a rightful place in the historiography of medieval art.

It took well nigh a century before such perceptions of the Romanesque could begin to be as readily and widely appreciated as Gothic. And, in our own day, the medievalist and even the general public see in the Romanesque an art more vital, more arresting, and even more of the essence of the medieval spirit, than the Gothic. One might say that Mérimée's Romantic intuitions were not only historic, they were prophetic.

NOTES

This essay is offered in admiration of Lillian Hornstein, whose fine teaching as a medievalist has so often left me the fortunate heir to her best students.

1. *L'Église de Saint-Savin et ses peintures,* which appeared in 1845; I have used the edition in the *Études sur les arts au moyen âge* (Paris, 1845), pp. 55-217, published in the *Oeuvres complètes de Prosper Mérimée.*

2. Lionello Venturi does not even mention Mérimée in the chapter on "Romanticism and the Middle Ages," in his excellent *History of Art Criticism* (New York, 1936).

3. Cf. the recent bibliography in A. W. Raitt, *Prosper Mérimée* (London, 1970).

4. Cf., e.g., Raitt, p. 363.

5. Cf. Pierre Trahard on "L'esthétique de Mérimée...." in *La jeunesse de Prosper Mérimée (1803-1834)* in his *Bibliothèque Mérimée,* vol. 2, pp. 355-364.

6. See below, pp. 61 f.

7. *Letters à Viollet-le-Duc (Documents inédits) 1839-1870,* ed. Pierre Trahard, *Oeuvres complètes de Prosper Mérimée* (Paris, 1927), pp. 27-28, letter of May 1857.

8. P. Trahard, *Prosper Mérimée de 1834 à 1855,* in *Bibliothèque Mérimée,* vol. 3 (Paris, 1928), pp. 201-202 (quoted from his *Mélanges historiques et littéraires* [Paris, 1852], p. 143).

9. Ibid., p. 203 (letter of Feb. 25, 1847).

10. Paul Léon, *Mérimée et son temps*

(Paris, 1962), p. 351 (letter of March 31, 1842).

11. Trahard, *Mérimée de 1834 à 1855,* p. 192.

12. Cf. Raitt, pp. 233-40, on Mérimée as historian of Rome.

13. For the context, see his letter of August 1858, in Trahard, *Lettres à Viollet-le-Duc,* pp. 33-35.

14. *Notes d'un voyage dans le Midi de la France, 1835,* in *Prosper Mérimée, Inspecteur-Général des monuments historiques de France, Notes de voyages,* ed. Pierre-Marie Auzas, Edition du Centenaire (Paris, 1971), p. 96. For all references to the four volumes of Mérimée's official reports to the Ministry of Interior that were published, I shall cite this important centennial edition with the brief title, *Notes de voyages.*

15. *Notes de voyages,* p. 127.

16. Léon, pp. 350-51, (letter of March 31, 1842).

17. *Notes de voyages,* p. 175.

18. Ibid., p. 65.

19. Raitt, p. 201.

20. Trahard, *Mérimée de 1834 à 1855,* p. 201.

21. It is interesting to note that Trahard (loc. cit.), even after declaring that Mérimée's spirit became so thoroughly classical after 1853, casts doubts on his own division. He does so by asking, rhetorically, whether on second thought we might not say that Mérimée was also classical in his preceding, "second period"; "n'aperçoit-on pas déjà que Mérimée pénètre cet esprit" already from 1834 to 1853? Even Raitt, who had declared him the "unashamed devotee of classicism" after his visit to Greece in 1841 (op. cit., p. 201) is impelled to add (loc. cit., n. 19) that "there had always been strong classical elements in Mérimée's aesthetic."

22. *Notes de voyages,* p. 96.

23. Ibid., p. 47.

24. Idem.

25. His essays, together with his book on the paintings of St.-Savin, were published in the collected works as *Études sur les arts au moyen âge* (see above, n. 1).

26. See, e.g., the excellent foreword to the centennial volume *(Notes de voyages)* by Pierre-Marie Auzas, and especially the discussion of Mérimée in Paul Léon's great work, *La Vie des monuments français; Destruction, restauration* (Paris, 1951), pp. 193-200 and passim.

27. *Notes de voyages,* pp. 195-96; at Vienne, a small "antique temple" similarly served as a museum of antiquities (Ibid., pp. 89-90).

28. Ibid., pp. 193-94; his outrage at what had been done there is instructive for the sensitive technical, historical, and

esthetic standards that he helped establish for the commission on historic monuments and for the future development of architectural conservation. "Instead of limiting themselves, as they should have, to the strengthening of the parts that were threatened by ruin, and whose destruction might have compromised the building, they have completely remade it; this is a rebuilding that they have attempted and not a repair."

29. *Notes de voyages,* p. 259.

30. Ibid., pp. 461 and 468.

31. Moreover, such repairs, "maintenance," and additional building that were carried out on Romanesque buildings made for even greater disasters to their art, in Mérimée's very sensitive eyes. Of the church of St.-Lazare in Vézelay, he tells that as he approached, "le spectacle était magnifique," and inspired in him a "prédisposition a l'admiration." But when he could first really see the building he was aghast. It had been brutally mutilated equally by both repairs and destruction, from the Gothic period, the Protestant revolt, and the Revolution. And he adds with sarcasm, "lest the nineteenth century yield the palm of vandalism to others," they have added a most ridiculous kind of octagonal observatory on top of the one remaining tower of the church. (*Notes de voyages,* p. 55).

32. Kenneth John Conant, "Mediaeval Academy Excavations at Cluny, The Season of 1928," *Speculum,* 4 (1929), 3-4, writes, "Who, eight hundred years ago, would have thought that the splendid sanctuary of the greatest of monastic churches would be taken down to extend a stable for government breeding-horses—that the middle part of the church ... would have been blown up to clear the way and provide the material for this stable ...—that the western end of the church would be occupied by two inns, a garage, a house, a stable, and a street used as a passage for cows?" See also his magnificent book *Cluny, Les églises de la maison du Chef d'ordre,* published by the Mediaeval Academy of America (Macon, 1968), especially pp. 11-12.

33. *Notes de voyages,* p. 63

34. Ibid., p. 444.

35. Ibid., p. 63.

36. Foremost among those early scholars of medieval art was Arcisse de Caumont; cf. Léon, *La Vie des monuments français,* pp. 94-97.

37. *Notes de voyages,* p. 468.

38. Ibid., p. 465.

39. Ibid., p. 63.

40. Ibid., p. 71.

41. Raitt, p. 142.
42. James Fergusson, *History of Architecture* (London, 1865-1867), vol. I, p. 352.
43. J. S. Mollett, *An Illustrated Dictionary of Art and Archaeology* (London, 1883, reprinted by the American Architects of World Art, Inc. New York, 1966).
44. In his "Essai sur l'Architecture Religieuse du Moyen Âge" (*Études sur les ârts au moyen âge*, pp. 17-19), published in 1837.
45. Léon, *La vie des monuments*, p. 194.
46. Idem.
47. Ibid., p. 200.
48. Léon, *Mérimée*, p. 296, and in his concluding chapter, on p. 478: "En Grece, il est enfin chez lui et cette fois c'est l'extase."
49. Trahard, *La jeunesse de Prosper Mérimée*, p. 357.
50. Trahard, *Prosper Mérimée de 1834 a 1853*, p. 67.
51. *Notes de voyages*, p. 438, referring to a relief lying on the ground in the octagon at Charroux.
52. Ibid., p. 47.
53. Mérimée, *L'Église de Saint-Savin*, in *Études*, pp. 165-167.
54. Cf. Frances A. Yates, *The French Academies of the Sixteenth Century* (London: The Warburg Institute, 1947), e.g., pp. 275 ff.
55. Léon, *La vie des monuments*, pp. 189-190.
56. *Notes de voyages*, p. 587.
57. Ibid., p. 163.
58. Ibid., p. 48.
59. Ibid., p. 441.
60. *L'Église de Saint-Savin*, in *Études*, p. 165.
61. Ibid., pp. 166-167.
62. *Notes de voyages*, p. 71.
63. Idem.
64. Idem.
65. *Notes de voyages*, pp. 446-447.
66. Idem, including the rest of the quotations on Chauvigny in this paragraph.
67. From the "Apologia" to William, Abbot of St.-Thierry, in the translation given in Elizabeth Gilmore Holt, *A Documentary History of Art* (New York: Doubleday Anchor Books, 1957); I cite from the edition of 1947, p. 21.

Reflections of Political Theory and Political Fact in Fifteenth-century Mirrors for the Prince

Diane Bornstein
City University of New York

The mirror for the prince was an extremely popular genre in European literature, from the fourth century B.C. to the Renaissance. The treatises written within this wide span of time show remarkably little variation in content. The perfect prince is portrayed as a man who is wise, temperate, just, devoted to the welfare of his people, a model of moral virtue, immune to flattery, opposed to aggressive war, and zealous for peace. In the twelfth century, John of Salisbury introduced a new note in *Policraticus* by employing the organic analogy of the state as a body with the prince as its head.[1] Not wishing to appear to be original, he claimed Plutarch as his source. The medieval treatises written in Latin tend to be abstract and divorced from reality. Writers considered the real in terms of the ideal and had little to say about contemporary life.[2] When we come to treatises written in the vernacular, however, we often find vivid pictures of the political struggles and social conditions of the time. This paper will set forth some of the evidence of this kind that can be found in treatises written in French and English during the fifteenth century.

Christine de Pisan's *Corps de policie* was written between 1404-7 as a guide for the education of princes of the royal blood, particularly the French dauphin, Louis of Guienne.[3] Christine employs a three-part division of her material and unifies the sections by using John of Salisbury's metaphor of the body politic. Part One is addressed to the prince, the head of the body; Part Two to the knights, the arms and hands; and Part Three to the "universal people," the

77

stomach, legs, and feet (which includes students, the clergy, merchants, and laborers).

Christine shows her originality by what she leaves out as much as by what she puts in. By placing the clergy within the third estate, she shows its relative unimportance during the fifteenth century. Most treatises dealing with the theory of the three estates treat the clergy as a separate estate. By the late fourteenth and fifteenth centuries, the church had lost a great deal of its influence. This was partially a result of the Great Schism. Since the double election of 1378, Europe had been divided into two camps supporting one or the other pope; the Schism tended to follow the main diplomatic groupings that resulted from the Hundred Years' War, England and its allies recognizing the Roman pontiff, France and its friends the Avignonese.[4] The division within the church left the monarchs of England and France free to follow their own diplomatic ends without interference. Yet they had to pay attention to the desires of their own nobility. Neither king was strong enough to act without the support of his most powerful lords. Since the king and nobility were the most influential political figures, these are the ones to whom Christine directs her attention.

Her method is to state general principles and illustrate them with exempla and anecdotes, usually from the *Facta et Dicta Memorabilia* by Valerius Maximus, a Roman historian and rhetorician of the first century.[5] Since Christine used examples mainly from ancient history, her work was equally suitable for an English audience. The *Corps de Policie* was translated into English during the latter part of the fifteenth century. The translation is close to the original version in thought and style. In references to contemporary events, the translator occasionally replaces "France" with "England," but he often does not bother. These references are frequently applicable to England since similar political and military conditions prevailed in both countries.

Christine's work contains the usual kind of moral exhortation that appears in mirrors for the prince. She states that the king must possess the virtues of piety, liberality, justice, prudence, wisdom, fortitude, temperance, pity, and humility. Although he should have a mild, forgiving disposition, he must be able to inspire fear and respect. She enumerates the three most important qualities of a prince:

> The firste is and the moste pryncipall, loue God and drede him, and
> serue him with oute feynyng, and rather to serue him *with* good dedis
> than by long lyyng in his orysons; an othir is this, he ought to loue
> singulerly the incresse of his realme and of his people, and in that
> poynte he ought to sett his study rathre than upon his singuler
> profyte; the thridde is that soveraynly he ought to loue iustice and
> kepe it, and holde it with oute brekyng and do equyte to all people.[6]

Although she identifies love of God as "the moste principall," she
gives most of her attention to the prince's political role.

We find an interesting Humanist influence in Christine's treatise,
which probably came through Petrarch. She knew his work and
may have seen a copy of a letter he sent to Pierre Bersuire. In this
letter, Petrarch expresses dismay at the state of military affairs in
France and Italy and claims that conditions had deteriorated
because Roman warriors had given way to a lesser, undisciplined
breed. The need to return to Roman virtues and to be inspired by
the example of Roman heroes is implicit.[7] This idea is stressed by
Christine in both the *Livre du Corps de Policie* and the *Livre des Fais
d'Armes et de Chevalerie*. For example, in the *Corps de Policie* she de-
scribes the rigorous training the ancients gave their children, unlike
the easy living of her day:

> As sone as they were any thy*n*g growyne that they myght suffir any
> payne they toke him a wey fro the modirs and made putte them in
> exe*r*cise to suffir payne and trauayle accordyng to their ages and
> strengthes. And in the same age acustomed them to bere harneys of
> werre aftir their strengthis and to putte theim in exe*r*cise of labor w*ith*
> their armes and hondis that was not to greuous for them. Also they
> were not noryshed w*ith* noutryaunt metis, nor they were not nycely
> arayed, as some men be nowe adayes, but they were fedde w*ith* gros
> metis. And as for their gownes, they vsed a prop*er* ffacion of an habite
> that the noble myght were and non othir men. But truste certaynly
> that they were not furred w*ith* martirus ne brawdered nethir. Also
> they acustomed them to lye harde and to go late to bed, and ryse erly,
> and mad them suffir all man*er* of othre portable peynes that be longed
> to the feete of armes. And by suche meanes the noble auncie*n*tes
> noryshed their childern.[8]

Like the Humanists, Christine believed that the prince should
receive a good education. She expresses her wish that the princes of
her day were as eager for learning as those of ancient times:

Neuertheles for as moche nowe in this tyme as the prynces be not so
couetous nowe adayis to be lerned in the science, whiche and it
pleasid God I wolde it were vsed nowe as it was wont to be. . . . So I
suppose verely that the prynce will that his sone be lerned in lecture
so ferre as that he myght vndirstande the rewlis of gramere, and to
vndirstonde latyne, whiche and it pleasid God I wolde that it were so
by a generall reule and custome of all prynces that be nowe and for to
come. For I suppose that moche shulde growe ther of to them and to
their subgectis, in so moche that it shulde cause the people to encrease
in gret vertu.[9]

Furthermore, the prince should be an eloquent speaker, well trained
in rhetoric. Not only must he be educated himself, but he should
support learned men and place them in high positions. In discussing
the role of students and the clergy in Part III, she has very high
praise for the value of learning.

One of the most important attributes of a prince is love of honor
and glory. In fact, Christine comes close to defining this as man's
"perfection" or highest good:

For it is well knowen like as auctours reciten and a man may well
knowe by their worthy dedis that the right excellent prynces and
worthy men in tyme passed were right gret in worchippe. And to gete
worchippe by vertue it is lefull, for it appereth naturally that euery
thyng desierith his perfeccione. As [the] philosophre seith glorye and
honoure engendreth reuerence, whiche is a shewing that man is made
to haue dignite. And this desiere is so roted and ioyned with nature of
man, and euery man is desireous to haue it.[10]

She does not define honor in military terms, however, and says
nothing about conquests. Her ideal prince is a skilled administrator
and a model of moral virtue.

A similar emphasis on moral virtue and honor appears in *De officio
militari,* written between 1404 and 1408 by Richard Ullerston
(chancellor of Oxford between 1407 and 1408) and dedicated to
Prince Henry.[11] The work is concerned with the spiritual and moral
requirements of a knight's office, the virtues he should possess and
the vices he should avoid. Since it was addressed to the future Henry
V, a large part is devoted to the role of a monarch. Henry is praised
for his religious zeal and for having counselors who are expert in
political and military science.

Ullerston states that the office of a knight is most suitable for a prince or nobleman but also asserts that the knight must support his nobility of birth by pursuing honor, practicing the virtues, and performing good deeds. The knight must be a *perfecte virtuosus,* a model of moral virtue—wise, prudent, strong, brave, temperate, and just. He carries his sword so as to protect the commonwealth against malefactors. In upholding the law, he should practice *epikeia,* justice tempered by moderation, as described in Aristotle's *Ethics.* Ullerston's discussion is based mainly on medieval adaptations of Aristotle, treatises on the vices and virtues, and the *Secretum secretorum.*

Thomas Hoccleve wrote the *Regement of Princes* for Prince Henry between 1411 and 1412. His sources were the *Liber de ludo scacchorum* by Jacobus de Cessolis, the *De regimine principum* by Egidio Colonna, and the *Secreta secretorum.* But his work is most interesting when he departs from these sources and comments on the life of his time. An interesting contradiction appears in his attitude toward war. He favors the ideal of a warrior king, speaks highly of the value of military science, and approves of Henry's plan to unite England and France so as to engage in a holy war against the Turks; yet, he criticizes the destruction and social dislocation caused by war and wishes for peace.

Some of the problems discussed by Hoccleve were not caused by the war: the prevalence of pluralism and absenteeism among the clergy; the practice of arranging marriages purely for money and betrothing children who were "al to yonge and tendir of age" (a boy was considered to be of age at fourteen, a girl at twelve); the frequency of adultery (not surprising in view of the marriage customs of the time); and injustice in the law courts, where the rich were favored and the poor oppressed.[12] He describes and criticizes the elaborate dress of the wealthy.[13] During the reign of Henry IV, sumptuary laws were passed to limit this excess in apparel, but apparently they were not obeyed. Extravagant dress was a sign of the ambition and social climbing of the time. Striking a practical note, Hoccleve describes how superfluous clothing could be a hindrance in a street fight between lords and their retainers (common occurences at the time), when a man's "armes two han right ynoughe to done / And somwhat more, his sleves up to holde."[14]

Other problems discussed by Hoccleve were directly related to the war. Not all soldiers who crossed the Channel managed to prosper. He laments the plight of knights who fought bravely in France when

they were young but were left to suffer in poverty in their old age.[15] The war encouraged lords to hire large retinues of men who would serve them, fighting by their side in wartime and staffing their households in peacetime. When quarrels arose, the fighting was often carried over into civil life. Hoccleve criticizes the lawlessness and violence encouraged by this maintenance of private armies:

> Now in goode feithe I pray God it amende,
> Lawe is nye flemede out of this contree;
> For fewe ben that dreden it to offende.
> Correccioun, and alle this is longe on the;
> Why suffrest thow so many assemble
> Of armed folke, wel nye in every shire?
> Partie is made to venge her cruelle ire.[16]

Hoccleve exhorts the princes of France and England to put an end to the destruction, suffering, and bloodshed caused by the war.[17] Yet he supported Henry's plan to unite England and France, which meant supporting his policy of imperialistic conquest.

An even more militaristic, imperialistic attitude appears in the *Governaunce of Prynces,* a translation of the *Secretum secretorum* by James Yonge, who belonged to an English family settled in the Irish Pale (the section of Ireland under English jurisdiction) and was in the service of James Butler, Fourth Earl of Ormond and Henry V's Lord Lieutenant in Ireland. Not surprisingly, Yonge has flattering things to say about the exploits of the Ormond family. He describes how God granted victory to his patron's grandfather, Sir James, who "slew huge pepill" including the Murphys and McMurroughs.[18] He tells how his patron subdued the Irish rebels in 1422, riding into the country of MacMahon and O'Neilboy to defeat their armies and burn their fields.[19]

Yonge's militarism is directed against the Irish. In criticizing the evil ways of Richard II, he states that one of his faults was that he "lytill or noone esploit dit" in Ireland. He insists on the need to deal harshly with Irish rebels.[20] Throughout the treatise Yonge comments on evil Irish rulers and rebels, the just title of English kings to Ireland, and brave English knights and soldiers who participated in the conquest of Ireland. He doesn't even attempt to cloak his imperialistic, aggressive sentiments in chivalric language.

Yonge's militarism vividly contrasts with George Ashby's practi-

cal, unmilitaristic attitude in the *Active Policy of a Prince,* written
while Henry VI was king (either in 1460-61 or possibly after the
reconciliation of Margaret and Warwick and the temporary Lan-
castrian success of 1470, when Henry was again placed on the
throne).[21] The work contains the same kind of general moral ex-
hortation that is found in most mirrors for the prince, but together
with this appears a great deal of economic and political advice
relating to conditions in fifteenth-century England. Ashby advises
the king to keep strict accounts, pay servants' wages so that they will
not be tempted to steal or resort to extortion, buy up goods when
they are cheap and in season, avoid creating too many lords, study
the history of foreign possessions so that he may learn from past
experience, and rule with justice and moderation. He warns the king
against making any subjects richer than himself, which the generous
Henry VI was in the habit of doing. His unworldly Christian hu-
mility made it impossible for him to appreciate the role of a mag-
nificent display in impressing the people of the time:

> Make knyghtes, squiers & gentilmen riche,
> And the pore Comyns also welthy,
> But to youre richesse make neuer man liche,
> If ye wol stande in peas and be set by.
> So wol god and polleci sykerly,
> Lyke as ye in estate other excelle,
> In propre richesse ye sholde bere the belle.[22]

Ashby's treatise is strongly antimilitaristic. He recognizes the im-
portance of a defensive army and recommends compulsory
archery.[23] But the Commons should not be allowed to bear any
other weapon, and lords should not be allowed to maintain private
armies.[24] He warns against war, which "may be lightly com-
mensed," but "doubt is how it shal be recompensed." [25] Historical
reality and economics strongly influenced Ashby's portrait of the
ideal king.

These mirrors for the prince provide a view of some of the major
tendencies of late medieval political thought. The central figure is
the king or prince. A personal view of rulership characterized the
period. Writers stress the moral virtue of the ruler, considering the
real in terms of the ideal. The abstract discussions of moral virtue
and justice were taken from Latin sources that went back to classical
models. Together with this derivative material, however, we find

discussions of contemporary social conditions and political struggles in the French and English treatises. The use of the vernacular languages in the genre of the mirror for the prince went along with a certain amount of realism and pragmatism. Writing in the vernacular apparently made the authors feel free to deal with new subject matter and to express new ideas.

NOTES

I wish to express my gratitude to the American Council of Learned Societies and to the Research Foundation of the City University of New York for the grants that they have given me to support my research on the work of Christine de Pisan.

1. John Dickinson, trans., *The Statesman's Book of John of Salisbury* (New York: Knopf, 1927), pp. xvii-xxii.

2. Lester K. Born, trans., *The Education of a Christian Prince by Desidirius Erasmus* (New York: Columbia University Press, 1936), p. 126.

3. Robert H. Lucas, ed., *Le Livre du Corps de Policie* (Geneva and Paris: Droz, 1967), pp. xii-xiii.

4. E. F. Jacob, *Henry V and the Invasion of France* (New York: Macmillan, 1950), p. 109.

5. Christine used a French translation of this work made by Simon de Hesdin and Nicholas Gonesse for Charles V. Lucas, *Corps de policie,* p. xxxix.

6. Cambridge University Library, MS Kk. 1. 5, fol. 7. I wish to thank the authorities of the University Library for giving me persmission to quote this manuscript. I am now preparing an edition of it.

7. Charity C. Willard, "Christine de Pisan's Treatise on the Art of Warfare," in *Essays in Honor of Louis F. Solano* (Chapel Hill, N.C.: University of North Carolina Press, 1970), pp. 179-91.

8. Cambridge University Library, MS Kk. 1. 5, fol. 41.

9. Ibid., fols. 3-4.

10. Ibid., fol. 39.

11. Ullerston's treatise survives in Trinity College, Cambridge, MS 359, fols. 16v-22r, and Corpus Christi College, Cambridge, MS 177, fols. 179v-184r. It has never been printed.

12. Thomas Hoccleve, *De Regimine Principum,* ed. Thomas Wright (London: Nichols, 1860), p. 102.

13. Ibid., p. 16.

14. Ibid., pp. 17-18.

15. Ibid., p. 32.

16. Ibid., pp. 100-101.

17. Ibid., p. 191.

18. James Yonge, *The Governaunce of Prynces,* in *Three Prose Versions of the Secretum Secretorum,*

ed. Robert Steele (London: EETS, 1898), p. 129.

19. Ibid., p. 204.
20. Ibid., p. 164.
21. George Ashby, *The Active Policy of a Prince*, in *George Ashby's Poems*, ed. Mary Bateson (London: EETS, 1899), p. vi.
22. Ibid., p. 33.
23. Ibid., p. 31.
24. Ibid., p. 30.
25. Ibid., p. 34.

A New Middle English Life of Saint Winifred?

Curt F. Bühler [1]

The Pierpont Morgan Library

A most interesting problem [2] is posed by a slim and unpretentious manuscript of a Middle English life of Saint Winifred. A brief description of this manuscript may be given as follows: [3]

> Life of Saint Winifred, in Middle English. Written in England, probably late in the sixteenth century (last quarter ?). [4] 8 leaves (180 × 118 mm.), paper. 1 col., 21-23 lines, with catch-words. Early XIXc. half leather.
> Contents: fly-leaf, recto (XVIIIc): Lyfe of St. Weneffryde; verso: Richard Wright Surgeon. [5] pp. 1-12: *Life of St. Winifred;* p. 13: blank; p. 14: *Y naw gradd kyrenydd (The Nine Degrees of Kinship,* in Welsh); p. 15; blank; p. 16: Richard Cynwal (d. 1634). [6] *Englyn ir eos (Englyn to the Nightingale,* in Welsh—a hitherto-unrecorded "englyn," unfortunately with loss of text); [7] signature of ownership of a William Hughes. [8]
> The manuscript is numbered 26 in the writer's collection.

It is the colophon of this tract which presents the problem, for it sets forth the statement, in unequivocal terms, that this life of Saint Winifred was "drawn out of an ould pryntinge boocke word by word"—in short, copied verbatim from an earlier text. One may be permitted to argue that by "pryntinge" the scribe was suggesting handprinting as well as typeprinting—or that the scribe could not or did not distinguish between handwritten and machine printed texts, as is true of some present-day scholars (this from personal observation). However, whether the archetype was produced by hand or by type, there is *no* surviving text which corresponds exactly to the life as found in the manuscript under discussion. It is certain that this text is closely related to that of extant versions of the English *Legenda aurea,* but neither the life in Caxton's (or any subsequent) edition nor that in the only surviving manuscript of the 1438 *Golden Legend* [9] to

preserve the biography of Saint Winifred (British Museum, MS Addit. 35,298) [10] agrees "word by word" with this *Life*.[11]

The similarity—and dissimilarity—of these three *Vitae* [12] may best be emphasized by quoting two short passages in parallel columns from the manuscript and Caxton texts of the *Legenda aurea*, which may then be compared with the "new" life as printed below.[13] In printing the text of the manuscripts (as well as of the several extracts and variant readings), the relatively few and standard contractions have been silently expanded; all punctuation (as well as capitalization) is editorial.[14]

The following passages correspond to lines 6-11 of the version printed below:

Addit. 35,298, f. 53	Caxton's edition, sig. T5ᵛ
Then he graunte hym his askyng with gode wylle. And then he lete make there—on a fulle fayre churche, to the which he, his wyfe and his doughter Wenefryde resortid to dayly for to here devyne seruyce. And then was Wenefride sett to scole to this holy man Beuno.	Thenne he graunted hym his askynge with good wyl. And thenne dyd do buylde theron a fayr chirche / to the whiche this worshipful man / his wyf / and his doughter Wenefryde resorted dayly / for to here therin dyuyne seruyse / And thenne Wenefryde was set to scole to this holy man Beuno.

The text comparable to that in lines 19-28 given below reads:

Addit. 35,298, f. 53

þe yong man was set a-fyre by the feend in vnchaste loue a-yenste this clene virgyn Wenefride. And when she se hym, she welcomyd hym godely, desiryng to knowe þe cause of his comyng. And when she knewe his corrupte entent, she drad leste he wolde oppresse hir by strenght. And then she feynid hir-selfe for to go in-to hir chambre to araye hir-selfe in suche wyse that she myght plese hym better.

Caxon's edition, sig. T5 ᵛ

whiche yonge man brenned in the concupiscence of her / by thentycyng of the fende / whiche had enuy at thys holy vyrgyne Wynefryde / And she de-maunded the cause of his com-ynge. And whan she vnderstode his corrupte entent, she excused her / and put hym of alle that she myghte / And he alweye aby-dynge in his fowle purpos wold in no wyse be answerd / Thenne she consyderynge his fowle desyre / and feryng lest he wold oppresse her / fayned her / as she wold haue consented / and said ‖ she wold go in-to her chambre / for to araye her-self for to plese him the better.

The text of the "new" *Life of St. Winifred* is here printed with *variae lectiones* which are the variant readings of the manuscript (A) and the Caxton (C) biographies of the *Golden Legend.* Though in some readings the new *Life* (B) is closer to the manuscript than to the printed text, it is nevertheless obvious that, on the whole, it is more closely related to Caxton's version.[15] The full text reads:

Hear foloweth the lyfe of St. Weneffryde, vyrgyn and martyre.

After that the holie mane Bevno had made many chyrches and had ordeyned
the seruice of God in the same to be sayd devoutlye, he came to a place of
a worshipfull mane namede Tenyth, the which was the sonne of a noble senatoure
5 cauled Alynde, and desired that he would geve hym so much grounde as he might
buylde a temple on in the honor of God. The place being grauntyd, and gevene,
vnto hym according to his request with good will, then made he thearon a
fayre churche, to the which churche this worshipfull mane, with his wyfe and
his doughter Wenefryde, resorted daylie to heare the devyne service of God
10 by the forsayd holye mane Bevno. At which tyme, Wenefryd was sett to scoole
to this holye mane Bevno and [fol. 1ᵛ] he taught her full deligently and
enformed her full perfectly in the faithe of Jesus Christe. And this holy
mayd Wenefryd gave creadence to his wordes and was enflamed with his holye
doctrine, in so muche that her onlye purpose was forsacke all worldlye

15 pleasures and to serve the allmightie God in meecknes and in chastytie.
And then it fortuned vpon a Sonday that she was not well and stayd at home
and keapt her fathers house whyle they weare at churche, to whome there came
a yonge mane for to defloure her, whoes name was Creadocke, the sonne of
kinge Alane, which yonge mane burned in the concupissence of her by the
20 entisment of the dyvill, which had envy at this holy vyrgyn Wenefryd. And
whene she demaunded the cause [fol. 2] of his cominge and vnderstandinge
his corupt intent, she excused her-selfe and put hym of as muche as she could
or might by intreatie with fayre wordes and he, abydinge style in his foule
purpose, would in no wyse be answered to the contrary. Thene she, consyderinge
25 his fylthie desire and fearing least he would oppresse her, fayned her-selfe
as thoe she would not denie hym of his request, but rather consent thervnto;
and sayd that she would goe to the chaumber for to araye herselfe for to please
hym the better. And whene he had a-greed with her of the same, she closed
fast the chaumber dore, and flead out previly at the backe dore towardes the
30 churche. And when this yonge mane had espide her, he folowed her with [fol. 2ᵛ] sword
drawen lycke a woodmane and whene he had ouertacken her, he sayd these wordes:
"In tyme paste I lovede thee and desired thee to be my wyfe. But nowe I will
tell thee in ffewe wordes: if thow willt not consent to accomplyshe my will
and pleasure, I shall slea thee with this sword." Thene this blessed vyrgyn
35 Wenefryd thought fyrmlye that she would not forsacke the Sonne of the euer-
lasting Kinge for to please the sonne of mortall kinge. And thervpon she
sayd vnto hym in this maner: "I will in no wyse consent to thye corupt nature
and fylthye desire, for I ame joyned to my spouse Jesus Christe which preserved
and kepethe my vyrgynitie; therfore resolve thye-selfe. I will neuer forsacke
40 Hym for all thye threatininges". And whene she had sayd thus, this cursed [fol. 3]
tirant full of ire and malyse incontynent smott of her head. And in the same
place wheare her heade fell on the ground, theare sprange a fayre well of verie
cleare wattere of the which our Lorde God yet sheweth many myracles daylie, in
so much that many seecke people having diueres deceases and thearby have bene
45 cured and made houle, bye the meryttes of God and this blessed vyrgyne Saynt
Wenefryd. And in the aforsayd well apereth yet stones that be sprynkled, as
yt weare, with bloude which may not be had a-waye by no meanes. And the mosse
that groweth on these stonnes are of marvelous sweet odoure, and that indureth
vnto this day. And when her ffather and mother heard of her deathe, they made
50 greatt lamentacion, be-cause they had no more children [fol. 3ᵛ] but she onlye.
And when this forsayd holye mane Bevnoe vnderstoode the deathe of Wenefryd and
sawe the hevines of her ffather and mother, he comforted them and brought them
to the place wheare she lay deade. And ther he made a sermone to the people,
declaringe her virgynitie and behavioure, and howe she hade a-vowed to be a
55 religious womane. And after he toke vpe the heade in his handes and sett yt
to the bodye wheare yt was cutt of. And desired of all the people that weare
theare present to knele downe and pray devoutly vnto the almightie God that
yt might please hym to rease her vp a-gayne vnto lyfe, and not only for the
comfort of her ffather and mother but also for to accomplyshe the vowe of
60 religion. And when they a-rose frome prayere, this holye virgine arose with
theme also, made by myracle [fol. 4] a-lyve a-gayne, by the powere of allmighty
God, whearfore all the people gave laude and prayse to His holy name for this
grett myracle. & euer as long as she lyvede, theare dyd appeare a-bout her
necke readnes lyck a reade thryde of sylke, in singe and tocken of her
65 martyrdome. And when this yong mane, which slewe her, had wyped his sworde
in the grasse, he stood still theare all this whyle, having no powere to

remove a-way, nor to repent hym of this cursed deed. And then this holy mane
Beuno reproved hym not onlye of the slaughter but also be-cause he reverenced
not the Sonday, and dreadyd not the grett power of God, thear shewyd vpon this
70 holy virgine. And sayd vnto hym: "Whye hast thowe no contrition [fol. 4ᵛ] for
thye mysdeedes? But sythe thowe repentest not, I beseche thalmightie God to
reward thee after thie deserving." And then he ffell downe to the ground
deade, and his bodye was all black and sodaynelye borne a-way by the dyvelles
most teryble. Then after this holy mayd Wenefryd was veyled and consecrated
75 into religion by the handes of this holy mane Beuno. And he comaundyd her
to a-byde in the same churche, that theare he had made for the space of
sevenne yeares and thear to assemble to her vyrgines of honest conversasion
whome she should informe in the lawes of God; and after the sevenne yeeres
to goe to some place of religion, and thear to a-byde the residue of her lyfe.
80 And when this holy mane should departe frome her and goe to Ireland, she
folowyd hym vntille she came to the forsayd well, [fol. 5] wheare they bothe
stoode talking a longe whyle of heavenly thinges. And when they should
departe, this holy mane sayd: "Yt ys the will of God that thowe shalt sende
to me some token euery yeare, and the same to put into the streame of this
85 well, and frome hence yt shall therby be broght, by the will of God, ouer the
sea to the place wheare I shall dwell." And after they weare departyd, she with
her vyrgins made a chesyble wroght with sylk; and the next yeare folowing she
wrapped yt in a whyte mantell and layd yt vppon the streame of the sayd well,
and frome thence yt was caried to this holy mane Bevno. After this the blessed
90 virgin Wenefryd encreasyd frome day to day in great vertue and goodnes, and
especially [fol. 5ᵛ] in holy contemplation with her sisters, moving them to
great devotion and love of all-mightie God. And when she had a-byden seavene
yeares ther, she departed thence and went to the monestarye called Wythearycheus,
in which weare men and women of vertues and godly conversation. And when she
95 had conffessed her vnto the holy abbotte Elerius, he receivyd her honorably
and brought her to his mother Theony, a blessed woman, who had the rule and
charge of the sisters of that place. And when Theony was deceased out of this
world, this holy abbotte Elerius deliuered to this virgine Weneffryd the
charge of sisters. But she refused as longe as she might, but by constraint
100 she tooke the charge and [fol. 6] lyved afterwardes a vertues lyfe & more
straighter and harder then she dyd a-fore, in geving good emsamples [*sic*]
to the systers. And when she had contynued ther in the servyce of God the
space of eight yeares, she yeldyd vpp her spirit vnto God her macker.
 Thus endeth the lyfe of Saint Wenefryd martir, drawen out of an ould
105 pryntinge boocke word by word & cetera per Jo. P. And also as yt ys a-forsayd
the lyfe which she after her decollacion lyved by the space of xv yeres, &
departed out of this lyfe the thyrd day of Novembre 651. And further, yt ys
to be vnderstood that the bodie of the sayd holie virgine lay at Gwytherine
[fol. 6ᵛ] for the space of 477 yeres and in the yere of our lord God 1138
110 in the second yere of the reigne of King Stephen, the bones of the sayd blessed
vyrgyne Saint Weneffryd weare brought by grett myracle to the Abay of
Shrewsbury, which translacion ys halowed the xixᵗʰ day of Septembre. And
also yt ys to be knowne that the forsayd martirdome of this blessed Saint
Weneffred, her pasion and decolacion, was the xxijᵗʰ day of June anno 636,
115 which thrie ffestes aforsayd bene solempnly halowed in the sayd Abbaye of
Shrewesbury to the lawde and praysinge of allmighty God, and of this blessed
and holie vyrgyne Saint Weneffryd.

2 the] *om.* C; a A made] do made C; do make A 3 in the same] *om.* CA deuoutely to be sayd in
them CA Then he A came] *repeated and cancelled* B þe place A 4 fulle wurshipfulle A namede]
his name was callid A 5 clepid A Elynde CA he desirid A as moche CA 6 temple] chyrche CA
in the honor] to þe wurship A The place . . .] *see above* 11 and and B 8 this]this holy (*with* holy
cancelled) B 12 he enformyd A full]*om.* CA 13 grete credens A and she A was so CA 14
doctrine . . . to] doctryne / that she purposed to CA 15 pleasures] plesaunces CA the] *om.* CA
16 that] *om.* CA not well] diseased CA stayd] she abode CA 17 to kepe A 18 defloure] defowle
CA who was anmed Cradok C; his name was callid Cradok A 19 kinge] a kyng named C; þe
A 19-28 Alane . . .] *for text of* A, *see above* 20 thentycyng C dyvill] fende C 21 whene] *om.* C and
whan she vnderstode C 22 his] the his (*with* the *cancelled*) B her-selfe] her C 22-23 of . . . might]
of alle that she myghte C 23 by . . . wordes] *om.* C abydinge style] alweye abydynge C 24 to the
contrary] *om.* C 25 fylthie] fowle C her-selfe] her C 26 thoe] *om.* C not . . . and] haue consented
C 27 that] *om.* C to the] in-to her C 28 agreed to her / she C; grantid hir she A closed fast]
sperryd A 29 dore to hir A fledde priuely by another dore C; fled previly at a backe dore A
toward CA 30 his swerd CA 31 sayd to her CA 32 In tyme paste] Somtyme CA thee and] and
A thee to be] to haue the to C; the to A 32-34 But . . . slea the] But one thyng telle now / to me
shortly / either consente to me taccomplysshe my plaisir / or els I shalle slee the C (*thus* A *but
omits* now *to and reads* "me nowe or I") 34 vyrgyn] mayden A 35 fyrmlye] *om.* A 36 to please]
om. A mortall] a temporell CA thervpon she] *om.* C; then she A 37 vnto] to CA in this maner]
sadly A in no wyse] not A thye corupt . . . for] thy foule and corrupte desyre / for C; the for A
38 the which A preserueth CA 39 therfore . . . I] and truste thow veryly / that I CA neuer] not
CA threatininges] menaces and thretenynges C; manassyngis and thretynges A thus, this] this
the A 41 ire and] *om.* CA incontynent] *om.* C; and of wrath A 42 wheare her] where as the C
on]to CA vp a C a fayre well . . . our] a fayr welle gyuyng oute haboundauntly fayr clere water
/ where oure C (*for extract from* A *to line 49, see above,* n. 13) 43 yet dayly C 43-4 daylie . . . that]
and C 44 and . . . bene] haue there ben C 45 made houle] heled C God and] *om.* C 46
aforsayd] sayd C appiere C stones bespryncte and spercled as C 47 may] can C 48 are] is C
of a C 49 her] the C and] and hir A heard] knewe CA of her deathe] of theyr doughter C; it
A fulle grete A 50 lamentacion for her deth / by-cause C; sorowe and lamentacion for there
doughter Wenefride for A but she onlye] *om.* A she] her C 51 forsayd] *om.* CA the deathe of
Wenefryd] this dede A 52 sawe the] se whate A of . . . mother] the fader and hir modir made
for hir then A them goodly CA 53 where as C 54 and behavioure] *om.* CA a-vowed] made a
vowe A 55 he] *om.* C 55-56 And after . . . of all] Wherefore he sette the hed ayen to the body
and he desirid A yt] *om.* C 56 bodye] place C 56 of all] all C that . . . present] for A there were
C 57-58 vnto . . . for] that if it pleasid almyghty God she myght haue hir lyfe ayen not only to
A 57 the] *om.* C 58 vp] *om.* C 59 her] *om.* C also] *om.* C also for to accomplyshe] to fulfylle A 60
frome] vp fro A holye virgine] maide A 60-61 arose . . . myracle] ros vp made A allmig *cancelled*
before allmighty B allmighty] *om.* A 62 gave . . . His] praysid His A praysyng vnto C 63 & euer]
shewid for this holy virgyn Seinte Wenefride and A lyued after / ther appiered CA 64 a
redenes round aboute lyke to a rede threde of sylke C; a rednesse lyke a red silkyn threde A 65
And . . . her] And the tyraunte that did slee hir A when] *om.* C that had thus slayne her C 66 in]
on CA he] and CA all . . . powere] beside / and had no power C; beside and he had neither
power A 67 remove] go A that cursyd CA 68 the slaughter] thomycyde C; that homycide A
68-69 be-cause . . . grett] that he yeafe no reuerence to the Sabbot-daye and to the grete A 69
dredde C 70 And sayd vnto hym] And then this holy man saide to hym A vnto] to C 71
mysdede CA But . . . not] Wherefore A almyghty CA 72 doune dede CA 73 deade] *om.* CA
73-74 by the dyvelles most teryble] with fendes CA 74 Then after] Than was A was] *om.* A
consecrate CA 76 theare] *om.* CA made] do make there C for] by C for . . . vyrgines] and there
she shulde dwelle vij yere to wurship and prayse God and þer she shulde geder to geder virgyns
A 77 yere C honest and holy C 78 whome . . . in] and þer to informe þem in A after these A
yere CA 79 holy place C; other holy place A of religion . . . lyfe] *om.* A 80 go in-to CA 81 tyll

C; tille A bothe] *om.* CA 82 stode a long tyme euer talkying of A And . . . departe] And at þe laste A 83 Oure Lordis wylle A God] Our Lord C shalt] *om.* CA 84 some . . . into] euery yere somme token / whiche thou shalt put in-to C; euery yere som tokyn & put it in-to A 85-86 welle / and fro hens it shalle by the streme be brought in-to the see / and so, by the purueaunce of God, it shalle be brought ouer the see the space of fyfty myle to the place where I shalle dwelle C; welle, which shalle brynge it in-to the se and then by the purviaunce of God it shalle be conveyd ouer the see the space of l myle to the place where I dwelle A And when A 87 chesyble of sylke werke CA 88-89 and leyd it vpon the streme of the said welle / and fro thens hit was brought vnto this hooly man Beuno thorugh the wawes of the see by the purueance of God / After thys C; and she put it in-to the saide streme and it was brough[t] thurgh the wawis of the se to the howse of this holy man Beuno. This A the] *om.* A 91 holy . . . with] talkyng of hevynly swetnes with A 91-92 moving . . . love] that she meovid there hertis mervelously to devocion and in-to the loue A to] in-to C 92-93 And . . . went] And after vij yere were passed, she wente A abyden there C 93 yere C ther] *om.* C to the] to a A Wytheryachus C; Witheriacus A 94 were bothe C; þer were bothe A and godly] and holy C; *om.* A 95 had . . . vnto] had confessid and told her lyf vnto C; had tolde hir lyfe to A honorably] wurshipfully A 96 Theonye C; Theonie A fulle blessid A who] whiche CA and the A 97 of alle the CA out of this world] *om.* A 98-99 deliuered . . . sisters] betoke to Wenefride the cure and the charge of þe susters A this holy C 99 of the C refused it CA 99-100 might . . . lyfe] myght, and after that she was compellid þer-to, she levid fulle vertuously but after that she levid a full vertues lyfe. A 100 afterward C 101 then she dyd a-fore in] *om.* A to-fore C ensample CA 102 to all her susters CA ther] *om.* A 102-3 the space of eight yeares] eyght yere C; þer certeyn yeris A 103 her] the A vnto God her macker] to her maker C; to God in the vth daye of Decembre A C *adds:* To whome late vs praye / to be a specialle intercessour for vs AMEN. Thus endeth the lyf of Wenefryde vyrgyne and martir; A *adds:* Here endith the lyfe of Seinte Wenefryde. 107 649 *cancelled and* 651 *supplied* B [According to *The Catholic Encyclopedia,* XV (1912), 656 and Frederick G. Holweck, *A Biographical Dictionary of the Saints* (St. Louis and London, 1924), p. 1040, she died on November 3, so A is probably wrong] 109 [Thus Holweck, though the second year of Stephen extended 26 December 1136-25 December 1137. Read 487 to make proper total?] 113 martirdome of the *(with* of the *cancelled)* B 114 [Thus Holweck: "Her 'Passion' was formerly celebrated in Wales, 22 June"].

There are, apparently, three possible explanations for the nature of the present text:

(1) that it is exactly what it claims to be, a verbatim copy of some (now lost) original;

(2) that it is a careful copy of a "sister-text" to the one which Caxton used freely;[16] and

(3) that it is a free copy of the Caxton version, thus denying the very positive statement by the scribe and giving a fine example of the liberties which copyists were prepared to take with their exemplars.[17]

This is as far as the existing evidence allows us to go, though the third alternative may seem to be the most probable explanation.

NOTES

1. Search for a possible proto-type for this *Life of St. Winifred* was undertaken when the writer was a Visiting Fellow at All Souls College, Oxford University, in 1969.

2. The problem is quite different from the oral, formulaic transmissions of the metrical romances; compare William E. Holland, "Formulaic Diction and the Descent of a Middle English Romance," *Speculum*, 48 (1973), 89-109.

3. Mentioned also by Manfred Görlach, *The South English Legendary, Gilte Legende and Golden Legend*, Braunschweiger Anglistische Arbeiten, Heft 3 (Braunschweig: Technische Universität, Institut für Anglistik und Amerikanistik, 1972), p. 21, n. 13.

4. Comparable handwriting may be found in plate 27 (Secretary hand, after 1573) of Noël Denholm-Young, *Handwriting in England and Wales* (Cardiff: University of Wales Press, 1954); in plate 14 (9 January 1590/91) of Hilda E. P. Grieve, *Some Examples of English Handwriting*, Essex Record Office Publications, no. 6 (Chelmsford: Essex County Council, 1949); and in a document (S. P. 12/ 118/ 11/ 1—dated 28 October 1577) in the Public Record Office.

5. This manuscript cannot be identified as one of the 2824 lots listed in *A Catalogue of the Library of Richard Wright, MD, Fellow of the Royal Society, (Deceased) . . . which will be Sold by Auction . . . on Monday, April 23rd 1787; and the Eleven Following Days* (London, 1787). It may have formed part of a group, such as lot no. 1425, "Thirty-two Histories."

6. Cf. *The Dictionary of Welsh Biography down to 1940* (Oxford: Blackwell, 1959), p. 92.

7. For an initial identification of the Welsh texts, I am much obliged to Professors Robert A. Fowkes of New York and Richard I. Aaron of Aberystwyth. A most detailed and thorough description of these texts by Professor Hywel D. Emanuel of Aberystwyth is retained in my files. I am most grateful to Professor Emanuel for his painstaking analysis.

 Originally a piece of paper appears to have been pasted down on page 16 and the "englyn" was partly written over this. Subsequently (at some uncertain date), this slip of paper became separated from the MS and thus a portion of the righthand margin of the poem was lost.

8. Besides the signature "William Hughes," there is the fragmentary entry: "William Hugh[es] owith this [booke]

teste William . . ." (OED recognizes "owe" as a good form for "own" as an adjective but cites no instance of this form under the verb). So far no evidence has come to light to establish this as the signature of the William Hughes (d. 1600), who became Bishop of St. Asaph in December 1573. On the one hand, this pamphlet, with its Welsh connections, would have been of great interest to this ardent admirer and student of Cambrian culture. On the other, the lack of the episcopal title in the signature would require a date of *ante* 1573, which may be a bit early for the handwriting. The signature of William Hughes (Asaphen) occurs in two documents at the Public Record Office (S. P. 12 / 118 / 10—4 November 1577 and S. P. 12 / 174 / 15 *now* 21 October 1584) and appears to be quite different.

9. For these texts, see Charlotte D'Evelyn, "Saints' Legends," in: J. Burke Severs, ed., *A Manual of the Writings in Middle English 1050-1500*, vol. II (Hamden, Conn.: Shoe String Press, 1970, pp. 410-57, 553-649; esp. pp. 432-39, 633-34). This account has been emended and enlarged by Görlach, op. cit. I have consulted most (if not all) of the manuscripts and printed editions, containing (or likely to contain) a life of Saint Winifred, cited by D'Evelyn and Görlach, including all those *post* 1500 in STC plus an additional *Golden Legend* curiously dated 30 February 1521 (cf. my "False Information in the Colophons of Incunabula," *Proceedings of the American Philosophical Society,* 114 [1970], 400). I am particularly grateful to Professor D'Evelyn for her assistance in my research.

10. MS Bodley 952 (O), old folio lxxxij, now numbered in pencil 215, contains a life of Saint Winifred incomplete at end. That this MS is a copy of the Caxton translation is evidenced by the note under Saint Rock (f. 219v, col. 2): "The ffeste off saynt Rocke ys alwey holdyn on the morne after the day of Thassumpcion off owre lady whych lyff is traunslatyd owte off latyn in-to englesche by me Wylliam Caxton" (see Caxton's edition, sig. H7v). It follows the printed edition practically word for word, though following its own order of the lives. The scribe, furthermore, felt free to vary the orthography. Four typical examples of the variants to be found in O are these: (C, T5v, b, 23) "parfyghtly in the faithe" / "in the ffayth parffytelye" (O); (C, line 5 up): "purpos wold" / "purpos

wyche wold" (O); (C, T6, a, 4): "the chambre dore" / "the dore off the chambre" (O); (C, line 31) "sprange vp" / "sprang" (O).

11. Caxton's separately printed *Life of St. Winifred* (c. 1485; STC 25853; copy in the Morgan Library, PML 35083) is, of course, quite an independent text.

12. The copy used for the quotations from Caxton's *Golden Legend* is that in the Morgan Library (PML 780), which contains the reprinted leaves (II). See William Blades, *The Life and Typography of William Caxton*, vol. II (London: Joseph Lilly, 1863), pp. 182-183 and Seymour de Ricci, *A Census of Caxtons* (London: Oxford University Press, 1909), pp. 101-7. The extracts have been compared with the readings in a copy of the University Library, Cambridge (Oates 4087), which is perfect and has the leaves of the original printing (I). The differences are inconsequential, these four being characteristic:

> (T5v, a, 3) "that the" (I), "that" (II)
> (T6, a, 16 *up*) "specled" (I), "spercled" (II)
> (T6, b, 30) "dradde" (I), "dredde" (II)
> (T6v, a, 12 *up*) "reffused

it" (I), "refused it" (II)

13. Another instance where the BM manuscript text departs widely from the other two (also not alike) may be noted for lines 42-49: "þer spronge a fayre welle, the which in-to this daye heelyth and curith manye dissesis. And in the bottom of the saide welle appiere stonys alle blody, which maye not be waish a-waye with no crafte nor with no laboure. And when hir fadir and hir moder . . ."

14. Although, for obvious chronological reasons, they could not have been the source for the text printed here, a number of later tracts on Saint Winifred have been consulted for possible leads:

> (1) Wilson, John, *The English Martyrologe* (St. Omer, 1608 & 1640). STC 25771/72.
> (2) *The Roman Martyrologe* (St. Omer, 1627). STC 17533.
> (3) Falconer, John, *The Admirable Life of Saint Wenefride* (St. Omer, 1635). STC 21102.
> (4) Fleetwood, William, *The Life and Miracles of St. Wenefrede* (London, 1713).
> (5) Gent, Thomas, *Holy Life and Death of St. Winifred* (London, 1743).

(6) Dalton, John, *Life of St. Winefride* (London, 1857).

(7) Meyrick, Thomas, *Life of St. Wenefred* (London, 1878).

(8) Owens, Theophilus, *The Worship of St. Wenefride* (Holywell, 1882). This investigation bore no fruit.

15. The manuscript copying of printed books was very extensive in the fifteenth and sixteenth centuries. See my *The Fifteenth-Century Book* (Philadelphia: University of Pennsylvania Press, 1960), pp. 15-39 and Carl Horstmann's observation: "Mehrere hss. [of the *Festiall*] sind nach drucken gefertigt" in "Prosalegenden: Caxton's Ausgabe des Lebens der Wenefreda," *Anglia,* 3 (1879), 293; cf. Görlach, op. cit., p. 26, n. 7.

16. Grace E. Moore, *The Middle English Verse Life of Edward the Confessor* (Philadelphia, 1942), p. 142 states that Caxton "gives the same material, occasionally condensing an incident, copies peculiarities, and records whole passages word for word, although he makes verbal changes according to his style preferences, for conciseness, and for clearness." See also Herbert C. Schulz's comments (on printers making free with their copy) in his "A Middle English Manuscript Used as Printer's Copy," *The Huntington Library Quarterly,* 29 (1966), 325-36. Cf. Görlach, op. cit., p. 94.

17. See also the comment made by Hans H. Glunz *(The History of the Vulgate in England from Alcuin to Roger Bacon* [Cambridge: Cambridge University Press, 1933], p. 213) to the effect that "with the pure form of the text nobody was concerned. What mattered first of all was the sense of the passage, its true reality. The text merely had to conform to it." As an example of the carelessness of scribes, one may recall Thomas Whythorne's reference to a Caxton edition of the *Myrrour of the World* of 1508 (James M. Osborn, ed., *The Autobiography of Thomas Whythorne* [Oxford: Clarendon Press, 1961], p. 236). The STC lists only two Caxton editions: c. 1481 (STC 24762) and c. 1490 (STC 24763). Caxton died late in 1491 or early the next year. The only other early edition of the *Myrrour* is that by Laurence Andrewe about 1529 (STC 24764). Compare also Lillian L. Stechman, "A Late Fifteenth-century Revision of Mirk's *Festial,*" *S P,* 34 (1937), 36-48.

Some Readings in the *Canterbury Tales*

E. Talbot Donaldson
Indiana University

Because of the labors of such scholars as Skeat, Root, Manly and Rickert, and Robinson, the works of Chaucer have been in general so well edited as to leave gleaners like Baugh, Pratt, and me few goodly words to gladden us. But the very thoroughness with which earlier reapers have led away the corn has perhaps discouraged modern Chaucerians more than it ought from searching among the stubble, and has caused too many readers to suppose that all textual matters have now been settled forever. At the risk of unintentionally suggesting that all *important* textual matters *have* been settled, I should like in this paper to examine some readings in the *Canterbury Tales* where alternatives to the received text seem to invite consideration, or where accepted explanations of anomalies seem dubious. I am aware that it takes a very long time for a reading to become accepted, and that several of the readings I would change have been accepted for a very long time; but while time is the only true test of a reading's worth, time can only test readings when their alternatives have not been buried from sight. I shall therefore exhume several from long-undisturbed graves in the textual notes. Because I am trying to encourage others to become more skeptical of what the received texts say, I have chosen examples that involve very various editorial techniques and display highly disparate kinds of problem.

I shall deal first with a reading which (one of many) as an editor I long failed to give proper attention to, having let myself be persuaded on several occasions that any question concerning it had been terminally answered or had proved unanswerable. The reading occurs at the very beginning of the *Canterbury Tales* in line 60 of the portrait of the Knight: "At many a noble armee hadde he be." The problem, of course, is the word printed as *armee,* whose minims may be reinterpreted to produce the word *ariuee,* or, perhaps more prop-

erly, *aryue*,[1] a variant that deserves consideration if only because Skeat thought it was what Chaucer wrote.[2] When I first came to the line in my editing, I looked up Manly and Rickert's note, which is as follows:

> The proper reading here is "armee." This is in French the usual word for an invading army by land or sea (cf. Span. armada), but, as the readings show, it was not understood by a few of the 15 C scribes. There is, however, no evidence for "aryue" in any sense that would fit the passage. The stroke over the first minim of the *m* in "armee" in Hg seems to be a later addition.[3]

Being a reasonably conscientious editor, I made what was at least a start on an independent analysis of the possible readings by doing the lexical work. OED lists for *arrive,* sb., this occurrence as unique in the Middle English period (the second is 1538) and says it is probably an error for *armee.* MED confirms OED, listing the word only from this line and similarly labeling it: it is thus one of those rare words to be included in MED only in order to be ejected from the Middle English language—a homeless ghost given permanently temporary shelter. Any possibility I entertained that *aryue* might be the original reading seemed to evaporate as a result of these two official certificates of its nonexistence.

Still, there is no question that a nonexistent word is a far harder reading than a well attested one, and the principle of *durior lectio* is one no editor can afford to ignore, even though, or rather, because harder readings cause editors headaches. But it turned out that *aryue* was not a provable *durior,* for both OED and MED list *armee* in this line as the first known use of the word in English in any sense;[4] the second is in the *Wars of Alexander;* thereafter, it is not recorded until the 1470s, after which it becomes relatively common. Even placing the *Wars of Alexander* far earlier than its manuscript dating of 1450, it is obvious that for an early fifteenth-century scribe there may have been little distinction, with respect to relative hardness, between *armee* and *aryue.* While the latter may be a ghost, *armee* may, when Chaucer wrote it (if he did), have had very little more corporality and an equally uncertain future. As far as the *durior* principle was concerned, it seemed to me to be a tie between the readings, to be settled in favor of the word that ran harder and lived longer. As a

result, my edition of the line read *armee*. I was cured of the headache
a *durior* causes.

But I was not permanently cured. Some years later I was back in
the Manly-Rickert critical notes looking for something else when my
eye fell on the note to line A60. I reread it, and was struck by a
certain edginess of tone, as though its writer were irritated that *aryue*
had reared its ugly head and were making sure to lop it off. By now I
had become aware that a critical note often proves to be a subtly
twisting serpent in which an editor may fiendishly disguise a false-
hood; as a brother Asmodeus I had become sensitive to a fishy odor
in the bridal chamber where readings are begotten. What struck me
about the note was that the editor could find no sense for the word
aryue that would fit the passage. I had never thought that there was
any problem with the sense—the French verb from which *aryue* was
presumably derived meant "to land," [5] and the kind of military
landing Chaucer might have had in mind was made familiar again
by the Second World War. It was not the word's sense that was in
question, but its existence. The note's preoccupation with the
former and neglect of the latter seemed a curious clouding of the
issue. I was struck, too, by the characterization of the scribes who
wrote *aryue* as "a few," for, as MED notes while dismissing the word,
eight MSS read it. According to Manly and Rickert, only twenty-
nine MSS have this line at all: in addition to eight which read *aryue*,
two read *ryuer*, which is a corruption of *aryue* and hence support for it;
seventeen read *armee* or obvious variants derived from it; one reads
armee over an erasure and hence may be a later correction (of
aryue?); [6] and finally, according to Manly and Rickert's note, Hg
reads either *armee* or *ariuee*,[7] depending whether there is or is not a
stroke over the first of the three minims (this stroke may have been
an optical illusion: Furnivall does not record it, Manly and Rickert
fail to mention it in their apparatus, and I am told by those who
have either examined Hg or have reproductions of it that they have
noticed no stroke).

I did all this counting with some ill will, for I knew that expe-
rienced editors like Manly and Rickert do not ordinarily try to
support a chosen reading by giving the results of a vote cast by the
surviving MSS. Democratic majority rule simply does not work in
editing, so that a final count of eighteen [8] to ten in favor of *armee* (or
of seventeen to eleven if the stroke on Hg's minim does exist) is of no

real significance. What is significant is that of the five independent lines of transmission from O^1 that Manly and Rickert find represented by the surviving MSS, four support *armee* and three support *aryue*.[9] In view of this, it seemed that the critical note should read not "a few scribes" but "a few scribes in the generations close to O^1." And in all honesty—if that is not too unlikely a phrase to be used by a textual editor—it seemed to me that as many of the earlier scribes could have mistaken an original *aryue* for *armee* as an original *armee* for *aryue;* if no more than a few did the one, then no more than a few had to do the other in order to achieve the effects apparent in the surviving MSS. In short, Manly and Rickert's phrase "a few" conceals the fact that genetic evidence favors neither reading over the other. But although I had now become skeptical about the originality of *armee,* I could find no way to disqualify it, and in an article I wrote at this time I said confidently that "it is probable that we shall never be certain which [word] Chaucer intended." [10]

Perhaps we never shall be; but once again I had stopped troubling myself about the problem too soon. One day I was looking up something in Skeat's notes, and my eye once again fell on a note to A60. Editors exist not only to produce good texts, but to exasperate later editors into producing better ones; but apparently Skeat's note had backfired in this respect with Manly and Rickert and had caused the irritation I had noticed in their note rejecting his reading. Skeat is laconic: *"aryue,* arrival or disembarkation of troops. . . . Many MSS have *armee,* army, which gives no good sense, and probably arose from misreading the spelling *ariue* as *arme.*" [11] Well, Skeat was wrong on the first count, for *armee* in the sense "armada" makes perfectly good sense. But on the second count he now appears to me right. The reason I had paid no attention to Skeat's note—had failed to work out the problem for myself—was that, nine times out of ten, when an editor explains that one word is a misreading of another, the word that has presumably been misread could just as easily be a misreading of the supposed misreading:[12] despite Skeat, there seemed no reason why *aryue* should not be the misreading of *arme* that Manly and Rickert announced it to be.

But of course there is a reason why it shouldn't. Assume that Chaucer wrote *arme:* he would have to spell it $a + r + three\ minims + e$. But a few early scribes say to themselves—independently of one another, mind you—"*Arme.* What a curious word! What in the world does it mean? Those three minims must stand, not for an *m,* but for

an *i-n* or *i-u* or an *n-i* or *u-i.* I've got it: *ariue!"* They then proceed to write down another word not known to have been previously or subsequently recorded in Middle English—a case of multiple *ignotum per ignotius.* And the action goes against scribal habit which, in cases of minim-confusion, characteristically seeks the easiest solution, preferring in cases like the present to write a single letter which appears sensible rather than bothering to analyze laboriously the potential minim-components. But suppose Chaucer wrote *aryue,* and he (or his scribe) spelled it precisely as he would have spelled *arme,* *a + r + three minims + e.* There may or may not have been a stroke over the first minim to signify that it represented *i;* most scribes of the period forgo such a stroke, and even when they use it, it is apt to be misplaced or else to have a rather spectral appearance and the faculty of vanishing and reappearing in different lights (which perhaps accounts for the matter of Hg). But a scribe who saw the word as *arme* would surely have no real trouble with it: the word is obviously related to *arm* ("weapon" or "armor") and *armen* ("to arm"), and the text concerns a knight-at-arms. One MS actually reads *armes,* and only one scribe perhaps misunderstands by writing *harme.* The probability seems strong that, despite the paucity of surviving examples of the word from the early fifteenth century, scribes would not have found *arme* hard when they encountered it in their exemplars. Furthermore, the care with which at least several scribes of surviving MSS wrote *aryue* with *y* for the first minim suggests that they knew the word *arme* but recognized the word before them as *aryue,* which they spelled in such a way as to make it impossible to mistake for *arme.* The spelling *aryue* represents a disciplined intelligence at work, and a disciplined intelligence among the drab mediocrity of so many copyists produces a situation not unlike that of *durior lectio.* And here, even if it is impossible to establish a lexical *durior,* an orthographical *durior* establishes itself. It is much easier for a scribe to go from *aryue (ariue)* to *arme* than from *arme* to *aryue,* and it seems that more than a few did. And, of course, if we were sure that *aryue* ended in long close *e* (as we are not), it would be possible to argue that all the apparent spellings *armee* represent, in actuality, *ariuee:* it is no easier for us to interpret minims correctly where the word is uncertain than it was for the scribes themselves.

The reader may properly feel that the product of this mountainously mousy labor is only a mouse, and I admit that Chaucer might not greatly care whether we think he wrote that the Knight was

present in many a noble armada or in many a noble armada when it landed somewhere. Still, we owe it to him not to put words in his mouth, and it is possible that he never thought of the word *armee*. I think he might feel worse, however, when we suggest that he canceled words which he may have composed with loving care, as in the couplet from the Friar's portrait which editors customarily place in square brackets.[13] The lines are 252a-b (the irregular numbering occurs because they were omitted from the six-text edition):

> And yaf a certeyn ferme for the graunt
> Noon of his bretheren cam ther in his haunt.

The couplet occurs only in Hg-Ch Py Tc[1]-Ld[2].[14] Manly and Rickert suggest that it came to Hg-Ch by descent, and to the others by contamination, and that Chaucer wrote it but canceled it because it interrupts "the flow of the narrative" and adds "little to the picture of the Friar." But the style of all the portraits in the General Prologue is a constant exercise in interruption of the flow of the narrative as the narrator thinks of or notices now this detail, now that; and while many lines add little to the portraits, the portraits themselves consist of an accumulation of small details. The disappearance of the couplet from the vast majority of MSS is accounted for on scribal grounds. An early copyist—perhaps a number of early copyists—momentarily paused upon completing 252:

> He was the beste beggere in his hous.

After looking up, the eye returns to what one has just written in order to find one's place, but instead of lighting on *in his hous* of 252 lights on *in his haunt* (probably in the form *in his haūt*), and continues with 253. Such homeoteleuton is one of the commonest sources of scribal omission. And it should be recognized as a firm principle that when a textual irregularity is explicable on well-attested scribal grounds, one ought not have recourse to grounds less firm in order to explain it. A couplet (637-638) in the portrait of the Summoner was similarly incorrectly ascribed to authorial revision by Manly and Rickert because of its absence from Hg Bo[2]:

> And whan that he wel dronken hadde the wyn
> Thanne wolde he speke no word but Latyn.

According to Manly and Rickert, Chaucer probably added this couplet after the portrait had in all other respects been completed.[15] But if one looks at the preceding line

> Thanne wolde he speke and crye as he were wood,

the omission appears as a classic example of error caused by homoarchy. Having looked up after transcribing 636, the scribe resumed work with the line following what appeared to be the last line he had written because, unfortunately, both lines begin *Thanne wolde he speke.* That Chaucer inserted the couplet later is doubly improbable, for without it the language the Summoner speaks a "few words" of when drunk is not specifically identified as Latin.

A passage near the beginning of the Wife of Bath's Prologue (44a-f) that is omitted by most MSS and that Manly and Rickert suppose to be a late Chaucerian addition shows another common scribal (and human) practice,[16] that of yielding to the urgency implicit in a numerical sequence. In all MSS the Wife, referring to her previous husbands, exclaims (44):

> Blessed be God that I have wedded fyue.

Thirteen MSS have her continue:

> Of whiche I have pyked out the beste
> Bothe of here nether purs and of here cheste
> Diuerse scoles maken parfyt clerkes
> And diuerse pracktyk in many sondry werkes
> Maken the werkman parfit sekirly
> Of fyue husbondes scoleiyng am I.

The next line:

> Welcome the sixte whan that euere he shal,

provides the logical numerical sequent for both 44 and 44 f, and it seems highly likely that a scribe early in the tradition made the leap from the *fyue* of 44 to the *sixte* of 45—perhaps Adam himself: rectification by squeezing the passage into the margin of O^1 would help account for its corruption in the MSS in which it appears.[17] Once again, when there is an apparent scribal cause for omission, it is bad

editorial practice to resort to conjectures about authorial revision.[18]

I shall conclude with a final reading where it seems to me all editors have missed an attractive alternative. This occurs in the altercation between the Friar and the Summoner at the end of the Wife of Bath's Prologue. The Summoner advises the Friar (838):

> What amble or trotte or pees or go sit doun.

The noun *pees* in a place requiring a verb is highly suspicious, and Manly and Rickert's note reads, "K[och]'s reading, 'pace,' is suggested by 'amble or trot" but no MS has it." [19] That no MS has *pace* is not surprising, for in Chaucer's time the words *pass* and *pace* had not become semantically differentiated:[20] for any meaning of "pass" within the line Chaucer (or his scribes) always seems to have written *passe;* at the end of the line in rhyme with words in *-ace* like *space* he wrote *pace.* Here, then, he would have written *passe.* And if he had done so, some scribes might, I suppose, have been puzzled; the generalized sense of *passe,* "go," might have made it hard to pick out the particularized sense "pace" *(pace* itself, as a word distinct from *pass* and with its meaning "proceed by the use of the legs," occurs first in the sixteenth century, probably as a re-formation from the noun).[21] But this mild indication that Koch's conjectural emendation could be a *durior* is counterbalanced by the strong probability that if Chaucer had written *passe* with the intended meaning "pace" even a scribe unable to extract from it the meaning Chaucer intended would have let it stand: "amble or trot or pass or go sit down" may not be usual idiom, but for general sense it will surely get by.

But while no MS has *passe,* there is a variant for the out-of-place noun *pees* which occurs in fourteen of the fifty surviving MSS that have the line.[22] This is a verb having the same shape as *pees* and a meaning wholly appropriate to the speaker's anal personality. It surely should have entered discussions of this line—if only to be discredited—because it is a word no student I ever had was too linguistically deprived to be unable to supply. Unfortunately, of the four independent lines of transmission from O[1] that Manly and Rickert trace in the Wife's Prologue, only one provides firm attestation for *pisse.* [23] Twelve of thirteen MSS of one genetic group have it, El being the odd man out; two MSS of another genetic group also read it, but both are said to have been heavily edited. But how is one

to weigh the weakness of the genetic evidence for the variant against the absolute rightness of its sense? One may, indeed, argue that three good editorial principles eliminate *pisse:* the genetic evidence, the indisputable fact that *pees* is a *durior lectio,* and the absence of a scribal motive for altering an original *pisse:* it apparently did not shock fifteenth-century scribes, for they rarely censor it out where it is authorial.[24] But this seems to me one of those occasions—all too frequent in an editor's life—where he is justified by the sense of a variant into violating all his own rules. The result will be at least to expose a possible original reading to the light of day, and to the test of readers' responses. It is these that will ultimately determine whether a reading is right or not, but they cannot do so if the alternatives are not, as it were, thrown in their faces.

I close with a little exemplum that shows that scribes are still with us, misunderstanding our not always very clearly expressed authorial intentions. When I joined the faculty of the distinguished university where I am employed I was required, naturally enough, to give my full name to the keepers of records. My first name is one which for personal reasons I have always tended to suppress. I therefore wrote it in a way that I thought would indicate that I wished it to be represented in normal circumstances by an initial only. Imagine my surprise when in the university's official register I appeared with the first name of Ecthelbert—as if Ethelbert were not bad enough. It was some time before I recalled that I had written E(thelbert). I suppose I should be happy that the closing parenthesis defeated the transcriber by resembling no known letter. And I hope future generations will not misunderstand me when I dedicate this article to that fine scholar and fine teacher, Lillian Hornstein.

NOTES

1. Discussion of the variants involves both orthographical and phonetic difficulties: (1) The word *armee* may either be so spelled or else be spelled with equal propriety *arme;* the doubling of final *e* to represent the long close sound was a sophisticated scribal convention which few scribes used invariably. (2) The word which results from reinterpretation of the minims of *m* in *arme(e)* has no lexical history in Middle English, so that it is not known whether its terminal vowel is the long close *e* or the central (un-

stressed) vowel *e.* J. M. Manly and Edith Rickert, *The Text of the Canterbury Tales* (Chicago: University of Chicago Press, 1940), vol. III, p. 5 and vol. V, p. 7, record no spelling except *aryue,* which is of course ambiguous as to the final sound. OED lists the word in this line under *arrive,* sb., and its sixteenth-century examples have silent final *e;* MED *(arive,* n.) tentatively derives the word from Old French *arivé,* p.p., but declares it a ghost (see text below). If the spelling *aryuee* occurred in the Chaucer MSS, it would be of some help in discussing the problem but of little help in solving it, and the present argument is able to proceed without its being necessary to take a position on the quality of the final *e,* since the pair *arme/aryue* provides all requisite grounds for discussion. It should be observed that just as with the doubling of final *e* to indicate a long close sound, so the *y* for *i* when next to a minim-letter *(aryue* for *ariue)* is also a scribal convenience often honored in the breach: many scribes might write *ariue,* which is generally indistinguishable from *arme.* In discussing the words lexically I use the received forms *armee* and *aryue,* but in discussing their spelling I use whatever forms illustrate my point.

2. W. W. Skeat, *The Complete Works of Geoffrey Chaucer* (Oxford: Clarendon Press, 1889-94), vol. IV, p. 3.

3. Manly and Rickert, vol. III, pp. 421-22.

4. OED, *army;* MED, *arme(e, n.*

5. French *arriver* is derived from late Latin *adripare;* but the noun *arivé* does not seem to occur in French before the sixteenth century, which would make Chaucer's use of *aryue* one of those rare but not unexampled cases where a borrowing from another language is not recorded in the language from which it is borrowed.

6. Manly and Rickert, vol. III, p. 5.

7. The faintness of the stroke they detected apparently led Manly and Rickert to suppose it had been added later; they give no evidence for this conclusion.

8. Ha[3], which has *armee* by correction, has to be excluded from the count.

9. For the lines of transmission see Manly and Rickert, vol. III, pp. 2 and 5. Two lines each represented by a single MS (El and To) have *armee;* one line represented by a single MS (Gg) has *aryue;* in the line represented by Hg-Cn Ha[4], Ha[4] has *aryue,* Cn has *armee,* and Hg remains questionable; in the best represented line of 22 MSS,

aryue or *ryuer* appears eight times sporadically.

10. "The Manuscripts of Chaucer's Works and Their Use," in Derek Brewer, ed., *Writers and Their Background: Geoffrey Chaucer* (London: G. Bell, 1974), p. 91.

11. *Works,* V, 8.

12. E.g., the explanation in Manly and Rickert (IV, 81) that in C318 the "widely attested reading 'Ihon Pardoner' may have originated in a hasty reading of 'thou Pardoner.'"

13. As in F. N. Robinson, *The Works of Geoffrey Chaucer,* 2d ed. (Boston: Houghton-Mifflin, 1957); A. C. Baugh, *Chaucer's Major Poetry* (New York: Appleton-Century, 1963); and R. A. Pratt, *The Tales of Canterbury* (Boston: Houghton-Mifflin, 1974). All call the couplet genuine; Robinson and Pratt suggest that it may have been canceled by Chaucer.

14. Manly and Rickert, vol. III, p. 424. The couplet is omitted from the text, p. 12.

15. Ibid., p. 425.

16. Ibid., pp. 454-55.

17. Line 44d is unmetrical and contains the awkward phrase *many sondry,* otherwise unexampled in Chaucer. A scribe may have written *many* for *sondry,* and then, noticing his mistake, he may have written *sondry* without canceling *many* (or the cancelation of *many* by expunctuation may have been subsequently missed). Dd, which according to Manly and Rickert alone has the correct version of the passage, has several examples of such false starts in these lines. Dd also has the plural verb *maken* in 44e, which points to an original plural subject in 44d, and for *pracktyk* Cn-Ma read *pracktykis:* apparently, the scribe of Dd and others mistook a sign for *-es* as the mere flourish which often appears on final *k.* The line should probably read: "And diverse pracktykes in sondry werkes."

18. Manly and Rickert, vol. III, p. 454, consider this passage as part of the same problem as that represented by four other passages in WBPro omitted by most MSS: 575-84, 605-12, 619-26, and 717-20. I believe that these passages also represent accidental omissions rather than authorial additions. The first is a whole verse paragraph, omitted because the scribe's eye skipped from one paragraph sign to another; the third is the kind of omission frequent in *Piers Plowman* MSS, where the scribe apparently decides to pause when he reaches a new paragraph some lines below where he is working and then, for one reason or another, stops before getting to the new

paragraph, but resumes work as if he had; the fourth was probably omitted because the scribe's eye went from *al man-kynde* of 716 to *al mankynde* of 720. Only the second passage offers no ready explanation, but the problem is real only with 609-612: 605-8 are in all but three MSS, which omitted them because of the logical connection of *Venus seel* in 605 with *al Venerian* in 609.

19. Ibid., 460.

20. See OED, *pass,* v.: *"Pass* and *pace* are the same word, the forms having been in later times differentiated, and *pace* restricted to those senses which are akin to or derived from PACE sb. . . ."

21. OED, *pace,* v.

22. Manly and Rickert, vol. III, p. 267.

23. For these lines see Ibid., p. 233, and the discussion in Ibid., vol. II, pp. 191-210. The genetic group most often attesting *pisse* consists of Cn Cx Dd Ds El En[1] He Ii Ma Ne Py Tc[2] and, presumably, Se.

24. But if Manly and Rickert's genetic grouping is correct, it seems that *pisse* was edited out in El, which reads *pees*.

The Intended Illustrations in MS Corpus Christi 61 of Chaucer's *Troylus and Criseyde*

John H. Fisher
University of Tennessee

Corpus Christi College, Cambridge, MS 61 of Chaucer's *Troylus* is a clear and handsome manuscript that forms the basis for several of the standard editions. [1] One of its chief claims to fame is the elaborate frontispiece of Chaucer delivering his poem before members of the court. This illustration has been reproduced and discussed in detail, along with the possible identities of the members of the audience and the iconographic significance of their colorings and arrangement, by Aage Brusendorff and Margaret Galway.[2] Dr. Galway, citing James and Root, observes in a note that there are ninety-four spaces for other illustrations in the manuscript.[3] Brusendorff sets the number at "almost one hundred," and supposes that they were for illustrations that actually occurred in the original from which the Corpus was copied.[4] But so far no one has given an exact account of the positions and sizes of the spaces, nor indicated their contexts. It turns out that in spite of a frequently mechanical format, a probable subject can be discerned for nearly every picture, and they would provide a glorious pictorial account of the story of Troylus and Criseyde.

One reason for the differences in the numbers of spaces cited is that they fall into three categories. First, there are six spaces for initials:

1 (2) [5] THE. The T is sketched in beside the first stanza (I. 1-7). It portrays the face of a woman (no beard, long hair), perhaps intended to represent Thesiphone (I.6).

2 (4) (Y)T. Space vacant facing I. 57-63. The stanza speaks of the Greek forces going to avenge the ravishing of Helen.

3 (27) Owт. O facing II. 1-7 is sketched in with a woman's face and headdress, perhaps intended to represent Lady Cleo (II. 8).

4 (63) (O) BLISFUL. Space facing III. 1-7 is vacant. The passage is an apostrophe to Venus; so presumably the initial would have been another female face or figure.

5 (64) (L)AY. Space facing III. 50-56 is vacant. The stanza is Troylus's interior monologue.

6 (93ᵛ) LIGGYNG. L facing IV. 29-35 is sketched in merely as a letter, without face or figure.

In addition to these six initials, three vacant and three with unfinished sketches, there are vacancies on six explicit and incipit pages. The first four do not appear to call for illustrations, but the last two do.

1 (26ᵛ) Explicit, Book I, comes in the middle of a page. There is no reason to suppose that an illustration was intended to fill out the page.

2 (27ᵛ) Prohem, Book II, ends at mid-page and the text begins at the top of 28, but, again, there seems no reason to suppose that the bottom of 27ᵛ was intended for an illustration.

3 (62ᵛ) Explicit, Book II, ends with one stanza at the top of a page.

4 (63ᵛ) Prohem, Book III, ends at mid-page.

5 (93) "Explicit Liber Tercius" appears at the top of the page; "Incipit Liber Quartus" appears at the bottom. The space between appears pretty clearly intended for an elaborate full-page picture illustrating the Goddess Fortuna with Troylus and Diomede on her wheel on the facing verso. This is IV. 10-11 in conventional numbering of the lines, but Corpus is one of the manuscripts in which the prohem to IV is written as the conclusion to Book III.

6 (119ᵛ) "Incipit Liber Quintus" followed by one stanza at the bottom of the page. The space above might have been intended for a picture of Troylus handing Criseyde over to Diomede (V. 15-42).

Finally, in addition to the six initials and six incipit pages, there are ninety-three spaces in the text for pictures. Leaving aside all the initials, and the four incipit pages which do not appear to call for pictures, this makes a total of ninety-five spaces left vacant for pictures in the Corpus manuscript, very nearly the total arrived at by M. R. James, though not calculated in exactly the same way.

The Corpus manuscript is set up on a format of five stanzas to a

page. Stanzas are never broken. When space is left, it is by omitting a whole stanza or several stanzas. In the following list, each space is identified by the line it follows and by the lines it faces on the opposite page, since either of these might provide a context for an illustration.

1 (2v) two bottom stanzas out, after I. 56, facing blank fol. 3. Perhaps there would have been here an initial picture of Troylus and Criseyde—in the guise of Richard and Anne, or other court celebrities (?), cf. I. 48-56.

2 (3) blank page, facing I. 36-56. If, as suggested by the frontispiece and I. 171, *Troylus* was a poem read aloud to the court, the facing lines would make it appropriate for this to be another court scene, like the frontispiece.

3 (3v) blank page, facing I. 57-91, the Greek armada, and the Greek host besieging Troy.

4 (4v) four top stanzas out, before I. 92, facing I. 99-126, Criseyde on her knees before Hector.

5 (5v) four top stanzas out, before I. 134, facing I. 141-75, springtime, festival of Palladion.

6 (6v) four bottom stanzas out, after I. 182, facing I. 183-217, Troylus leading his young knights about the temple.

7 (7v) four top stanzas out, before I. 218, facing I. 225-59, the god of love sitting in majesty.

8 (8v) blank page, facing I. 260-94, Troylus first perceiving Criseyde in the temple.

9 (9v) three middle out, after I. 301, facing I. 309-36, Troylus going into his palace to contemplate his new emotion.

10 (10v) four bottom out, after I. 350, facing I. 351-85, Troylus in his chamber on his bed.

11 (11v) blank page, facing I. 386-420, the "Cantus Troili." There are many images in the lyric; it is hard to tell what an artist might have chosen for this full-page illustration.

12 (12v) four top out, before I. 421, Troylus speaking to the god of love; facing I. 428-62, no appropriate illustration.

13 (13v) four top out, before I. 463, facing I. 470-504; either Troylus in battle against the Greeks (I. 470), or sick with love (I. 484).

14 (14v) four top out, before I. 505, facing I. 512-46. Troylus lamenting his love agony. No illustration immediately suggests itself. This could have been intended for a picture of Pandarus entering Troylus's chamber, which begins the text at the bottom of the next page.

15 (15v) four top out, before I. 547, facing I. 554-88. I. 547 describes

Pandarus entering; if this was pictured on 14v, this illustration would take its clue from the facing page, Troylus on his bed conversing with Pandarus.

16 (16v) four top out, before I. 589, facing I. 596-630. This is a continuation of the conversation between Pandarus and Troylus. Any illustration would have to come from the substance of that conversation, e.g., from Pandarus's proverb about blind men (I. 628-30).

17 (17v) three middle out, after I. 637, facing I. 652-72. Possibly an illustration of Paris and Oënone (I. 652-65).

18 (18v) three middle out, after I. 686, facing I. 701-21. Troylus's and Pandarus's discussion continues; no good illustration suggests itself.

19 (19v) three middle out, after I. 735, facing I. 750-70. Possibly a picture of Pandarus's proverb of the ass and the harp (I. 731-35).

20 (20v) three middle out, after I. 784, facing I. 799-819, vultures tearing at Ticius's liver (I. 786-88).

21 (21v) three middle out, after I. 833, facing I. 848-68, Wheel of Fortune (I. 837-54).

22 (22v) three middle out, after I. 882, facing I. 904-24. Pandarus's and Troylus's discussion continues; no good picture. Possibly some illustration of Criseyde's beauty (I. 876) or Troylus's former hubris (I. 911) (?).

23 (23v) three middle out, after I. 938, facing I. 953-73. Images of well-tended gardens representing controlled and cultivated emotions (I. 946-66).

24 (24v) three middle out, after I. 987, facing I. 1002-22. Proverb about the churl and the moon (I. 1023-29).

25 (25v) three middle out, after I. 1036, facing I. 1051-71. Two possibilities: Troylus on his knees in gratitude before Pandarus (I. 1044); Pandarus leaving Troylus's palace (I. 1058).

26 (28v) three middle out, after II. 91, facing II. 106-26. Either Criseyde and her maidens reading in her garden (II. 81-84 of the previous page) or Criseyde and Pandarus in her garden (II. 85-91). The former would be more probable because the latter would be 29v.

27 (29v) three middle out, after II. 140, facing II. 155-75, Criseyde and Pandarus conversing in her garden.

28 (30v) three middle out, after II. 189, facing II. 204-24. Various possibilities: Hector and Troylus in arms against the Greeks (II. 186); Troylus in arms or in peaceful array (II. 197, 204).

29 (31v) three middle out, after II. 238, facing II. 253-73. Discussion between Pandarus and Criseyde continues; opportunity for depicting planetary deities (II. 232-34).

30 (32v) three middle out, after II. 287, facing II. 302-22. Discussion

continues. Pandarus reveals identity of Troylus to Criseyde. Perhaps the most likely picture would be of the Goddess Fortuna (II. 288-91).

31 (33ᵛ) three middle out, after II. 336, facing II. 351-71. Discussion continues. No good picture. Pandarus importuning (threatening) Criseyde.

32 (34ᵛ) three middle out, after II. 385, facing II. 400-20. Discussion continues. Perhaps the figure of "The kynges fool" (II. 400) might provide some sort of picture.

33 (35ᵛ) three middle out, after II. 435, facing II. 449-69. Discussion continues. Perhaps the apostrophe to Mars and the Furies might supply a pictorial idea (II. 435).

34 (36ᵛ) three middle out, after II. 483, facing II. 498-518. Pandarus telling how he learned of Troylus's love: the friends playing in the palace garden (II. 508-13), or Troylus sleeping on the ground and Pandarus wandering about (II. 515-16).

35 (37ᵛ) three middle out, after II. 532, facing II. 547-67. Criseyde in startling black (II. 534), or Troylus on his bed, suffering the agony of love (II. 557).

36 (38ᵛ) three middle out, after 581, facing II. 596-616. Troylus riding from battle past Criseyde's window (II. 616).

37 (39ᵛ) three middle out, after II. 630, facing II. 645-65. Criseyde looking out of her window at Troylus riding by—"Who yaf me drynke?" (II. 651).

38 (40ᵛ) three middle out, after II. 679, facing II. 694-714. Venus sitting in her seventh house (II. 680).

39 (41ᵛ) three middle out, after II. 728, facing II. 743-63. No good picture; Criseyde's internal debate.

40 (42ᵛ) three middle out, after II. 777, facing II. 792-812, Criseyde brooding over the pros and cons of love. Some picture representing this internal debate?

41 (43ᵛ) three middle out, after II. 826, facing II. 841-61. Criseyde and her nieces in her garden; Antigone singing.

42 (44ᵛ) three middle out, after II. 875, facing II. 890-910. Same setting as 43ᵛ; at II. 904 it grows dark and they go inside.

43 (45ᵛ) three middle out, after II. 924, Criseyde's dream of the white eagle; facing II. 939-59, Pandarus "leaping in" to give Troylus a progress report on his suit.

44 (46ᵛ) three middle out, after II. 973, facing II. 988-1008, Troylus and Pandarus again in conversation. No good illustration.

45 (47ᵛ) three middle out, after II. 1022, facing II. 1037-57, Troylus writing a letter to Criseyde (II. 1023).

46 (48ᵛ) three middle out, after II. 1071, facing II. 1086-1106, Pandarus coming to Criseyde with the letter.

47 (49ᵛ) three middle out, after II. 1120, facing II. 1135-55, Pandarus in the garden with Criseyde, thrusting the letter into her bosom.

48 (50ᵛ) three middle out, after II. 1169, facing II. 1184-1204, Criseyde and Pandarus dining in her hall.

49 (51ᵛ) three middle out, after II. 1218, Criseyde writing a letter to Troylus; facing II. 1233-53. At II. 1248, Troylus comes riding by while Pandarus and Criseyde look out of her window, but this would be more appropriate for 52ᵛ.

50 (52ᵛ) three middle out, after II. 1267, facing II. 1282-1302, Troylus riding by while Criseyde and Pandarus look out of her window.

51 (53ᵛ) three middle out, after II. 1316, facing II. 1331-51, Troylus reading Criseyde's letter.

52 (54ᵛ) three middle out, after II. 1365, facing II. 1380-1400. Possibly a symbolic figure like "Kynde" or "Daunger" (II. 1375); less probably oaks or millstones as figures of achievement (II. 1380).

53 (55ᵛ) three middle out, after II. 1414, facing II. 1429-49, Pandarus with Deiphebus.

54 (56ᵛ) three middle out, after II. 1463, facing II. 1478-98, Deiphebus comes to invite Criseyde to his house (II. 1487).

55 (57ᵛ) three middle out, after II. 1512, facing II. 1527-47, Troylus ill in Deiphebus's house.

56 (58ᵛ) three middle out, after II. 1561, facing II. 1576-96, gathering of the clan at Deiphebus's house.

57 (59ᵛ) three middle out, after II. 1610, facing II. 1625-45, Pandarus speaking his "process" (II. 1615).

58 (60ᵛ) three middle out, after II. 1659, facing II. 1674-94, Helen, Deiphebus, and Pandarus visit the "sick" Troylus.

59 (61ᵛ) three middle out, after II. 1708, facing II. 1723-43, Pandarus and Criseyde at the door of Troylus's chamber.

60 (64ᵛ) three middle out, after III. 91, facing III. 106-26, Pandarus and Criseyde beside Troylus's bed.

61 (65ᵛ) three middle out, after III. 140, facing III. 155-75, Criseyde bending down to kiss Troylus (III. 182, the last line on the facing page).

62 (66ᵛ) three middle out, after III. 189, Pandarus on his knees, thanking Venus for this progress in love; facing III. 204-24, Helen and Deiphebus returning up the stairs.

63 (67ᵛ) three middle out, after III. 238, Pandarus sitting on the side of Troylus's bed talking to him; facing III. 253-73.

64 (72ᵛ) four top out, before III. 561, facing III. 568-95, Criseyde and her attendants coming to Pandarus's house for dinner—Troylus's face looking out at a basement window (III. 396-602).

65 (73ᵛ) bottom three out, after III. 616, Pandarus entertaining Criseyde and her party at dinner; facing III. 631-51, the famous

conjunction of the moon, Jupiter, and Saturn in Cancer (III. 624-25).
66 (74v) three middle out, after III. 658, facing III. 673-93, the middle chamber arranged for sleeping (III. 666), or the private closet arranged as Criseyde's bedchamber (III. 682).
67 (76) blank recto, facing III. 701-35, Pandarus egging Troylus on in the basement.
68 (85v) two middle out, after III. 1372, Troylus and Criseyde in bed exchanging rings; facing III. 1394-1407, Troylus and Criseyde embracing in bed—not a likely picture.
69 (86v) three top out, before III. 1422, facing III. 1436-56. The aubade—a picture of dawn approaching and the lovers arising?
70 (92) two bottom out, after III. 1813, idealized picture of Troylus as a courtly knight; facing III. 1779-92.
71 (95) three middle out, after IV. 140. Calkas speaking before the Greek consistory; facing IV. 106-26.
72 (96v) two top out, before IV. 218, Troylus running mad in his chamber; facing IV. 239-52.
73 (98v) three top out, before IV. 344, Pandarus creeping into Troylus's darkened room (IV. 351-55; facing IV. 358-78).
74 (102v) three bottom out, after IV. 658, facing IV. 673-93, women visiting and comforting Criseyde (IV. 682-83).
75 (105) three top out, before IV. 806, facing IV. 771-91, Pandarus comes to the sorrowing Criseyde (IV. 771).
76 (107) two bottom out, after IV. 939, facing IV. 911-24, Criseyde prostrate and weeping (IV. 911).
77 (110) four bottom out, after IV. 1121, facing IV. 1093-1120, Troylus and Pandarus conversing (IV. 1086), or Troylus going secretly to Criseyde (IV. 1124).
78 (110v) blank verso, facing IV. 1128-62, evidently intended for an elaborate picture of the final meeting of Troylus and Criseyde.
79 (119) blank recto, facing IV. 1674-1701, for another idealized picture of Troylus (IV. 1674-87) or of the lovers' final parting (IV. 1688-89).
80 (122v) three bottom out, after V. 190, Criseyde arriving at the Greek camp, being received by Calkas; facing V. 211-31.
81 (126) last stanza out, after V. 434, facing V. 400-6, the lords entertaining themselves at Sarpedoun's palace.
82 (126v) four top out, before V. 435, facing V. 442-69. Feasting, music, ladies at Sarpedoun's palace.
83 (128) blank recto, facing V. 477-511, Troylus in dejection, leaving Sarpedoun's palace with Pandarus.
84 (128v) three top out, before V. 512, facing V. 526-46, Troylus looking at Criseyde's deserted house.
85 (131) two bottom out, after V. 686, facing V. 652-65, astrological

pictures of the sun and moon. This could also be Troylus walking on the walls of Troy (V. 666-86), but see 132v and 133.

86 (132v) three bottom out, after V. 770, facing V. 771-84.

87 (133) three top out, before V. 771. The most appropriate illustrations for these facing spaces would be to have Troylus looking from the walls of Troy towards the Greek camp (132v, from V. 666-86 on fol. 131), and Criseyde from the Greek camp towards Troy (V. 729-70, just before the illustration on 132v). Of course, V. 771 immediately following the illustration on 133 introduces Diomede; so we cannot be sure.

88 (138) blank recto, facing V. 1065-99, an elaborate final picture of Criseyde.

89 (138v) four top out, before V. 1100, facing V. 1107-34. Troylus and Pandarus on the gate, looking for the return of Criseyde.

90 (145v) two top out, before V. 1590, facing V. 1611-24.

91 (146) two bottom out, after V. 1631, facing V. 1597-1610. Again facing pictures, this time perhaps of Troylus (V. 1317-1421) and Criseyde (V. 1590-1631) writing their final letters to one another.

92 (146v) two top out, before V. 1632, facing V. 1653-66. Troylus reading Criseyde's letter (V. 1632), or Deiphebus holding up Diomede's captured armor (V. 1651).

93 (148v) three middle out, after V. 1764, facing V. 1779-99, Troylus and Diomede fighting (V. 1758-64).

These ninety-three spaces fall into well-defined positions. Nine are blank full pages, five recto and four verso.[6] Fifty-one are the space of the three middle stanzas on a page, with one stanza above and one below.[7] Ten are the space of four stanzas at the top of a page with one stanza below.[8] Five are the space of three stanzas at the top of a page with two stanzas below.[9] Five others are the space of two stanzas at the bottom of a page with three stanzas written above.[10] Four are the space of the bottom four stanzas with one above.[11] Four others are the space of the bottom three stanzas with two above.[12] Three are the space of two stanzas at the top with three written below.[13] One is the space of two stanzas in the middle, one above and two below (85v). And one the space of a stanza at the bottom of a page (126). In all, excluding the full pages, seventy-five spaces fall on versos and nine on rectos. As indicated by the completed frontispiece, the illustrations were in the main intended to appear on the verso and the body of the text on the recto. This pattern is reinforced by the fact that only twenty times does the best context for the

illustration appear in the verso text; in the majority of instances it would appear that the pictures would have illustrated the facing (recto) text.[14]

The pattern of leaving out the three middle stanzas on the verso page, which extends with only two breaks from fol. 17v-fol. 67v is so consistent that it appears mechanical. Hence, it is interesting to observe that of the ten spaces for which the context does not suggest illustrations, all but one are among these fifty pages of "mechanical" format.[15] All of these occur in the long dialogues between Troylus and Pandarus or Pandarus and Criseyde, when, after an initial picture showing the participants in conversation, it is hard to guess what would have been the subsequent pictures illustrating the same discussion. Other than these, there is little difficulty in finding appropriate illustrations for the spaces in contiguous text; so we should not fault the designer of the manuscript for his layout.

The blank full pages offer the opportunity for dramatic presentations—particularly the rectos: 3 another court scene like the frontispiece; 3v the Greek armada; 8v Troylus first perceiving Criseyde; 11v Troylus uttering the "Cantus Troili"; 76 Pandarus egging Troylus on in the cellar; 110v the final meeting of Troylus and Criseyde; 119 an idealized portrait of Troylus as the perfect knight and lover; 128 Troylus in dejection; 138 a final picture of Criseyde. Opportunities for special effects are offered by the facing spaces on 132v-133, which could have depicted Troylus looking from the walls of Troy towards the Greek camp, and Criseyde in the Greek camp looking towards Troy; and 145v-146 which could have contained companion pictures of Troylus and Criseyde writing their final letters to one another. Interestingly, the famous triptych of the three lovers in Book V. 799-840 was not selected for representation.

The nature and positions of the spaces support the evidence of the frontispiece, that the Corpus manuscript or its ancestor was laid out by a scribe and artist with insight into the text of *Troylus and Criseyde,* and with awareness of the dramatic possibilities of the illustrations. What a glorious picture book it would have made if it had been completed! [16]

NOTES

1. R. K. Root, *The Textual Tradition of Chaucer's Troilus* (London: Chaucer Society, 1916), judges the Corpus "the best basis for the constitution of a critical text" (p. 6), and —with emendation as detailed in his introduction (pp. lxxxi ff.)—it serves as the basis for his edition (Princeton University Press, 1926), and those of F. N. Robinson (Boston: Houghton-Mifflin, 1957), A. C. Baugh (New York: Appleton-Century, 1963), Daniel Cook (Anchor Books, 1966), and, less directly, others. My citations are to the Baugh edition.

2. Aage Brusendorff, *The Chaucer Tradition* (Oxford University Press, 1925), pp. 21-23, with a small black and white reproduction as a frontispiece; Margaret Galway, "The 'Troilus' Frontispiece," MLR, 44 (1949), 161-77, with a fine color reproduction. The color reproduction appearing as the frontispiece to Patricia M. Kean, *Chaucer and the Making of English Poetry,* vol. I (London: Routledge, 1972), is smaller and less vivid.

3. M. R. James, *A Descriptive Catalogue of the Manuscripts in the Library of Corpus Christi College* (Cambridge: Cambridge University Press, 1912), p. 127, lists 95 or 96 spaces, but I cannot discover where Root cites the number of spaces for illustrations.

4. Developing a suggestion by W. W. Skeat, *Oxford Chaucer* (Oxford University Press, 1900), vol. II, p. lxix, Brusendorff hypothesized that Corpus 61 was copied for the granddaughter of John of Gaunt from a copy of the *Troylus* originally executed for her grandfather, which contained all the illustrations.

5. The numbers in parentheses preceding each space are folio numbers. The MS is unnumbered, and, like others who have used it, I have counted the rectos only, beginning with the frontispiece as 1^v; hence, the text begins on 2 and ends on 151.

6. Full-page spaces: 3, 3^v, 8^v, 11^v, 76, 110^v, 119, 128, 138.

7. Three middle stanzas out: 9^v, 17^v, 18^v, 19^v, 20^v, 21^v, 22^v, 23^v, 24^v, 25^v, 28^v, 29^v, 30^v, 31^v, 32^v, 33^v, 34^v, 35^v, 36^v, 37^v, 38^v, 39^v, 40^v, 41^v, 42^v, 43^v, 44^v, 45^v, 46^v, 47^v, 48^v, 49^v, 50^v, 51^v, 52^v, 53^v, 54^v, 55^v, 56^v, 57^v, 58^v, 59^v, 60^v, 61^v, 64^v, 65^v, 66^v, 67^v, 74^v, 95, 148^v.

8. Top four stanzas out: 4^v, 5^v, 7^v, 12^v, 13^v, 14^v, 15^v, 72^v, 126^v, 138^v.

9. Top three stanzas out: 86^v, 98^v, 105, 128^v, 133.

10. Bottom two stanzas out: 2^v, 92, 107, 131, 146.

11. Bottom four stanzas out: 6v, 10v, 16v, 110.
12. Bottom three stanzas out: 73v, 102v, 122v, 132v.
13. Top two stanzas out: 96v, 145v, 146v.
14. Pictures suggested by the verso text (this list includes those for which both verso and recto suggest a subject): 12v, 19v, 20v, 28v, 30v, 40v, 45v, 50v, 51v, 55v, 59v, 66v, 67v, 73v, 85v, 86v, 96v, 98v, 122v, 148v.
15. Spaces for which the text does not suggest a subject: 14v, 18v, 22v, 31v, 32v, 33v, 34v, 35v, 41v, 46v.
16. I wish to thank Dr. Raymond I. Page, Librarian of Corpus, for his kindness in allowing me to examine the manuscript at length, and Miss Jane Rolfe, Assistant Librarian, for her keen suggestions about its format and production.

The *Dróttkvætt* Stanza

Roberta Frank
University of Toronto

Old Norse poetry is conventionally classified under two headings, "eddic" and "skaldic." The first type tends to be anonymous, composed in simple diction and meter on a legendary or mythical theme; the second usually but not always involves a named poet—the skald—composing for a named prince in a highly intricate, compressed style. The skalds' most important meter—the stanzaic form in which five-sixths of their verse was composed—was called *dróttkvætt*.

The following pages form a prelude to a much longer study on the art of *dróttkvætt* poetry. They are dedicated with gratitude and affection to Lillian Herlands Hornstein who, fifteen years ago, introduced me to the beauties of Norse verse.

Dróttkvætt, short for *dróttvæðr háttr*—the meter fit for the *drótt,* the king's band of retainers—is the crown of Old Norse poetic art. Many hundreds of these stanzas have been preserved, occupying more than 1,000 double-columned pages in the only modern edition which attempts to be complete. Joined together end to end, the verses would form a chain one mile long and six syllables wide. Like most literature, *dróttkvætt* arises from the attempt of the human race to overreach time by dint of creation: *le dur désir de durer;* it also reflects humanity's desire to overreach their fellows, to endure by grasping the moment. Hardly another corpus is so dedicated to bullying, boasting, overdoing, satirizing, and the other competitive games men play. The skald had no use for the failures of this world. There are just a few moments of that gentle melancholy and passive acceptance of change, that delight in solitude and meditation, that deep attachment to transient blossoms and blackbirds so characteristic of other medieval stanzaic forms from Japan to Ireland.

Although the *dróttkvætt* poets composed in a wide range of genres, encomium and satire were their central concern and constitute the bulk of the early poetry that has come down to us. Their social

function was traditional: Tacitus speaks of the panegyrics, dirges, and genealogical verse of the Germanic peoples; Ausonius refers to Rhenish lampoons and Priscus to victory odes by two barbarians at Attila's court; Sidonius knows of Frankish marriage songs, Venantius Fortunatus mentions Merovingian eulogies, and Procopius recites a Vandal king's elegy. But the mold into which the Norse skald poured his art is unparalleled.

The *dróttkvætt* stanza is in an almost fully developed state from the moment of its first appearance in mid-ninth-century Norway and changes only in inessential detail during the 400 years of its existence. Its origins are as obscure as its form is stable. According to twelfth- and thirteenth-century sources, *dróttkvætt* was the creation of one man, Bragi—the first skald; yet it is more likely that the meter evolved gradually, a native development in contact with the rest of Western Europe, where court poetry had waxed and waned with the fortunes of king and emperor for more than 1,500 years. Simonides, Epicharmos, Aischylos, Pindar, and Bacchylides were part of a brilliant circle of poets around Hieron I of Syracuse in the fifth century B.C.; Alcuin, Peter of Pisa, Paul the Deacon, Theodulf, Angilbert, and Riculf composed for Charlemagne at the turn of the ninth century. There was at least one goliard in the service of Barbarossa's imperial chancellor in the twelfth century, while love poets thrived at the court of Frederick II in thirteenth-century Sicily. Greek, Latin, and Romance court poetry presents a continuum: the Mediterranean was a tideless sea; when the first wave of court poetry swelled from the North it came with the surge of the Atlantic behind it.

The skald had one advantage over his southern counterpart: his tradition did not recognize the sacrilegious, deity-rivaling artist of classical and Hebraic lore. There is no torn Orpheus, no flayed Marsyas, not even a single Tower of Babel in the Norse myths surrounding the creative act. Bragi, the legendary first maker, was himself made a god, a dignity blind Homer never achieved. It was Óðinn, not Bragi, who gave an eye for a drink at the spring of wisdom, who endured spear wounds and nine nights of hunger for a sip of the mead of poetry. This one-eyed god shared his filched mead with fully sighted people, mead he had stolen from giants; its recipe, devised by dwarfs, called for a mixture of blood and honey, a warrior's taste alien to the spring of Hippocrene. The skald's presumption in creating something that would never die could not

anger the very gods who had instilled this gift in him. The pagan Germanic poet was neither a *musarum sacerdos* like Horace nor an inspired prophet: unlike the languages bordering the Mediterranean or the Irish Sea, Old Norse did not even possess a distinctive future tense. If *dróttkvætt* poetry claimed for itself vision and psychic force, it was because its first practitioners saw themselves as gods perched on the shoulders of giants.

Like all literary genres, *dróttkvætt* verse has its specific historical context. Its emergence coincides with the strengthening of royal power in late ninth-century Norway, a period which witnessed the foundation of a state, missionary activity, and the burgeoning of towns; in the fourteenth century, it fades into the popular ballads and rhymed romances of an urbane Europe. We know the names of over 200 *dróttkvætt* poets. At first they are Norwegians; but soon Icelanders appear to enjoy a virtual monopoly as the court poets of Norway, a situation reminiscent of the fourth and fifth centuries when the eccentric province of Egypt provided the courts of the Roman Empire with a stream of official poets. If hatred of monarchy was indeed the key political factor leading to the colonization of Iceland, how fitting that it was back to the Norwegian court that these independent people soon hastened in droves. At home, delusions of greatness and brittle dreams of omnipotence could always be shattered by the harsh winds of spring.

Though its beginnings may have been contemporaneous with the founding of permanent trading settlements in the North, *dróttkvætt* was not particularly a product of towns or town life. Twelfth- and thirteenth-century Iceland, whose sagas and treatises preserve the greater part of the skaldic corpus, did not even have a single village. People lived in isolated, scattered farmhouses, amidst long light and shadows, rocks, lichen, and great silences. Games like chess still thrive in this gaunt setting, where there are no rustling trees to disturb concentration and where obsessions can have the mute, erosive drive of lava. *Dróttkvætt* and the settlement of Iceland are contemporaries, both products of a culture which did not waste its syllables, where the shapes of stillness, of what is not uttered, had their own meanings. Wit and a ready tongue were prized when combined with lean, taut words. In 999, a new Christian convert, Hjalti Skeggjason, stood up at the Althing and spoke a *dróttkvætt* verse, short and to the point:

> I don't want to blaspheme the gods;
> Freyja still strikes me as a bitch.

The missionary effort in Iceland did not depend on ponderous theological tomes and learned disquisitions: the half-said thing alone worked wonders.

Dróttkvætt poets include kings, bishops, outlaws, seven women, and, the sagas claim, ghosts and Swedish berserks. They adopt whatever role the situation called for—genealogist, prime minister, historian, warrior, storyteller, journalist, satirist, prophet, diplomat, lover, or fool. The poet communicates delight in a good ship or a good kill, in a bowl of porridge or the sacking of a city, sorrow for a dead patron, for a cloak that is too short, for a girl given to another, for his own cold heels. Whatever was suppressed in the controlled, impersonal prose of the sagas—words of defiance, triumph, hope, obscenity, or despair—might surface in *dróttkvætt*. The poet's central task, however, was to catch and keep those fleeting moments of triumphant joy, of heightened consciousness, in which humanity seemed illumined by a divine force whose whole being was enveloped in a new confidence. Few subjects were thought unsuitable for such versemaking. In 1915 a Japanese biochemist was able to concentrate his elation over a scientific breakthrough in the seventeen-syllable *haiku:*

> Cancer has been artificially created!
> With pride I advance
> A few steps.

In the eleventh century a Norse salter could show similar pride in his work by composing a twenty-four-syllable *dróttkvætt* quatrain:

> I burned seaweed on the beach.
> I flung kelp to the red flame.
> Strong, thick smoke began to reek.
> That was a short time ago.

Poetic unexpectedness was an artistic principle. A twelfth-century Orkney earl could describe his Provençal mistress' hair in a verse which ends on a distinctly nontroubadour note:

Your hair, woman, is more beautiful
 than that of most blondes.
The woman lets her hair, gold as silk,
 fall upon her shoulders.
I reddened the feet of the greedy eagle!

Perspective is all-important here: just as in Brueghel's *Icarus* the insignificance of human suffering was conveyed by painting from an immense distance a boy falling unnoted, unmourned, out of the sky, so the *dróttkvætt* poet flatters his lady by visualizing her smallest gesture—the tossing of golden hair—at such close range that an act of momentous consequence—his own victory over the infidel—is put, incongruously, into the shade. Yet the causal connection between the two events, the poet's association of Venus and Mars, comes through: men in love fight like tigers. To be sure, *dróttkvætt* could register those moments moderns immortalize in a photograph: a baby's baptism, the sight of Constantinople from the sea, a wedding reception, Uncle Kormakr eating boiled sausage; but such verses have an air of being very meticulously developed and framed, the product of months in the darkroom. This is occasional poetry in a sophisticated tradition, elegant, precise, arrogant. It is backward-looking, aristocratic, and conservative.

The Norse skalds were essentially recorders of events, people whose profession it was to fix or stabilize memory in a brief statement that would outlast time. When eyewitnesses to the capture and burning of an Arab warship in 1152 differed in their accounts of what had happened, the man of highest rank among them presented his version in *dróttkvætt*; all present agreed that this description alone would stand for posterity. Around 1180, Theodricus wrote a Latin history of Norway in which he makes reference to Ovid, Pliny, Sallust, and Lucan, but declared that his main source of information was the oral poetry of Icelanders. By 1200, Saxo Grammaticus had acknowledged their authority in Denmark as well. The skald shaped history.

The poetics of *dróttkvætt* verse is a poetics of memory, the art of concentrating in a particular way. The skaldic stanza used repeated patterns of sound and of images to impress discrete scenes from the past on the mind—a kind of mnemotechnics. Only what you had in your head was safe, indestructible. Mnemosyne, goddess of memory, was mother to the muses, and it was to her Norse counterpart

Mímir, guardian of wisdom, that Óðinn, father of poetry, repaired in need. Cicero tells the vivid story of how Simonides invented the art of memory at a fatal banquet given by his patron. The early skalds, whose longer compositions often took the form of descriptions of their patrons' halls, shields, or pictorial panels, were unconsciously exploiting this Greek court poet's doctrine of places, a technique of artificial memory which associated successive stages in a speaker's narrative with specific corners of a building, room, or work of art simultaneously visualized by him. This emphasis on retention must have had its negative side, leading to a kind of brainstorming or deadening of the critical faculty: Xenophon tells of the man who boasted to another of having—like the rhapsodes—memorized all the *Iliad* and *Odyssey*. "Well," replied his friend, "do you know any tribe of men more stupid than the rhapsodes?" Yet intellectual logic also has its limitations. The skald's dependence on memory made more precious to him the gifts of language and tradition, the whole mysterious world of verbal magic: when his analytic mind was silenced and numbed, the poem itself could speak.

The mode of existence of the Old Norse poet is scantily documented. There is no mention of bardic schools in our sources, no evidence that he received specialized training in his craft; we have no way of knowing whether his profession was hereditary, whether he was entitled to wear distinctive garb or colors, or whether his manner of composing was rigidly prescribed. A stanza by a tenth-century skald, son of a Scottish princess, reveals that he readied Óðinn's drink—the mead of poetry—while others slept. This statement and a handful of later saga references to nocturnal composition are reminiscent of the richly documented Irish practice of sequestering poets in darkened bedrooms where they were to compose without distraction. Indeed, the associative rhythm of *dróttkvætt*—the hypnotic sound and memory links—seems to retain a connection with dream, to work below the level of consciousness. Yet the Norse evidence remains ambiguous, proof of nothing more than the occasional oral poet's ability to stay up late without burning midnight oil.

It is probably safest to treat the Norse skald as something *sui generis,* the product of a culture alien in some respects to all others. The unionized *filid* and bards of medieval Ireland and Wales, whose duties, privileges, and pay scales were defined by law, seem in

their rigid self-regulation an altogether different breed from the shadowy Germanic poet. One early Irish legal text envisions a poet composing extemporaneously, prophetically, and with the "tips of his bones." But when an Icelander is described as having *bragar fingr* "fingers of poetry," it is his artistic dexterity and not his magical powers of divination that is being cited; and when a saga portrays a skald as "playing with his fingers and speaking nearly every word in verse," the remark seems to mean no more than that the fellow was cheerfully twiddling his thumbs. Yet it is also clear that the early skald, like that other Odinic initiate, the berserk, was regarded as a dangerous, uncontrollable being, a prober of unknown powers, a manipulator of the deep structure of language, a specialist in loving and hating. He was a man who focused vast, little-understood mental gifts and energies on endeavors which, however ultimately trivial they appear to us, were known to exercise an assailing mastery over the imagination and over fate itself.

The performance and reception of *dróttkvætt* poetry are also hidden from us. Old Norse distinguishes clearly between composing *(yrkja)* and reciting *(kveða, flytja, færa fram)*. *Dróttkvætt* was probably composed orally and memorized for delivery; yet when a stanza is inserted into a saga it is almost invariably quoted as direct speech, as a poet's spontaneous reaction to an event, a spur-of-the-moment improvisation. *Dróttkvætt* is that odd creature: orally composed poetry dependent on the concept of a fixed text. It is highly patterned poetry, yet not formulaic in the manner of archaic Chinese song, Homeric epic, or Old English verse. Hardly one stanza shares six consecutive syllables with another; indeed, poets enjoy playing upon their hearers' expectation of a formula such as "hawk on hand" only to mislead and disappoint them. What borrowings there are within a *dróttkvætt* stanza are learned and artful, like those of contemporary poetry where quotations and allusions to earlier writers are used—as in Eliot's *The Waste Land*—as a kind of pun, the original context of a quotation serving as its own second meaning. The skalds may have intoned or chanted their verses, but there is no evidence for the presence of harp or lyre or any other musical accompaniment. Verse rhythms seem to have been of primary importance to the *dróttkvætt* poets, who probably resented—just as some modern poets have—the domination of music over words.

Much passion and ferocity has been expended in this century in a debate over the intelligibility of *dróttkvætt* verse to its original

hearers. There is no doubt that the poetry revels in obscurity; in all court poetry there is a certain impulse to difficulty, a desire to outdo all competitors in wit and craftsmanship. Yet it would be surprising if a verse form which retained its supreme popularity in the North for more than four centuries was not intended to communicate something to its public. Even if a verse were at first incomprehensible, the sagas indicate that it could be memorized by its hearers and mulled over at leisure: Þordís in *Gísla saga* managed to solve a murder by slowly puzzling out the meaning of her brother's riddling stanza. Some *dróttkvætt* stanzas might be deliberately cryptic: the syntactic ambiguity in one allows a commemorated loyal retainer to share in his lord's glory; that in another seems designed to protect its author from prosecution in a paternity suit.

That riddling allusiveness and knottiness were prized and consciously sought after by skalds is evident in a story Snorri tells of Haraldr harðráði. The king is portrayed composing a stanza in simple, straightforward eddic meter. The verse displeased him so he at once made another and "better one" on the same subject, but this time in elaborate skaldic style, hiding his meaning in ambiguous kennings and convoluted syntax. By anecdotes of this kind, thirteenth-century literary criticism in Iceland touted the superiority of what was difficult, their own *trobar clus,* the *dróttkvætt* metre in which five-sixths of all extant skaldic poetry is composed.

It is in many ways a philosophic style: *dróttkvætt* incorporates a view of reality in which people can never fully understand what they have literally observed or heard. Skaldic verse is the art of a profound skeptic. Prose and looser verse forms can pretend that things are as they seem; in *dróttkvætt*, where meter and patterning form the overriding truth, we perceive only as we can. *Dróttkvætt* confirms Wittgenstein's apprehension that speech is a kind of infinite Chinese box, with words only spoken of in other words. The shape of reality in such verse is mathematical: all things are number. To compose poetry in this rigid, demanding style is to wipe out an infinite number of poetic possibilities, but there is at the same time a compensatory gain—the divining of a multitude of new and quite unexpected thoughts, the conjuring up of the unprecedented and the inexpressible. The poet says things that he did not know he was capable of saying.

Where literacy is severely restricted, the very act of committing oral poetry to writing is in some ways equivalent to putting it into

code, making it more esoteric and unbreakable. The only *dróttkvætt* stanza from the pagan period still surviving in a contemporary inscription was carved in runes around 1000 on the Karlevi stone in Öland; it serves as a memorial to a dead Danish chieftain. Two difficult skaldic lines in runes also appear on a copper box from Sigtuna, Sweden, dated to the early eleventh century. *Dróttkvætt* stanzas from the thirteenth and fourteenth centuries inscribed on rune sticks have recently been unearthed in Bergen, sole evidence for the late survival of a Norwegian skaldic tradition.

The idea of committing *dróttkvætt* to vellum seems to have caught on slowly. When, in apparent imitation of the practice of Latin grammarians, the author of the *First Grammatical Treatise* (an orthographic proposal probably dating from the late twelfth century) invoked the authority of earlier poets, he found it necessary to justify his procedure by declaring that "the skalds are authorities in all matters touching the art of writing or the distinctions made in discourse." Such a general apologia would probably not have been necessary had he been following a traditional model of native poetics—one that took its association with orthography for granted. The First Grammarian cites within his *Treatise* lines from two secular *dróttkvætt* stanzas of the eleventh century. But the first extensive *dróttkvætt* compositions to be recorded in the Latin alphabet seem to have been the long Christian poems of the twelfth century: *Geisli* 'Sunbeam,' an encomium on Saint Óláfr presented at Níðaróss Cathedral in 1153; *Harmsól* 'Sun of Sorrow,' the first Norse poem to tell of the Crucifixion, Ascension, and Judgment Day; and *Plácítús-drápa,* the edifying story of Saint Eustache, extant in a manuscript from around 1200. A comparable pattern is observable today among certain African tribal groups moving gradually from an oral into a literary culture: vernacular poets first slip into print by composing didactic Christian verse; only afterward is the native tradition exploited.

Most of the skaldic poetry that has come down to us occurs in Icelandic vellums of the thirteenth, fourteenth, and fifteenth centuries, when *dróttkvætt* was fast going out of fashion. Some verses are only extant in seventeenth-century paper copies. In these manuscripts, *dróttkvætt* stanzas are written out as prose in traditional scribal shorthand; often a *.v.* or *.u.* in the margin announces the presence of verse. Sometimes the scribe picked out the initial letters of stanzas in sequence, using red ink or decorative capitals. The

same person did not always handle verse and prose: in the important saga-codex *Moðruvallabók,* the first scribe left blank spaces for the poetry, which was written in by a second copyist in a distinctive coal black ink. There are occasional marginal notes and addenda. One fifteenth-century Icelander corrected the verses in his text of *Egils saga* with the assistance of at least one other manuscript. But textual uncertainties abound. Once an error crept into the chain of transmission, the whole interpretation of a stanza could become problematic. Confusion would be multiplied in subsequent copies—by scribes who no longer understood what they were copying or who tried to improve an obviously corrupt text. Housman's editorial proposition that a false emendation is far worse than murder had no parallel in early Icelandic law; indeed, the whole concept of a fixed text was fragile in a culture which prided itself on poetic learning and ingenuity. Stanzas and parts of stanzas might become detached in oral circulation and later recombined in exotic sequences; a single stanza attributed to two different poets and cited in two different sagas could end up with completely divergent verses and rhyme schemes.

In dating *dróttkvætt* verse, one can point to features which are clearly late, but there are no early features which could not have been imitated sporadically in later centuries. Moreover, some apparently late features, such as the suffixed definite article, are often only the result of scribal modernization. Trustworthy criteria on which to estimate the age of a verse are few and far between. It is generally believed, for example, that the rhyming pair o/a disappeared before the end of the twelfth century: The last datable example of such a rhyme is from the middle of, or the third quarter of, the twelfth century, while the earliest datable poem of some length having no examples of o rhyming with a is Snorri's *Háttatal* (1222-23). The presence of o/a as a full rhyme in a stanza does not prove that the verse is early and not an archaizing imitation, but the employment of the pair without full rhyme may—if we could only be sure that the stanza in question was perfectly regular—point to a date of composition after c. 1150. As a rule, the conservatism of the skaldic tradition, which preserved ancient forms long vanished from the language of prose, makes it impossible to distinguish confidently between older and younger verses.

A more positive dating can sometimes be obtained by studying a

poet's use of words, alone or in the figurative expressions characteristic of *dróttkvætt* style. The eleventh-century poet Sneglu-Halli's employment of the words *brauð, sufl,* and *belti* is paralleled only in poetry and prose composed after the middle of the twelfth century. The same prematurity is observable in a stanza in which the tenth-century skald Egill calls summer "mercy of the snake," a type of circumlocution not met with again until the mid-twelfth century. Poets are always borrowing from their predecessors, but two and a half centuries does seem a long time to wait before doing so. Egill's stanza records a Viking attack upon Lund around 930, mentioning this settlement in Skåne for the first time in literature. Yet the poet's raid and his parodic use of religious terminology *(miskunn* 'mercy,' *drýgja* 'to commit,' *seiðr* 'incantation') would have more point and literary merit respectively if Lund were already the wealthy and thriving ecclesiastical center it became only at the end of the eleventh century. Uncertainty will always remain, but it is not impossible that both stanzas—and a number of other verses in the sagas associated with well-known tenth- and eleventh-century skalds —were actually composed in the twelfth century, a period of great literary activity, when *dróttkvætt* verses were needed to embellish and authenticate tales told about Icelanders of an earlier time.

We possess a number of treatises from the high medieval period on skaldic poetics. Chief among these are Rognvaldr kali's *Háttalykill,* a twelfth-century *clavis metrica* from the Orkneys; Snorri Sturluson's *Edda,* composed in Iceland around 1220, an encyclopedia of Norse pagan mythology, poetic diction, and metrical experimentation (illustrating forty-eight different varieties of *dróttkvætt*); and *The Third Grammatical Treatise* by Snorri's nephew Óláfr Þórðarson hvítaskald, a handbook of rhetoric which applies the rules of Latin *artes poeticae* to Icelandic verse. These authors—all *dróttkvætt* poets themselves—can be misleading or downright wrong, but modern skaldic scholarship would be severely hampered without them. One of the aspirations all three men shared to varying degrees was that of bringing Norse poetry into the European orbit, to show the world, as Óláfr put it, that "the art of speech which Rome learnt in Greece . . . is the same as the meter and poetry which Óðinn and other of Asia brought northwards. . . ." No more *ab aquiline omne malum;* all Western Europe, having fought on the right side at Troy, was in one and the same immense meadhall. In the course of effecting this family

reunion, Snorri in particular says a great deal that is of value to the literary critic and preserves most of the genuinely early poetry that we have.

The authors of these medieval handbooks clearly thought that skaldic verse had a future. Perhaps Auden thought so too when he slipped an English *dróttkvætt* imitation into *The Age of Anxiety*. For the historian—whether of northwest Europe, Russia, Byzantium, or Provence—the *dróttkvætt* stanzas of medieval Scandinavia are invaluable primary sources. For the student of religion, the verses transmit a more authentic pagan tradition than anything in the rest of Germanic literature. And in their craftsmanship and humanity, their striving for a gemlike brilliance and a rugged perfection, the stanzas speak to all of us. When with some luck and hard work we begin to sense the jagged conglomerate of the sensual and spiritual that is *dróttkvætt*, the sudden glory of fused metaphor, of rounded perception, we have learnt something about the mind's apprehension of reality, the Norse poet's vision of the world.

Meter

It was Robert Louis Stevenson who said that some metrical forms provide suitable occupation for a person serving a jail term. *Dróttkvætt* demands of its practitioners the same sangfroid and acoustic sensitivity found in accomplished safecrackers, the same delight in contortion sometimes seen in cat-burglars. The poets were the Charles Atlas muscle men of language. In Old Norse, the knack of making such verse counted as an *íþrótt*, a feat of dexterity like tightrope walking or standing on one's head. Welsh bards called themselves the "carpenters of song," and claimed as their own all the tools of the worker in wood. Norse poets compared skaldic composition to shipbuilding: The complicated system of sound correspondences was like the skillful joining by nail, tongue, and groove of the ship's boards; one faulty joint, one loose tongue, and the poem sank along with your reputation for versemaking prowess. There are few meters more intricate, subtle, or more like a straitjacket than *dróttkvætt*.

Around 1020, Sighvatr Þórðarson, an Icelandic poet at the court of King Óláfr Haraldsson of Norway, found himself on a hard and uncomfortable embassy to Västergotland. He composed a series of anecdotal verses on the leaky ferryboats and unfriendly natives he encountered, and on his own blisters and sores. It is a versified

travelogue, the *descriptio itineris,* a type of poetic narration familiar from classical and medieval Latin poetry. One stanza reveals that the conjunction of horse and poet was not always auspicious:

> Jór renn aptanskœru
> allsvangr gotur langar;
> voll kná hófr til hallar
> —hǫfum lítinn dag—slíta.
> Nú's þat's blakkr of bekki
> berr mik Donum ferri;
> fákr laust drengs í díki
> —dœgr mœtask nú—fœti.

A literal translation:

> The steed runs in the evening twilight
> famished over long paths;
> the hoof the ground to the hall
> —we have little daylight—beats.
> Now the burnished horse over streams
> bears me far from Danes;
> the gentleman's nag caught in a ditch
> —day and night now meet—its leg.

This is the normal eight-line *dróttkvætt* stanza; a syntactic break after the fourth line divides the whole into two symmetrical halves. The basic metrical unit is the three-stress, six-syllable line, with a prescribed ending in a long stressed syllable followed by a short unstressed one. In Germanic verse, metrically long syllables were those in which a short vowel was followed by two or more consonants *(voll, blakkr)* and those in which a long vowel—those marked here with an acute accent and the digraphs *æ* and *œ*—or diphthong *(au, ei, ey)* was followed by at least one consonant *(jór, fœt-)*.

Since such syllabic poetry is not otherwise found in early Germanic, metrical models have been sought elsewhere, particularly in medieval Irish, Welsh, and Latin verse. Yet the Norse development could have occurred without borrowing, as an elaboration and tightening of the earlier, freer meters of early Germanic (including eddic) verse. Various metrical liberties were taken in *dróttkvætt* to adjust the number of syllables and disposition of stress. In the practice known as resolution, two short syllables could stand for a

long one; thus *hofum* in line four of Sighvatr's stanza may count as a single syllable. The omission of an initial letter from a monosyllable in order to shorten the verse was frequent: in line 5 the verbal form *es* and the relative particle *es* are both reduced to *'s*. Stress normally fell on a metrically long syllable, but shifts of weight were possible: a long noun or adjective stem could be subordinated and a short stem stressed. In the sixth line of Sighvatr's stanza, the short stem *Don-* is accented; and, in the second line, *'svangr,* although a long stem, gets only secondary stress while *got-*, a short syllable, carries full accent. Normal practice seems to be that when three full stresses and one secondary occur in a single line, one of the accents must fall on a metrically short stem; furthermore, a noun-stem in fourth syl-lable—such as *dag* in line four—must be metrically short. A poet was free to use inverted or unnatural word order to carry out the various parts of the metrical scheme: a noun *(fákr)* and its genitive modifier *(drengs)* are separated in line seven, resulting in comic emphasis. A diagram of the metrical scheme in Sighvatr's first quatrain, showing stressed (´) and unaccented (x) syllables, and those bearing second-ary stress (`), looks something like this:

$$´ \; x \; ´ \; x \; ´ \; x$$
$$´ \; ` \; ´ \; x \; ´ \; x$$
$$´ \; x \; ´ \; x \; ´ \; x$$
$$´ \; ´ \; x \; ` \; x$$

In the second half of the stanza, the same pattern is repeated with a single deviation in the second syllable of the second line *(mik* is metrically short and unstressed). Such rhythm is a sculpture carved into time, possessing a meaning of its own.

Alliteration

Lines in *dróttkvætt* verse are linked in pairs by means of alliteration or initial correspondence. Each consonant alliterates with itself, while the cluster *sp* alliterates with *sp, st* with *st,* and *sk* with *sk;* all vowel sounds alliterate with each other and with words beginning with *j*. There are two alliterating syllables in the odd and one in the even line, the pattern Óðinn on the gallows knew when he declared with reference to his acquisition of poetry—*orð mér af orði / orðz leitaði*—"one word from another sought a third word for me." Alli-teration may fall on any stressed stem in the odd line, but in the even

line only the first syllable (which is always stressed) can alliterate in classical *dróttkvætt*. In the opening couplet of Sighvatr's stanza, *jór*, *aft-*, and *all-* are the alliterative syllables; in the second, *hófr, hall-, hofum;* in the third, *blakkr, bekk-, berr;* in the fourth, *drengs, dík-, dœgr.*

Internal Rhyme

There is also a system of end correspondences or internal rhyme. In each line, the next to last syllable—always stressed—chimes with a stressed or semistressed stem in the same line. In even lines, there is *aðalhending* or full rhyme: *svangr/lang-, lít-/slít-, berr/ferr-, mœt-/fœt-;* in odd lines, *skothending* or half rhyme (different vowels followed by an identical consonant): *jór/skœr-, blakkr/bekk-, fákr/dík-.* Only the first consonant after the vowel counts; *skalk/mildra* would be as valid a half rhyme as *blakkr/bekki.* In many cases, the same syllable both alliterates and rhymes: *jór, blakkr, bekk-, berr, hall-, dík-.*

The regular use and placement of full and half rhymes here described was introduced only towards the end of the tenth century. Earlier *dróttkvætt* poets treated rhyme more as an embellishment than as a metrical necessity. In certain verses of Egill and Kormakr, rhyme appears to be mandatory only in the last line of the half-stanza, where it serves to tighten and secure the end of the quatrain. The rhyme in such keystone positions frequently has a slight element of surprise, as is still the case in Sighvatr's stanza with *slíta* and *fœti;* words similar in sound *(lítinn/slíta, mœtask/fœti)* seem to be drawn together in meaning (we have little daylight—to wear out; days will now join—by foot), yet end up belonging to different statements (the hoof wears out the ground; the nag stumbles with its foot). Such patterning creates a continual and pleasurable hesitation in each line between sound and sense, a sensitivity to the tricks that language can play on its users. Before the end of the twelfth century, the anonymous author of *The First Grammatical Treatise* had developed the notion of minimal oppositional pairs or phonemes in order to analyze the underlying system of the language; the discovery of a concept so fundamental to modern structural linguistics seems to have arisen naturally in a cultural milieu trained to distinguish the alternating *skothendings* and *aðalhendings* of the skalds.

Skaldic art tends not to repeat formal patterns such as alliteration, rhyme, or stress schemes in successive stanzas of a longer poem. Sighvatr's stanza forms part of a sequence called the *Austrfararvísur* or "East-Journey Verses," a group of some twenty stanzas whose

original order and number is uncertain. *Vísur* is one term for a gathering of verses on a single theme; another name is *flokkr*, a "flock" of stanzas. The most esteemed *dróttkvætt* composition was the *drápa (drepa* or "to strike, to inlay"), a series of at least twenty stanzas broken by one or more refrains at regular intervals. Besides these longer forms, numerous single stanzas have come down to us; these are called *lausavísur* or "loose-verses," with reference to their unattached state. Some *lausavísur* were surely composed as independent units; others are the detritus, the scattered fragments of lost poems, set adrift by the vagaries of literary taste and manuscript transmission in a kind of skaldic diaspora.

Looseness is not otherwise a characteristic of *dróttkvætt* poetry: of the forty-eight syllables in a stanza, normally twenty-four were metrically long and stressed, twelve bore alliteration, eight had to form half rhyme and eight, full rhyme; there was no choice in the placement of eight rhyming and four alliterating syllables. Each significant word in the eight lines is linked in one or more ways to others in the same or adjoining lines. When a *dróttkvætt* verse is bad, the sheer metrical accomplishment of it all still evokes a kind of admiration, like an elegantly designed whalebone corset in a lingerie display which stands firmly and shapely although nobody is in it. But when a good poet comes along and merges meaning and meter in one gleaming amalgam, imaginatively, wittily, the whole point of the exercise becomes clear.

The appeal of *dróttkvætt* was primarily to the ear; each stanza was an aural design. The poet's delivery—his speech rhythms, his facial expressions, and his gestures—was part of his art and is now irrecoverable; yet, the outline of his metrical structure is still audible. In Sighvatr's stanza, for example, the first three lines of each quatrain have a trochaic rhythm. The narrator seems to be posting along at a tired but regular trot. Subject and verb are established in the first few syllables of each line; the remainder is taken up by an adverbial clause which checks the flow of the line after the second or third syllable: a kind of syntactic falling rhythm which reinforces the metrical. The sound/sense nexus seems to create a similar rising-falling balance between quatrains. In the first set of three lines, the alliterating and rhyming staves are predominantly relaxed low vowels, semivowels, and liquids, suited to the calm, romanticized landscape; in the second set, high vowels, plosives, and stops prevail. It is as if the speaker tensed his lips and clenched his teeth as

darkness deepened and his weariness and apprehension increased. Sighvatr seems to deploy his vowel sounds in the final lines of each half-stanza so as to parallel the progressive dimming of day, the sun sinking in the sky from high to low: "hofum lítinn dag—slíta" is a more gleaming, radiant twilight than the final "dœgr mœtask nú—fœti." We find the same six syllables and the same trick of darkening sound in Nashe's "brightness falls from the air."

The third line of each quatrain consists of five words (all mono-syllables with the sixth syllable an inflection) in a regular falling rhythm. This trochaic beat is broken in the fourth line. The sentence hangs suspended while the poet goes on to note the lateness of the hour—a three-word parenthesis packed with heavily weighted, slow syllables. Then each quatrain jolts to a close on a single word which completes the earlier sentence and shows the speaker's horse to be one of those things that go bump in the night. Attention is focused on *slíta* and *fœti* by their isolation—as when a modern satirist impales a name at the end of a couplet. There is wit in Sighvatr's metrical imitation of the beating he is taking from his stumbling mount; the line fairly hiccups as the horse trips. The technique resembles that of the Irish meter *deibide baise fri tóin*—"slap-on-the-buttocks" *deibide*—in which the third line of the quatrain is completed by a lone rhyming word—the slap or blow—in the fourth.

The *dróttkvætt* stanza tends to be structured on a binary principle: an act or process in the first quatrain is met by a counterbalancing or antithetical movement in the second. Sighvatr's verse is remarkable in the near-perfect metrical balance of the two halves. The unusual sound-correspondences which link the last line of the second quat-rain (*dœgr, fœti*) with the last line of the first (*dag, slíta*) affirm the coherence of the two parts at the very moment that the two halves of day meet, the lingering twilight of the northern summer melting imperceptibly into morning dawn. The very structure of Sighvatr's poem seems to reflect the intuition of his senses that all things are inextricably woven into a whole: a solitary ride through gathering darkness, a final shudder at day's ending—that flaw in the nature of existence, the promise of a new sunrise; his forty-eight syllables enclose a vision into the nature of the world.

The two halves of twilight ("light-between," "half-light") touch and part again in Ben Jonson's picture of the Greek twins Castor and Pollux, paired stars in Gemini, cut off from each other in death:

To separate these twi-
Lights, the Dioscuri

The statement of separation is itself quite literally cut in two, typography and meter mirroring the sense. Such formal sophistication is expected from the seventeenth century; the comparable structural subtlety of *dróttkvætt* teaches us that an oral literature need not necessarily be a simple one.

Irish Medieval Sculpture: The Art of the High Cross

David H. Greene
New York University

A great flood in this year [918], *so that the water reached the Abbot's Fort of Cluain-mic-Nois, and to the causeway of the Monument of the Three Crosses.*[1] Annals of the Four Masters.

The Termon[2] *of Ciarain was burned this year* [957] *from the High Cross to the Sinainn* [Shannon], *both corn and mills. Annals of the Four Masters.*

[1024] *The pavement from the place in Clonvicnois called the Abbess her Garden to the heap of stones of the three crosses was made by Breassall Conealagh. Annals of Clonmacnois.*

[1058] *The Eile and the Ui Focartai plundered Clonmacnois and took a great prey from Cros na Screptra* [Cross of the Scripture] *and killed two people there, a scholar and another youth. Chronicon Scotorum.*

I

The Irish annalists are seldom vague about facts or dates, but on the subject of what Arthur Kingsley Porter called those "mysterious and enigmatic" stone monuments known as High Crosses[3] they give only tantalizingly vague information. The entries cited above, all referring to one of the most celebrated of Irish monasteries, are typical. The crosses were evidently so inherently fundamental a feature of the monastic landscape that their existence was taken for granted, and they were referred to only when they "made the news" by marking the spot where some act of violence or important event took place. Fortunately enough crosses have survived intact—including the Cross of the Scripture which witnessed the killing of two people in 1058—for us to know exactly what they looked like.

Irish High Crosses are free-standing stone monuments, between eight and twenty-three feet high, to judge by surviving examples, and they rise from bases which are generally four-sided and in two or

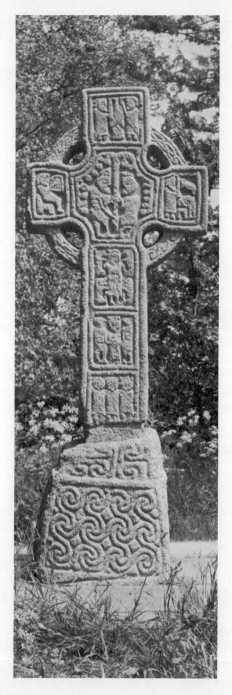

Fig. 1. Castledermot Cross, west side.

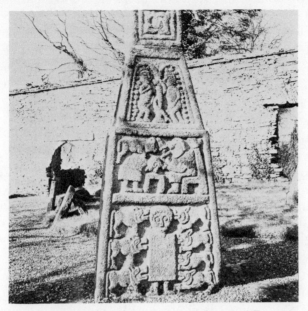

Fig. 2. Moone Cross, east side, three panels (Adam and Eve, Abraham and Isaac, and Daniel in the Lions' Den).

Fig. 3. Moone Cross, west side, panel (The Twelve Apostles).

143

three steps. Some crosses are bare of all decoration and must have been used solely for devotional purposes. Others, however, were covered with carvings, generally separated into panels, and were obviously something more than devotional objects. In Ireland and in Celtic Britain their characteristic form is with a ring encircling the head, but there were some variations and a number of them had no ring.[4]

Of the carved crosses which remain, thirty-four are intact, or substantially so in the sense that only a capstone is missing. In addition there are more than twenty surviving crosses from which a more substantial part than a capstone is missing. All of these crosses and fragments of crosses represent only a small part of the number which must have existed at one time. One realizes this when one looks at the Ordnance Survey map of monastic Ireland and sees how many monastic establishments there were, including some of the most important ones, from which no crosses—and in some instances nothing else—have survived. Except for some of the damaged or fragmented crosses which have been placed in the National Museum in Dublin or moved indoors locally for safekeeping, most of the crosses which remain still stand on their original sites, very probably in their original positions. With the tall, graceful Round Towers, the beehive-shaped stone huts, and the little steeply pitched, stone-roofed oratories, which are comtemporaries of the crosses, they convey to the modern observor a vivid, though fragmentary, vision of an early Irish monastic settlement. The illuminated codices and the "shrines" in which they were kept, the bejewelled chalices like the Ardagh Chalice, crucifixes like the Cross of Cong, objects like the Tara Brooch, preserved in museums, help to fill in the picture of a society and a period which continue to interest us because of the Irish contribution to European Christianity and Christian art.

II

The study of Irish High Crosses began with the work of George Petrie, who studied, sketched, and transcribed in the field Irish inscriptions on the crosses and on grave slabs which lay in greater abundance on the ancient monastic sites than they do today. He was the foremost Irish antiquarian of his time, and his interests embraced not only monumental remains of the past like the Round Towers, whose function he explained, but also traditional Irish music, which he collected and wrote about. His *The Ecclesiastical*

Architecture of Ireland was published in 1845. His *Christian Inscriptions in the Irish Language,* edited by Margaret Stokes, a student of the art of early Christian Ireland, was published in two volumes in 1872 and 1878. After Petrie, Henry O'Neill, who was born in Dundalk, County Louth, in 1800 and died in 1880, "in straitened circumstances," as the entry in the DNB indicates, published in 1857 an imperial folio containing thirty-six fine-tinted lithographs, with descriptive essay, of the most notable of the High Crosses.[5] O'Neill's lithographs were striking but also remarkably accurate in view of the difficulties under which he must have worked in the field. He illustrated eighteen different crosses in full view, and in separate lithographs he demonstrated specific details of the ornamention.

In 1887 R. Romilly Allen's *Early Christian Symbolism in Great Britain and Ireland* dealt with seventeen Irish sites and with many of the more notable Irish High Crosses. The modern student, with his Leica mounted on a tripod before a High Cross from which the lichen has been scientifically removed by the Irish government, under whose protection the monuments stand, cannot resist speculating about Petrie, O'Neill, and Allen working in the field before the days of the automobile, the camera, and chemical weedkiller.

In 1907 came Henry Crawford's "A Descriptive List of the Early Irish Crosses," [6] and in 1926 his *Handbook of Carved Ornament from Irish Monuments of the Christian Period,* a definitive study of the ornamentation on more than thirty crosses and cross slabs. Crawford was the first to make full use of the camera; and his method of demonstrating the intricate spiral, star, interlaced and fret patterns, the geometrical and zoomorphic designs, as well as the figure carving was to illustrate his commentary by juxtaposing photographic prints of individual panels and details alongside touched-up prints of the same photographs. Smaller details which could not be handled in this manner he illustrated by drawings. R. A. S. Macalister, Professor of Archaeology at University College, Dublin, who wrote more, and more interestingly, about his field than any of his contemporaries, published his *Corpus Inscriptionum Insularum Celticarum* in two volumes in 1945 and 1949. His interest was not limited to inscriptions or to the Christian period, but what distinguishes his work on crosses and cross slabs was his ability to piece together the fragmentary parts of an inscription and make sense of it. It must be acknowledged, however, that he sometimes saw inscriptions in places where nobody else to this day has been able to detect their

presence and where they probably did not exist. Macalister's identification of a unique inscription in Greek on a cross slab at Fahan,
County Donegal, which had been studied by many people before
him, including Crawford, however, was a stunning achievement.[7] In
his *Monasterboice, Co. Louth* (Dundalk, 1946), he presented a detail-
by-detail description and analysis of the crosses on that site, using
photographs taken not of the crosses themselves but of the full-sized
casts of the crosses made between 1900 and 1903 and still on display
in the National Museum in Dublin. Macalister resorted to this
unusual procedure, he explained, because the lichenous growth had
been cleaned off the crosses just before the casts were made but had
presumably grown back on the crosses again when he was writing his
book.[8]

In 1931 Arthur Kingsley Porter, Professor of Fine Art at Harvard
and author of a two-volume history of medieval architecture and
numerous studies of medieval art, published *The Crosses and Culture of
Ireland,* its text based upon a series of lectures he had given at The
Metropolitan Museum of Art in New York. At the time of his death
in 1933—he apparently fell into the sea at Inishbofin Island in
County Donegal and drowned—Porter and his wife owned Glenveagh Castle, a castellated edifice with a Gothic keep and round
tower, built in 1870, and standing in a beautiful demesne of 22,000
acres on the shore of Lough Veagh in County Donegal.[9] Porter had
made a careful study of the Irish crosses *in situ,* and to equip himself
for the unique approach he intended to take to the subject he
studied Old Irish with his colleague Fred N. Robinson, the foremost
American Celticist of the time. Porter had become convinced that
the crosses, to an extent far greater than had been realized, had been
influenced by Irish secular literature and Irish hagiography. He
advanced the thesis, therefore, that although many of the subjects
depicted in the figure carvings on the crosses had been inspired by
the Bible, many also had had their origin not in biblical sources but
in Irish sources, specifically the secular heroic literature centering
about Cuchulain and Finn mac Cumhail—legendary heroes of the
Ulster and Fenian cycles of tales—and the lives of Irish saints, particularly Saint Patrick and Saint Columcille. He was the first
American to study the crosses, and it was unusual that the attempt
to claim that they owed so much of their inspiration to native Irish
sources should have been made by a foreigner.

Porter discovered fifteen different instances of subjects from Fen-

ian literature carved in scenes on the crosses. Cuchulain he discovered in three carvings, Saint Patrick in seven carvings, Saint Columcille in twelve, and other Irish saints in four. Other carvings he found sources for in Irish history, though he had been anticipated here in some instances by others. An example of Porter's method is his interpretation of three panels on the north side of the South Cross at Castledermot, County Kildare, which Françoise Henry—I think accurately—illustrates with drawings in her *Irish Art During the Viking Invasions*.[10] In the lowest panel a seated figure raises his arms in the air. In the panel above a child or small adult is held on the back of a seated figure who holds a sword erect in front of him. In the panel above this a large standing figure dwarfs another figure standing beside him and holds a sword or club in one hand over the smaller figure's head while in the other hand he holds a square object, probably a book, in front of him. All three panels are obviously a puzzle, and it is not entirely clear that the bottom one is related to the two above it. Porter, citing as his sources passages in Lady Gregory's *Gods and Fighting Men*[11] and Standish O'Grady's *Silva Gadelica*,[12] says that all three panels illustrate an incident from Fenian literature in which Finn is depicted, in the topmost panel, holding his dwarf Cnu Deireoil on his lap. Porter's identification of the dwarf—described in the source as being four feet high—rests on the assumption that the smaller figure in the carving is in fact a dwarf. But the "dwarf" is obviously riding piggyback and not sitting on the lap of the larger figure. And why the book and the sword? Dr. Henry's interpretation, that all three panels represent The Slaughter of the Innocents, is more plausible and derives support from the fact that the same subject has been identified on six other crosses, including the North Cross at Castledermot, standing only a few yards away from the South Cross.[13]

Not all of Porter's interpretations can be dismissed so easily, but very few of them have been accepted. Although the art and the inspiration which the crosses represent are native, the scenes depicted in the figure sculptures on them are still believed to be biblical or religious, even though the interpretation and treatment are peculiarly and uniquely Irish. One would be hard pressed to make a convincing case that Cuchulain or Finn, Saint Patrick or Saint Columcille, are depicted on a single High Cross. Most attempts to explain individual carvings in connection with contemporary historical events also seem labored and unconvincing and, indeed, are

usually offered because no other interpretation presents itself. This is
what Porter meant by the enigma and the mystery.

Eric Sexton's *A Descriptive and Bibliographical List of Irish Figure
Sculptures of the Early Christian Period,* published in 1946, was the best,
and certainly the most attractive, descriptive catalogue of Irish High
Crosses which had yet appeared.[14] Sexton examined the problems of
origin, evolution, and chronology and assembled a compendium of
various interpretations of individual carvings, illustrated with pho-
tographs taken by Crawford, Porter, and himself. Among people
active in the field today, Helen Roe, president of the Royal Society of
Antiquaries of Ireland, has published important monographs on a
number of sites, especially *The High Crosses of Western Ossory* [15] and *The
High Crosses of Kells.*[16] Miss Roe sees the carvings more clearly, and
reports what she sees more accurately, than anyone else. The person
who, next to Crawford, perhaps, has contributed the most to the
study of Irish High Crosses—and indeed to the whole field of early
Irish art—is Dr. Françoise Henry, a Frenchwoman who for many
years has been Professor of Fine Art at University College, Dublin,
and is the author of the recently published study, *The Book of Kells*
(London, 1974). Between the publication of her first book, *La Sculp-
ture irlandaise pendant des douze premiers siècles de l'ere chretienne,* in Paris in
1932, and her three-volume work *L'Art irlandaise,* in Paris in 1963-64,
by Zodiaque with spectacularly beautiful photographs,[17] she has
explained much of the iconography of the crosses, demonstrated their
relationship to the art of Europe and the Near East, and established a
chronology.[18]

III

Most of the surviving High Crosses were carved and erected
between the eighth and eleventh centuries, but there must have
been a sharp decrease in production during the period of the Viking
incursions. When production was resumed after the Viking fury, the
style had changed. The ring was smaller and less dominant, the
figure sculptures tended to be larger and were no longer confined to
panels, appendages of an unknown nature were sometimes attached
to the crosses by means of mortices, and the style of the ornamenta-
tion was freer, perhaps in keeping with the architectural style known
as Irish-Romanesque, which reached its peak in the twelfth century
and came to an end rather abruptly with the introduction to Ireland
of Cistercian austerity.[19]

There is some uncertainty about the function of the figured High Crosses. The evidence indicates that they were not used—as crosses in Britain were apparently used—as funerary or memorial monuments, even though some of them were inscribed with the names of the ecclesiastical superior or public dignitary who commissioned them: "A prayer for Muirdach, who caused this cross to be erected." "Pray for Tuathgall, who caused this cross to be erected." "Colman erected this cross for King Flann." One of the most notable of the surviving crosses, the South Cross at Kells, is inscribed with the names of Saint Patrick and Saint Columcille.[20] But it is not self-evident that the inscription is contemporary with the cross itself, which most recently has been dated to the latter part of the eighth, or early part of the ninth, century. One could be suspicious about an inscription which neatly links the name of the founder of Irish Christianity with that of the founder of Irish monasticism, the two most famous of Irish saints.

The annalists sometimes use names of saints or ordinary people in referring to the crosses—"The Cross of Brigit," "The Cross of Columcille," "The Cross of Bishop Eogan," "The Cross of Sechnall," and sometimes names which suggest historical associations—"The Cross of the Executions." (All from *The Annals of Ulster* and in entries for the twelfth century.) There is some evidence in the annals indicating that the crosses, four or more of them oriented to the main points of the compass, served as markers to indicate monastic boundaries, perhaps to demarcate the *termon,* the limits of sanctuary.[21] Some crosses, today at least, stand not literally on monastic sites, though close by, at a crossroads in an adjacent village or marketplace. One suspects either that such crosses were moved from their original sites or that they were simply erected "outside the walls" and crossroads and marketplaces subsequently grew up around them. It is not easy to believe that the Market Cross at Kells, for example, which probably stands on the site of a vanished Norman castle but is today in the main street of the town, exposed to automobile traffic, was always so exposed, or that it had not belonged with the other three crosses at Kells within the monastic enclosure.[22] According to a modern inscription at the base of the shaft on the Market Cross, where the original carving was cut back to make room for the inscription, the cross was "erected" in 1688. John O'Donovan of the Ordnance Survey reported in 1836 that the local people attributed the "lifting" of the cross to "Dean Swift"!

Another inscription, for which the carver refrained from destroying still more of the original ornamentation by placing it on a modern plinth under the base, indicates that the cross was once again erected by James Ferrall, Esq., in 1893. With such a history it does not seem unreasonable to believe that the cross might have been transported from its original site altogether.

Whether this and the equally remarkable Market Cross at Tuam, County Galway, as well as other crosses presently standing in public places, were transplanted may be debatable. But there can be no uncertainty about some other crosses which stand today in private demesnes, like the three in Tynan Abbey, County Armagh, for example. While some of the gentry were converting these ancient monuments into garden ornaments, however, the ordinary people discovered their therapeutic power to cure bodily ills. The capstones of the crosses at Ahenny, County Tipperary, to cite only one case, are said to have been occasionally removed to cure sick cows. But that pieces of a cross were occasionally broken off and taken by departing emigrants to guarantee a safe voyage to the new world—a local legend which Macalister reported about the West Cross at Monasterboice, County Louth—I find difficult to accept. If a simple Irish peasant believed in the power of a High Cross to cure a toothache, for instance, he also must have accepted the fact of its being a holy object, a sacramental reminder of Christ's crucifixion, like the Penal Cross of wood which he carved himself and hung on the mud wall of his cabin as a sign of faith. Although the fifty or more remaining crosses are only a remnant of what once existed, there is surely a more acceptable explanation for the disappearance of the others than appropriating landlords or vandal peasants. The crosses are not the only objects in the Irish landscape which bear witness to a turbulent history.

It has been observed many times that the art of the cross sculptors bears a striking similarity to the work of their colleagues in the *scriptoria,* who copied and decorated the illuminated manuscripts— *The Book of Durrow, The Book of Kells,* and others. For example, Dr. Henry has recently shown that the decoration and iconography of the South Cross at Kells, with its symbols of the four evangelists, its Apocalyptic Vision, and its inhabited vine—rare in Ireland—are linked to *The Book of Kells,* which came from the same monastery.[23] The differences between these two remarkable works are due chiefly to the differences in the medium. Dr. Henry observes that they may

also be due to the fact that the sculptor "having in view a less sophisticated audience, did not feel as inclined to subtlety as the painter who was working for a few theologically minded monks." [24]

It is true that *The Book of Kells*, like other such deluxe editions, was an altar book, used only by the clergy and shown to distinguished visitors,[25] whereas the High Cross stood in the open air and was contemplated by all. But to argue from this that the crosses were little more than "picture books of the common people," as Sexton says,[26] is to oversimplify and to ignore the reality of what the man in the street was capable of understanding. Many of the figure sculptures, for example, have resisted all efforts of modern observers to identify them, even on crosses like Muirdach's Cross at Monasterboice, where the stone has not deteriorated and where the modern observer sees virtually the same thing that the tenth-century observer saw. It makes serious demands on one's credibility to ask one to believe that what puzzles the learned observer today was comprehensible to an illiterate peasant in the tenth century. One is reminded of the story told by the paleographer John Westwood, in which a local Dublin artist refused to copy one of the decorated pages of *The Book of Kells* because the delicate lines of the minute interlacements could only have been traced by angels and that it would bring bad luck even to try to duplicate it. One wonders if a thought of the same possibility might not have occurred to Henry Crawford as he stood with pad in hand before a High Cross, trying to trace the bewildering designs of the spiral, star, fret, and interlaced patterns which reflected the same angelic workmanship.

We have almost no information about how the cross sculptors worked, what training they had, and what tools they used. But an unfinished cross at Kells—it's one of several such which survive—suggests that the carver, or carvers, worked from a comprehensive master design, made test carvings, and then worked on several panels at the same time. Crawford, either discounting or being unaware of the fact that this cross had lain on the ground in parts until comparatively modern times, thought that it was evidence indicating that the crosses generally might have been erected while still in a rough state and the carving finished after having been placed in position. Some crosses seem to have been the work of several hands, master and apprentice in all likelihood, since one hand seems less skilled than the other. The styles of some crosses vary so much as to suggest the existence of different schools, each with its

own flourish. The crosses of the Barrow Valley, for example, at Old Kilcullen, Moone, Castledermot, and Ullard, exhibit certain basic similarities which have suggested to some people that they all reflected the influence of a single master sculptor or school. Up till now most of the attention has been directed toward identifying the figure sculptures and ornamental designs on the crosses and relating them to insular and continental sculptures. The more practical questions of how and in what circumstances the carvers worked has yet to be dealt with.[27]

IV

Whatever the original function of the High Cross was, it became, among other things probably, a work of art, like the illuminated manuscripts, to be contemplated and admired and shown to distinguished visitors. The focus of interest, however, continued to be the Crucifixion, and this indicates that it never ceased to be a devotional object. It was the opinion of the Benedictine Celticist, Dom Louis Gougaud, who studied the treatment of the Crucifixion in early Irish art, that the Irish interpretation of the theme was *sui generis* and distinctly different from "foreign productions of the same or an earlier age." [28] On the Irish crosses, he pointed out, Christ always appears with head not inclined and eyes wide open, with long hair and beard, and with a *perizonium* around the loins. On three later crosses in County Tipperary—Cashel, Roscrea, and Mona Incha—Christ is clothed in a long robe or dress which Porter pointed out as having been inspired by the famous Volto Santo Crucifixion figure of Lucca, copies of which in the form of medals were brought back to the British Isles in the eleventh and twelfth centuries by pilgrims returning from Rome. On later crosses also, such as the one at Glendalough, County Wicklow, a suggestion of realism is introduced by giving Christ's body a slump—the "Gothic sag," as Sexton described it. Although the Irish sculptors generally included the sponge and lance bearers as well as the two angels supporting Christ's head, they frequently displayed ingenuity in fitting them into the available space.

In his study of the Crucifixion in early Irish art, and in his later work, *Christianity in Celtic Lands*,[29] Dom Gougaud argued that the Irish artists, despite their considerable skills, did not know how to represent the human figure. The faces they painted or carved were without expression, the nostrils being represented simply as two circles as though viewed from below. The hands had no joints, and

there was sometimes no distinction between a left foot and a right foot. There was also no verisimilitude in the arrangement of costume, and the figures frequently looked as though they were swathed in bandages instead of clothing. The Irish artists had chosen to concentrate instead upon the decoration, where they excelled. But what one generation perceives another generation is blind to. Contemporary opinion seems to be that it is more a matter of emphasis than of skill and that the Irish artists were simply not interested in verisimilitude and realism. Certainly the faces which stare at us from the portraits in *The Book of Kells,* for example, which Dr. Henry describes as haunting, as well as those multicolored, agile little human figures wrapped around the letters in the script, make their own kind of appeal to us today. As will be seen later, the sculptures on one of the crosses which have fascinated the present generation were considered repulsive by a leading spokesman of an earlier generation.

Apart from the Crucifixion, what strikes one is the number of figure sculptures which dramatize incidents and personalities from the Bible and which are repeated on cross after cross, each time with some variation. Like the Greek tragic dramatists the Irish sculptors seem to have worked in a tradition which allowed room for individual treatment but very little in the choice of subject matter. To be specific, only ten stories or events from the Old Testament are treated, and they are repeated at least 112 times on thirty-one crosses.[30] Furthermore, these ten motifs are all taken from only three books of the Old Testament—Genesis, Daniel, and First Samuel.[31] Adam and Eve, who appear on twenty-four crosses, top the list for frequency of appearance, and they always are shown unclothed, modestly shielding themselves with their hands. The tree, in many instances with the serpent twined round its trunk, stands between them, and on some crosses its leaf- and fruit-bearing branches are draped gracefully across the top and down the sides of the panel— clearly an exotic plant, quite different from the Irish apple tree described in Oliver St. John Gogarty's poem.

> Firm and erect,
> In spite of thin soil,
> In spite of neglect . . .
> No outlandish grafting
> That ever grew soft
> In a sweet air of Persia,

Or safe Roman croft;
Unsheltered by steading,
Rock-rooted and grown,
A great tree of Erin,
It stands up alone.[32]

Next in frequency is Abraham and Isaac, on eighteen crosses, in which Abraham wields a sword or cleaver over an Isaac draped across a stool or chopping block. The ram is in the offing, however, in the upper corner of the carving. Daniel in the Lions' Den appears on fifteen crosses, with Daniel standing placidly between two or more lions who leap into the air like frolicsome Saint Bernards on either side of him. David appears in three different manifestations. On three crosses he confronts Goliath. On ten he is shown killing a lion with his bare hands. On nine he is shown playing a kind of harp which has interested music historians because it appears to be the earliest representation in Europe of that ancient instrument as it was modified by the Celt. David's harp on the Irish crosses is oblong in shape, has only six strings—they can be clearly seen and counted on four crosses—and is small enough to be held on the knee with one hand and played with the other.[33]

The remaining Old Testament subjects which recur are Cain and Abel, Jacob Wrestling with the Angel,[34] Noah's Ark—each appearing on eight crosses—and The Three Children [35] in the Fiery Furnace, on nine crosses. Noah's Ark is generally made to resemble a double-ended Viking ship, which Irish monks of the period unhappily had many opportunities to observe. On some crosses human passengers can be seen looking over the ship's railing at us, but on the West Cross at Kells the human passengers peer at us through four, rectangular portholes in the hull of the Ark.

From the New Testament, ten important events in the life of Christ are depicted in sixty-two panels—The Slaughter of the Innocents, The Adoration of the Magi, The Flight of the Holy Family, The Baptism of Christ, The Miracle of the Loaves and the Fishes, The Triumphal Entry into Jerusalem, The Arrest of Christ, The Two Soldiers Guarding the Tomb of Christ, The Twelve Apostles and, of course, The Crucifixion. All are treated by the sculptors with a degree of realism except for The Miracle of the Loaves and the Fishes in which only the bread and the fishes appear on display as though they were for sale on a shop counter. The sculptor of Moone

Cross, in County Kildare, carved all of his figures as though they were identical twins with armless, square-shaped bodies, looking like cartoons from a comic strip. His twelve apostles, arranged in three rows of four each, one row above another, all peer at us from the same expressionless countenances over their square bodies, as though they were hiding behind packing cases.[36] The Flight of the Holy Family, on the same cross, which has been reproduced so many times, looks like the work of an inspired juvenile. The Virgin Mary sits sidesaddle on the donkey, her feet dangling below the armless rectangle which is her body. Saint Joseph, who has been provided with one arm and hand to lead the donkey by, plods ahead on foot. The Christ child is merely a face tucked sidewise at an awkward angle into the space between Mary and the arched neck of the donkey as though it were an afterthought. Moone Cross, which was the cross chosen to be exhibited in plaster cast at the New York World's Fair in 1965, has a kind of calculated artlessness which appeals to a generation brought up on modern art. But sixty years ago Macalister described the sculptures on the same cross as being "perfectly hideous."

The Two Soldiers Guarding the Tomb of Christ, a subject which appears on four crosses and is almost literally duplicated on two of them, is puzzling because the slab of the tomb, which the nodding soldiers crouch upon, has been moved off center so as to leave an opening through which a mysterious object either enters or departs. Porter and others have suggested that it was a bird which personified the soul entering or departing from Christ's body. Crawford thought it was nothing more than a straying foot of one of the sleeping soldiers. My own perception is that it is a fish, which is probably not very helpful.

If it can be said that Irish saints are not featured in sculptures on the crosses, it can also be said that two foreign saints are—Saint Anthony of Alexandria and Saint Paul of Thebes. Saint Athanasius's life of Saint Anthony, written in Greek in the fourth century, was known to the West through the Latin translation made of it by Evagrius, the friend of Saint Jerome.[37] Any question, however, of whether the Irish knew Evagrius's life is irrelevant since the only two incidents in the life of Saint Anthony which interested them were derived not from the life of Saint Anthony but from the life of Saint Paul, by Saint Jerome.[38] One can understand why Saint Anthony, the founder of Christian monasticism and the first hermit,

as Saint Jerome described Saint Paul, would have appealed to Irish monks whose monastic ideals and practices bear so striking a similarity to early Egyptian models.

Saint Anthony appears in nineteen panels on fourteen crosses. In eleven of these he is shown with Saint Paul and in eight he is alone except for two half human monsters. In Saint Jerome's life of Saint Paul we are told that a raven provided food for the hermit by bringing him a daily half loaf of bread but that when the meeting of the two saints took place, in Paul's cave, the raven doubled the daily ration to a full loaf. The two saints, however, then argued over which of them would divide the loaf—"and nearly a whole day until eventide was spent in the discussion." Paul argued that he was the host while Anthony countered by claiming that he was the older. Finally a compromise was reached—"each should seize the loaf on the side nearest to himself, pull towards him, and keep for his own the part left in his hands." On the crosses the saints are depicted sitting opposite each other, seated on straight-backed chairs, holding a round loaf in the air between them, with the raven overhead watching the tug-of-war.[39]

In the panels in which Saint Anthony appears without Saint Paul he stands facing us with a half human creature standing on each side of him and facing him as though they were saying something to him. On each of the two crosses at Castledermot, County Kilkenny, and on the West Cross at Monasterboice, County Louth, both side figures have human bodies and animal heads. On the Market Cross at Kells one side figure has the horned head of a goat while the other's, probably also bestial, is partly concealed by a mantle or cape. On Moone Cross one side figure has a horned goat's head while the other has what appears to be a cock's comb extending backward from the forehead.[40] The scene thus depicted is invariably described as the Temptation of Saint Anthony, which is inaccurate. What is evidently being dramatized has its source in two passages in Saint Jerome's life of Saint Paul in which Saint Anthony, on his way to the meeting with Saint Paul, encounters two monsters. The first one is a "half horse, half man," what the poets call a "Hippo-Centaur," Saint Jerome observes. The second has a "hooked snout, horned forehead, and extremities like goat's feet." But neither monster tempts the saint. The first one, in fact, answers his query about the most direct route to Saint Paul's cave by giving him directions and then departs swiftly. "But whether the devil took

this shape to terrify him, or whether it be that the desert, which is known to abound in monstrous animals, engenders that kind of creature also," writes Saint Jerome, "we cannot decide."

The second monster is quite clearly not a diabolic emissary since he informs Anthony that he is one of many unfortunate beings like himself—"inhabitants of the desert whom the Gentiles deluded by various forms of error worship"—who now petition the saint to intercede with God for them. Saint Anthony is moved to tears by the request and comments on the inconsistency in a world in which "beasts speak of Christ" while human beings worship animals.

There are, of course, numerous animals in the life of Saint Anthony, as reported by Saint Athanasius. The saint was constantly being besieged by demons in the form of animals. But with only one exception they appear and act as nothing more than animals. This fact is emphasized in the narrative, where the animals are itemized as "lions, bears, leopards, bulls, serpents, asps, scorpions and wolves, each of which was behaving in its natural manner." The lion roared, the bull charged, the serpent writhed, and the wolf rushed at the Saint. But none of them spoke to him or tempted him. It was all just a threat, a show of force. The only exception occurs when Saint Anthony sees "a beast resembling a man as far as his thighs, but with legs and feet like an ass." But this half man, half ass does not speak to the saint and is soon sent packing when Saint Anthony defies him. " 'I am a servant of Christ; if you have been sent against me here I am.' The beast with its evil spirits fled so fast that in its speed it fell and died." What is being depicted by the Irish sculptors is not the temptation of Saint Anthony, which for later generations became a popular theme in art and literature, but the Saint's conversations with the desert creatures he met on his way to the meeting with Saint Paul.

<p style="text-align:center">V</p>

In addition to the carvings inspired by biblical stories or by incidents in the life of Saint Anthony, which are treated more or less realistically, the crosses also exhibit an extensive and varied repertoire of religious symbols and emblems, such as the Hand of God—a human hand with extended fingers, which appears on three crosses—scepters, croziers and on two crosses the traditional symbols of the four Evangelists. Eight crosses depict on their heads, in a dominant position paralleling that of the Crucifixion on the other side, the

Majestas Domini, or God in Judgment. God is represented by a full-length human figure, holding a cross over one shoulder and a flowering branch over the other. It has been observed that the conception undoubtedly derives from the figure of Osiris, the god described as Judge in the Egyptian *Book of the Dead* and represented by many Egyptian sculptures, most of them from sarcophagus lids.[41] In the Egyptian carvings the god invariably holds a crookhead scepter over one shoulder and a flail over the other.[42] In the process of adaptation by the West the scepter and flail were Christianized, but how the idea was transmitted from the Near East to the British Isles has yet to be demonstrated, despite the discovery of cross-inscribed Coptic pots in Britain [43] and the possibility that they contained wine and oil used for liturgical purposes and were objects of trade between the Near East and the coasts of Ireland, Scotland, and Wales during the fifth and sixth centuries.[44]

Not all the motifs which recur on the Irish High Crosses are of religious origin or association. Indeed, there is a frequent mingling of religious and secular, sacred and profane, and of religious emblems and legendary animals with household objects and domestic animals. Macalister counted twenty household objects from one cross alone at Monasterboice, including a wallet, a drinking horn, a billhook, a pitchfork, a cleaver, a chair, musical instruments, a brooch, a loaf of bread, and a set of balances.[45] A list of animals on the crosses would include cats, dogs, horses, donkeys, cows, geese, sheep, birds of all kinds and sizes, fish, serpents, lions, leopards and hyenas as well as half-human animals and mythical animals like the griffin and the manticore. Moreover, the animals are not always placed in subordinate positions as they are in the illuminated manuscripts. At Drumcliff, for example, two catlike animals, larger than any other figures on the cross, occupy the middle positions and dominate the carvings on the two broad sides of the shaft. On the South Cross at Castledermot the largest panel of sculpture on the cross is devoted to a carving depicting two men, one armed with spear and shield, the other with a club, who drive a herd of six animals before them which includes a duck, goose or pelican, a stag, and a boar which has turned round to give fight. More obviously benign, even domestic, are the two panels on the South Cross at Monasterboice in one of which two cats play with a stick while in the other panel a third cat licks a kitten and a fourth plays with a bird between its paws. One is reminded of the story from *The Book of Leinster* about the three monks who went on a pilgrimage in a

coracle, taking with them only three loaves of bread and the monastery cat, or of the poem in Old Irish from the ninth century about the monk and his cat.

I and Pangur Ban my cat,
'Tis a like task we are at:
Hunting mice is his delight,
Hunting words I sit all night.

Better far than praise of men
'Tis to sit with book and pen;
Pangur bears me no ill will,
He too plies his simple skill.

'Tis a merry thing to see
At our tasks how glad are we,
When at home we sit and find
Entertainment to our mind.

Ofentimes a mouse will stray
In the hero Pangur's way;
Oftentimes my keen thought set
Takes a meaning in its net.

'Gainst the wall he sets his eye
Full and fierce and sharp and sly;
'Gainst the wall of knowledge I
All my little wisdom try.

When a mouse darts from its den
O how glad is Pangur then!
O what gladness do I prove
When I solve the doubts I love!

So in peace our tasks we ply,
Pangur Ban, my cat, and I;
In our arts we find our bliss,
I have mine and he has his.

Practice every day has made
Pangur perfect in his trade;
I get wisdom day and night
Turning darkness into light.[46]

Some observers have seen Celtic divinities on the Irish crosses, which may be carrying things too far for a Christian monument. But there are carvings on the crosses which are difficult to reconcile with the iconography as a whole. A typical example is the crouched figure, bound or bandaged hand and foot, with the body of a man and the head of a bird with long crest, occupying the entire panel on the base of the North Cross at Castledermot.[47] Other secular scenes or motifs on the crosses are chariots and chariot processions—on six crosses—and hunting scenes—on eleven crosses. Typical of the carvings in which human figures are used as part of the ornamentation is that of four elaborately interlaced human figures. Six crosses display this particular form of zoomorphic design, and on two of them the design is expanded to include eight human figures. Zoomorphic patterns like this are, of course, a fundamental feature of Irish manuscript decoration.

VI

This account has focused upon the general characteristics of the Irish High Crosses and upon those figure carvings and motifs which recur and seem to be typical. But it should be emphasized that for all such carvings which can be recognized and identified there is possibly an equal number which cannot be and which remain a mystery. Typical of these, perhaps, is a panel, appearing on more than one cross, in which three human figures stand side by side, the one in the middle being upside down. Another is the scene on a cross at Old Kilcullen, County Kildare, in which a man wields a hatchet over another man bound hand and foot and lying on the ground. Still other carvings depict similar acts of violence for which no satisfactory explanations have been advanced. There are carvings portraying processions of men and animals, like the one on the base of the North Cross at Ahenny, County Tipperary, in which a donkey, accompanied by a dog trotting beside him, carries a headless corpse and is preceded by a procession which includes one man holding a crozier and another a ringed cross. The rear of the procession is brought up by a man carrying a child on his back. Meanwhile two birds perch atop the headless corpse and tear away at his flesh while nobody tries to stop them. The fact that this gruesome event, or a similar one, is portrayed on another cross at Dromiskin, County Louth, some 150 miles away, has suggested that it describes the funeral of Cormac mac Cuillenain, King of Cashel, who was de-

capitated at the battle of Ballaghmoon in 908. But the identification obviously rests only on the coincidence of the decapitation and leaves too many other questions unanswered. Ballaghmoon is 45 or 50 miles distant from Ahenny, in a different county of present-day Ireland, and is even more distant from Dromiskin. If what is shown is the funeral cortege of a king, led by a bishop carrying a symbol of his office, one might wonder why the vultures are allowed to feed on his shattered remains.

Most attempts to explain a carving which appears to depict an actual event by searching the historical record for the clue which will explain it have not been very successful. It would have been most convenient for us if some sculptor at Clonmacnoise had dramatized on a cross the killing of the two young students before *Cross na Screptra* which the annalist recorded. Perhaps he did—on a cross which has disappeared. Undoubtedly, the historical record itself is inadequate. Like Porter's attempt to discover Finn mac Cumhail, Saint Patrick and Saint Columcille on the crosses the idea remains an attractive one. For that reason the mystery and the enigma remain. Perhaps it is one of the reasons why these majestic monuments retain their power to interest us. The High Crosses are not only a vivid manifestation of the Irish temperament and imagination but also represent in themselves an important chapter in the history of art during the Dark Ages. Porter did not think it too much to claim that they represented "a sculpture which is not only immeasureably in advance of all the rest of Europe, but is among the remarkable manifestations of medieval art."

NOTES

1. I am grateful to Professor John V. Kelleher for identifying references to High Crosses in the Irish annals and for allowing me to quote his translations.

2. The *Termon* is the lands of the ecclesiastical establishment within which the right of sanctuary prevailed.

3. *The Crosses and Culture of Ireland* (New Haven: Yale University Press, 1931), p. 3.

4. The "wheel" crosses in Britain are also ringed, but the wheel is generally much smaller and less dominant than on the Celtic cross. There are, of course, Celtic crosses in Britain.

5. Henry O'Neill, *Illustrations of the Most Interesting of the Sculptured Crosses of Ancient Ireland; Drawn to Scale and Lithographed* (London, 1857).

6. *The Journal of the Royal Society*

of Antiquaries of Ireland,
XXXVII (Dublin, 1907),
187-239. This list was fol-
lowed by a supplementary list
in *JRSAI,* XXXVIII (Dublin,
1908), 182ff.

7. "The Inscriptions on the Slab
at Fahan Mura, County
Donegal," *JRSAI,* LIX (Dub-
lin, 1929), 89ff. The existence
of the inscription at Fahan
Mura had been reported in
1881 by a writer in *Proceedings
of the Royal Irish Academy* who
assumed that it was in Irish.
As Macalister demonstrated,
the inscription was in Greek
and reads, Δοξα και τιμε
(misspelling for τιμη) πατρι
και υιω πνευματι 'αγιω,
"Glory and Honor to the
Father and to the Son and to
the Holy Ghost." This is the
first versicle of the prayer
known as the *Gloria Patri.*
What is unusual about the
text of it as it appears on the
slab is not only the fact that it
is in Greek but also that it is a
version of the prayer first used
at the Council of Toledo in
633 and differs from the one
in general use by its addition
of the phrase "and honor."
Macalister pointed out that
this text of the *Gloria Patri* was
adopted for use in the Moz-
arabic liturgy of Spain, in
which the prayer differs from
that used in the liturgy else-
where not only by the addi-
tion of the "and honor" but
also by the omission al-

together of the second versicle
of the prayer, "As it was in
the beginning, is now and
ever shall be, world without
end, Amen."

Macalister was aware of
the possibility that the in-
scription could be much later
than the slab it was carved
on, but he discounted the
possibility. Confirmation of
his theory has come recently
from Dr. Henry *(Irish Art in
the Early Christian Period,* p.
126), who points out that
same version of the *Gloria Pa-
tri* appears in *The Antiphonary
of Bangor,* a seventh-century
Irish codex.

8. The lichenous growth so con-
cealed and distorted the
carvings on stone monuments
which had stood for centuries
in the open air that one
wonders how accurate any-
one's impression of them
could have been before
chemical weedkiller and
other methods of cleaning
were introduced. Even a
superficial examination of the
cross casts in the National
Museum in Dublin will
explain why at least one Mu-
seum official today is embar-
rassed about their still being
exhibited to the public.
The condition of the crosses
themselves today, when they
are regularly inspected and
cleaned, and the modern
methods of plaster cast mold-
ing, make it possible to

produce much better models. The full-sized plaster cast of Moone Cross, which was exhibited at the 1965 New York World's Fair offered a remarkable contrast to the Museum cast of the same cross.

9. There is a description, with photographs, of Glenveagh Castle in Desmond Guinness's and William Ryan's *Irish Houses and Castles* (London, 1971), pp. 85 ff.

10. Ithaca, N.Y., 1967, p. 147.

11. London, 1904, p. 171.

12. London, 1892, II, 115.

13. Dr. Henry's identification, however, does not draw much support from the panel on the North Cross, which is quite different from that on the South Cross. It exhibits two figures standing on either side of a third figure of equal size who stands on his head. Porter thought the panel depicted the Fall of Simon Magus.

14. I have not been able to discover anything more about Sexton than what is indicated in his book. Like Porter he may have been an American. He had an M.A. degree from Harvard and a B.Litt. from Oxford. He did his field work in Ireland in 1927, when he was apparently a graduate student at Harvard, and he acknowledges the help of a grant from the Dean of the Harvard Graduate School.

He had access to Porter's collection of photographs of the crosses. Although his book was not published until 1946—because of the war—in Portland, Maine, its Foreword was dated 1940 and the text itself was apparently written much earlier. There is no thesis by Sexton currently on deposit in the Harvard University Library.

15. Kilkenny Archaeological Society, 1958, revised and enlarged edition in 1962.

16. Meath Archaeological Society, 1959.

17. Published in English translation by Cornell University Press as *Irish Art in the Early Christian Period (To 800 A.D.)* [1965], *Irish Art During the Viking Invasions (800-1021 A.D.)* [1967], and *Irish Art in the Romanesque Period (1020-1170 A.D.)* [1970].

18. There are, of course, other writers whom space prevents my mentioning. Liam de Paor, for example, who as a field archaeologist has excavated early Christian sites, has written about the limestone crosses of County Clare and the Aran Islands. *Early Christian Ireland* (London, 1958), which he wrote with his wife Maire, also an archaeologist, illuminates the entire field of Irish monastic art.

19. The Cistercian reform is identified with the introduc-

tion by Saint Malachy, Archbishop of Armagh and friend of Saint Bernard of Clairvaux, of French Cistercian monks, who worked with Irish monks trained at Clairvaux in building Mellifont Abbey in County Meath in 1142. By 1148 four daughter houses had been established in other parts of Ireland, and Irish monasticism, as it had existed for more than five centuries, came to an end.

20. The inscription reads *"Patricii et Columbae Crux,"* a formula quite different from that of the inscriptions on other crosses, quoted above.

21. A plan of a monastery drawn on one of the pages of *The Book of Mulling,* a seventh-century gospel book, which came from the monastery of Saint Mullins in County Carlow and is now in Trinity College, Dublin, shows the disposition and names of twelve crosses—eight on the quarters outside the enclosure, named after the four evangelists and the prophets Jeremiah, Daniel, Ezekiel, Isaiah, three within the enclosure and one at the entrance of the enclosure.

22. Although one of the other three crosses standing in the churchyard at Kells has had its entire top half broken off, neither the shaft, which remains, nor the other two crosses, shows signs of anything more than the normal wear and erosion. But the Market Cross has had the top of its shaft sheared off, its capstone removed, its ring badly damaged, and a large portion of the surface on one side of the shaft broken off. Miss Roe suggests that all or part of the damage could possibly be attributed to the "iconoclastic fury of the religious factions of the 17th century" which damaged so many of the Ulster monuments. But when one considers its exposed position in the main street of a busy market town, learns of a local tradition that it was used as a gallows, and compares its condition to that of the crosses in the protected precincts of the churchyard, a more obvious explanation presents itself.

23. *The Book of Kells* may not have been actually written and decorated, entirely at least, at Kells. But it was the product of a Columban monastery and was in fact the property of Kells as early as the year 1006, when, as *The Annals of Ulster* tells us, "the great Gospel of Columcille, the chief relic of the Western World, was wickedly stolen during the night from the western sacristy of the great stone church at Cenannas [Kells] on account of its wrought shrine." It was subsequently retrieved from

its hiding place "under a sod."

24. *The Book of Kells,* p. 218.
25. Giraldus Cambrensis saw it and described it.
26. *A Descriptive and Bibliographical List of Irish Figure Sculptures,* p. 36.
27. One wonders what light a modern stone sculptor would be able to shed upon the work of the Irish cross carvers. The archaeologists Glyn Daniel and the late Sean P. O'Riordain, in their study of the prehistoric chambered tomb at Newgrange, County Meath, asked O'Riordain's wife, a distinguished sculptor, to reproduce one of the carvings at Newgrange using only stone chisels. A photograph of the result appears in Daniel's book *New Grange* (London, 1964) with the observation: "Gabriel O'Riordain is thus perhaps the only megalithic artist whose name is known."
28. "The Earliest Irish Representations of the Crucifixion," *JRSAI,* L (December, 1920), 128.
29. English translation by Maude Joynt, London, 1932.
30. In compiling these figures and those which follow I have omitted from consideration those figure panels—and there are many—whose identification is either uncertain or a matter of dispute, and those whose identification I myself am unable to accept.
31. There is of course a possibility—in fact a probability—that other books inspired carvings which have not been identified.
32. *The Collected Poems of Oliver St. John Gogarty* (New York, 1954), p. 48.
33. The famous harp of Brian Boru, in the National Museum, which has been considered the prototype of the national instrument, is of course not oblong but triangular. Furthermore it had thirty strings and is thus quite different from the harp with which the cross sculptors were evidently familiar. Harps, incidentally, are mentioned frequently in the Behon Laws and in early Irish heroic literature. Eugene O'Curry *(Manners and Customs of the Ancient Irish,* vol. II, p. 262) quotes a passage from *The Book of Lecan* in which the abbot of a monastery is described, "who took his little eight-stringed harp from his girdle and played sweet music and sang a poem on it."
34. Genesis 32:24-31.
35. Shadrach, Meshach, and Abed-nego were actually young men, old enough to be set over the affairs of the province of Babylon by Nebuchadnezzar.
36. Dr. Henry described them as looking like dolls in a toyshop window.
37. Athanasius's life is in J. P. Migne, *Patrologiae ... Graeca,* vol. CCVI, pp. 835-976. Eng-

lish translations are in *A Select Library of Nicene and Post-Nicene Fathers,* Second Series (New York, 1907), vol. IV, pp. 188-221 and in R. T. Meyer, *Life of St. Anthony,* London, 1950. Evagrius's life is in Migne, *Patrologiae . . . Latina,* vol. LXXIII.

38. There is an English translation of Saint Jerome's life in *A Select Library of Nicene and Post-Nicene Fathers,* Second Series, vol. VI, pp. 299-303, but I quote from a more recent translation by M. L. Eward in *The Fathers of the Church: Early Christian Biographies,* ed. R. J. Deferrari (1952), vol. XV, pp. 219-38.

39. The identification of the sculptures is confirmed, incidentally, by the fact that the same subject appears on the famous Ruthwell Cross, near Dumfries, where it is accompanied by an inscription which has been read as *"SCS Paulus et A(ntonius) Freger(un)t Panem in Deserto."* The question of whether the Ruthwell Cross came first and thus inspired the others would be answered if there were some agreement about the date of Ruthwell Cross as well as the Irish crosses. But the dating of stone monuments in the British Isles is still subject to differences of opinion. Baldwin Brown (*The Arts in England,* London, 1937) dated Ruthwell to the period between 675 and 685. W. G. Colling-

wood (*Northumbrian Crosses of the Pre-Norman Age,* London, 1927) dates the appearance of the earliest Northumbrian crosses to the middle of the eighth century or slightly before. R. I. Page (*The Bewcastle Cross,* Nottingham, 1960) argues for a date between 750 and 850.

Françoise Henry (*Irish Art in the Early Christian Period,* p. 142, n. 2), who has changed her mind about Moone Cross, believing at first that it belonged to the ninth century, now assigns it to the eighth, which would make it a contemporary of Ruthwell. I have not myself been able to believe that the Northumbrian Cross is earlier than the Irish, chiefly because of its sophisticated treatment of Mary Magdalene Washing the Feet of Jesus, a scene which does not appear on any Irish cross. If it is not possible to argue from this that Ruthwell is later than Moone—accepting Dr. Henry's latest date for Moone—then it is at least not necessary for us to believe that it is earlier.

40. On each of the other three crosses—Galloon Island, Killamery, and a cross shaft from Drumcliff, now in the National Museum—the surface of the stone has deteriorated so that it is not possible to be certain about the matter.

41. Françoise Henry, *Irish Art*

During the Viking Invasions, pp. 164-66.

42. The best known example is on the mummy case of Tutankhamen. Other examples—a limestone relief, two huge full-length Osiride statues, and a sarcophagus lid —are illustrated by photographs in Cyril Aldred's *The Egyptians* (London, 1961), pls. 54, 56, 58.

43. C. A. Ralegh Radford, "Imported Pottery at Tintagel, Cornwall," in *Dark Age Britain, Studies Presented to E. T. Leeds,* ed. D. B. Harden (London, 1956), pp. 59 ff., and C. Thomas, "Imported Pottery in Dark Age Western Britain," *Medieval Archaeology* (London, 1959), pp. 89 ff. Dr. Henry's discussion of the theory is in her *The Book of Kells,* p. 213.

44. Parallels between Egypt and early Christian Ireland continue to present themselves. The unique feature of early Irish monastic communities is the fact—exemplified by the *clochan,* or beehive-shaped stone huts, on the sites of early monasteries like Skellig Michael, County Kerry and Inishmurray, County Sligo —that the Irish monks lived singly, though frequently within an enclosure, and assembled only for prayer or instruction in a way which suggests the *laura* of the Egyptian desert monasteries.

(See Dom Cuthbert Butler, *The Lausiac History of Palladius* [Cambridge, 1898, vol. I, p. 233]).

The Pierpont Morgan Library recently exhibited a Coptic book of the fourth or fifth century, its text a copy of *The Acts of the Apostles* in the Coptic language, containing a full-page illustration of the Crucifixion. The cross of the illustration is a ringed cross, even though the ring does not circle the intersection of arms and shaft, as it does on the Celtic Cross, but is placed above the cross piece of a Tau Cross—the so-called "Nile Key." Furthermore, the entire cross, as well as the ring, is covered with interlace—another characteristic which suggests the possibility thwhe Celtic Cross peculiar to Ireland and Celtic Britain, like the *Majestas Domini* on it, may have originated in Egypt.

45. *Monasterboice, Co. Louth,* p. 44.

46. Translation by Robin Flower, *The Irish Tradition* (Oxford, 1947), p. 24. Irish text in Whitley Stokes and John Strachan, *Thesaurus Palaeohibernicus* (Cambridge, 1903), vol. II, p. 293.

47. It has been suggested that the figure on the Castledermot Cross represents a pre-Christian interment, like the crouched remains found in cist graves.

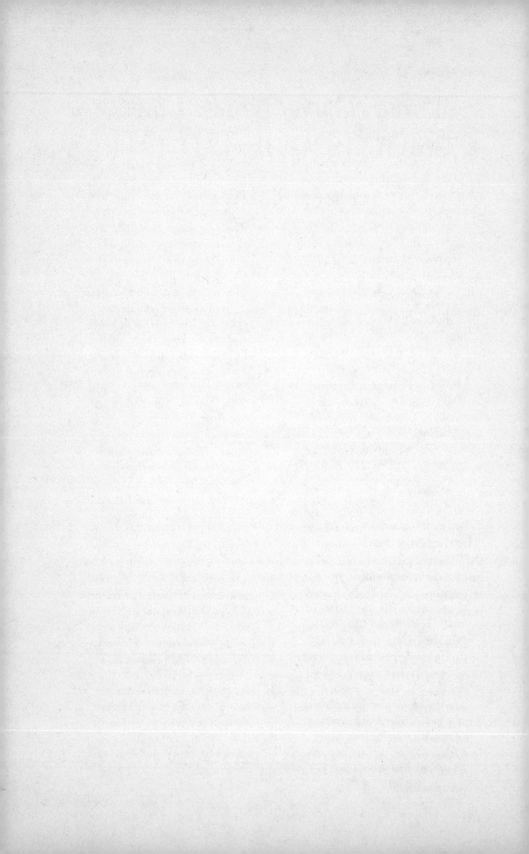

Three *Beowulf* Notes: Lines 736b ff., 1331b ff., 1341-1344

Stanley B. Greenfield

University of Oregon

As a small token of my scholarly esteem and personal affection for Lillian Hornstein, I should like to offer the following notes. They are attempts to grapple with textual and contextual matters that have disturbed my students and me as we have studied the Old English epic over the years.

Lines 733b ff.:

> þryðswyð beheold
> mæg Higelaces, hu se manscaða
> under færgripum gefaran wolde.
> Ne þæt se aglæca yldan þohte,
> ac he gefeng hraðe forman siðe
> slæpendne rinc, [1]

Beowulf's conduct in this passage, which allows one of his thanes (Hondscioh) to be devoured before he himself takes action against the monster Grendel, has been variously criticized and excused. The most cogent analysis, to my mind, is that of Arthur G. Brodeur, who, refusing to accept the folk tale "carry-over" excuse,[2] or a characterization of the hero as a deliberate, cunning, but callous man, wrote:

> Lines 736b-738 cannot mean that Beowulf deliberately allowed Hondscio to die in order that he himself might observe Grendel's mode of attack. Such conduct would be utterly inconsistent with his character as the poet has disclosed it, and would have horrified the poet's audience. These lines must mean that Beowulf, expecting the first attack to be directed against himself, was waiting to see how Grendel would bear himself under Beowulf's sudden counterattack. *Gefaran* can mean 'conduct oneself' as well as 'proceed'; and *under* is never used in the poem in the sense of 'in course of' (attending circumstances).[3]

169

Brodeur's interpretation of these lines can be made more plausible yet, I believe, by not accepting the usual editorial punctuation of a full stop after *wolde* in 738b, and by not taking *aglæca* as referring to Grendel (as even Brodeur takes it), but to Beowulf himself. Repunctuated in the following manner:

> gefaran wolde,
> ne þæt se aglæca yldan þohte;
> ac he gefeng hraðe

the passage may be translated as follows: "The mighty one, the kinsman of Hygelac, considered how the evildoer would fare under [Beowulf's] sudden attack, nor did that champion think to delay [his sudden attack]; but he [Grendel] seized suddenly at the first opportunity a sleeping warrior. . . ." Although *aglæca* usually refers to Grendel or the dragon, it is also used of Sigemund (893) and of Beowulf *and* the dragon together (2592), and possibly of Beowulf in line 1512. The sudden change of referent to Grendel in the *he* of the *ac*-clause has many parallels in the poem (lines 108-109 are a convenient example). If the passage can indeed be read in the way I am proposing, Beowulf's thought about action [4] and his intention to take action are seen as almost simultaneous, and the hero is forestalled only by Grendel's even quicker action.

Lines 1331b ff.:

> ic ne wat hwæder
> atol æse wlanc eftsiðas teah,
> fylle gefægnod.

These lines are part of Hrothgar's speech lamenting the death of Æschere. Almost all editors have emended the MS *hwæþer to hwæder* [= *hwider* 'whither'] in 1331b; though Holthausen recommended keeping the MS reading and meaning "whether," Hoops called the suggestion "unwahrscheinlich." [5] But the meaning "whither" in this passage has always troubled me,[6] since in a few lines Hrothgar is going to give a description of the haunted mere, the "whither," and ask Beowulf to *sec gif þu dyrre* (1379b). Why should he say here, then, that he "knows not whither that fearsome one, exulting in carrion, has turned on her homeward journey, having rejoiced in the feast"? If we accept the other emendation in the passage (*gefægnod;*

MS *gefrægnod*], "whether" seems to make more sense: Hrothgar does not know *whether* Grendel's mother has indeed *eaten* Æschere—all the knows is that she has *taken* him; and such an open question would make more poignant the finding of Æschere's head, his sole remains, on the cliff, in 1420-1421. I therefore opt for the MS *hwæþer*.

Lines 1341-1344:

> þæs þe þincean mæg þegne monegum,
> se þe æfter sincgyfan on sefan greoteþ,—
> hreþerbealo hearde; nu seo hand ligeð,
> se þe eow welhwylcra wilna dohte.

These lines, too, are part of Hrothgar's lament for Æschere: the king has just told about Grendel's kinswoman coming to avenge her son, and having done so "she has far advanced that feud [in the killing of Æschere]"—"as it may [well] seem to many a thane who mourns in his heart for his lord with cruel breast-grief;[7] now that hand lies low which was available to you for each one of your desires." The *sigcgyfa* of 1342a is usually taken as referrring to Æschere, as is the *hand* of the following line, and the comment is made that Æschere was a lord and giver of treasure in his own right. This is certainly a possible interpretation, but since Hrothgar is here concerned with his own grief as a result of Grendel's mother's revenge, it seems a little strained. I wish to suggest an alternative: that Hrothgar is referring to himself as the *sincgyfa* in this passage, saying "as it may [well] seem to many a thane who mourns in his heart along with [8] *me* (the treasure-giver)." The *hand* reference would then be to his own hand, and the king would be suggesting the paralysis of his will,[9] a metaphoric crippling of the hand that distributed treasures to the retainers in Heorot.[10] Such an interpretation would make Beowulf's response, *Selre bið æghwæm, / þæt he his freond wrece, þonne he fela murne* (1384b-1385), his attempt to cure that paralysis, more pointed.

Whether or not the suggestions I have made will seem acceptable to students of *Beowulf,* I hope the honoree of this volume will accept them in the spirit of their dedication.

NOTES

1. All quotations are from Fr. Klaeber, ed., *Beowulf and The Fight at Finnsburg,* 3d ed. (Boston: Heath, 1950).

2. See Klaeber, p. 155, or W. W. Lawrence, *Beowulf and Epic Tradition* (Cambridge: Harvard University Press, 1928), p. 176.

3. *The Art of Beowulf* (Berkeley and Los Angeles: University of California Press, 1959), p. 93, n. 9.

4. I am taking *behēold* to mean "considered" rather than "beheld," the usual translation; see Bosworth-Toller, *behealdan,* VII (d).

5. Johannes Hoops, *Kommentar zum Beowulf* (Heidelberg: Carl Winter, 1932), p. 161.

6. Klaeber evidently felt some uneasiness about it, though he adopted it: "It might be urged, in defense of a literal interpretation, that Hroðgar, as a matter of fact, did not know the abode of Grendel's mother quite accurately. But it is more important to ob-

serve that the phrase is suggestive of formulalike expressions and that, in addition, a general statement of this kind is not altogether unsuited, since the allusion is to the 'uncanny' dwelling-place of the mysterious *ellor-gæstas"*—pp. 181-182.

7. I do not adopt Klaeber's dash after *grēoteþ* in my translation.

8. *Æfter* can have the meaning "along with," as in 2261: *æfter wigfruman wide feran.*

9. Cf. Edward B. Irving, Jr., *A Reading of Beowulf* (New Haven and London: Yale University Press, 1968), p. 78.

10. On Hrothgar's loss of power to distribute treasure, cf. my paper "Gifstol and Gold-hoard in *Beowulf," Old English Studies in Honour of John C. Pope,* eds. Robert B. Burlin and Edward B. Irving, Jr. (Toronto and Buffalo: University of Toronto Press, 1974), pp. 111-12.

Raptus: A Note on Crime and Punishment in *Le Bone Florence of Rome*

Carol Falvo Heffernan

U.S. Merchant Marine Academy

The Middle English romance, *Le Bone Florence of Rome,* is one of hundreds of tales about persecuted women, popular in folk legend as well as in medieval romance literature. The version to which Florence gives her name is distinguished from the other tales about persecuted women (i.e., Emaré, Constance, Griselda) by two characteristics: (1) her exile is caused by the accusations of a rejected brother-in-law, and (2) after numerous persecutions and sufferings, the heroine's healing powers bring together all her persecutors, who then confess their crimes. There is, interestingly, a rather singular confession in this romance which occurs early in the tale, before the rejected brother-in-law accuses Florence of having committed adultery with one of the knights (Egravayne) charged with protecting her and which stands apart from the flood of confessing persecutors at the end of the tale. Although paleographical and linguistic evidence in the unique manuscript, MS Cambridge Ff. 2.38, places its composition at the end of the fifteenth century,[1] the handling of this scene from the point of view of ecclesiastical laws relative to the crime of *raptus* seems to reflect rulings which were not codified until later during the Council of Trent (1545-63).

Shortly after the villainous brother-in-law Mylys has falsely accused Florence of adultery, the knight Egravayne recapitulates for Emere, the heroine's husband, the story of Florence's abduction by Mylys and his retinue, his own brother Sampson's death, and his unwilling participation in the plot, of which crime Egravayne is absolved by the Bishop of Rome. His account follows in stanzas 112-14 of the poem [2]:

112

Syr Egravayne seyde, "Syr now Y schall 1330
Telle yow a full sekyr tale,
 And ye wyll here hyt wele.
Syr when ye went vnto þe see,
Ye lefte an hundurd men and vs thre,
 Armed in yron and stele, 1335
To kepe Florence tyll ye came agayne;
And þat made my brodur Sampson slayne,
 And wroght hath myn vnhele.

113

"Vnnethe were ye on the see,
When Mylys seyde, here standyth he, 1340
 That ye foreuyr were gone.
He seyde he wolde be emperowre,
And wedde yowre lady whyte as flowre,
 That worthy ys yn wone.
He had an hundurd at hys assente, 1345
And hyght þem londys and ryche rente,
 That made Syr Sampson slone.
And broght hym home on a bere tree,
And tolde Florence þat hyt was ye,
 Then made sche full grete moone. 1350

114

"And when he wolde hur haue wedde,
Faste away from hym sche fledde,
 And wolde haue stolyn awaye.
Then Mylys made to arme xij knyghtys,
To kepe þe place day and nyghtys, 1355
 And wach abowte hur lay;
And certys Y was to them sworne,
And ellys had my lyfe be lorne,
 The certen sothe to saye.
J went to þe Pope and tolde hym sa 1360
And he assoyled me a pena et culpa
 Wythowtyn any delay.

Absolution *a pena et culpa*—"From punishment and guilt." The phrase is familiar from the much discussed pardon scene of *Piers the Plowman* (B. Pass. VII, 1.3). There a mere pardon, which normally remits the punishment due to sins but does not forgive their guilt, absolves the Plowman. However, the phrase in Langland's poem has no real meaning; it is used merely as a commonplace expression. Properly, only the sacrament of penance could offer absolution, while pardons and indulgences might remit only the temporal punishment. In *Le Bone Florence of Rome*, Egravayne receives absolution *a pena et culpa* in the true sense. He is freed by sacramental absolution from the *culpa* and by the bishop's authority from the *pena*.

But what is Egravayne guilty of and why does he make his confession to the Bishop of Rome?

Etymologically the word *raptus* means a forcible carrying off. It includes the two ideas of removal from one place to another, and violence in this change of place. Technically it would seem that Florence had not been, properly speaking, abducted in as much as she was not carried off but merely *detained* in her own palace by her brother-in-law Mylys and his accomplices. Let us suspend discussion of this point for the moment and return to it later. There is a distinction between the impediment of *raptus* and the crime. Viewed as a crime, it involves the carrying off by force of any virtuous woman from a free and safe place to another morally different, and neither free nor safe from the captor's power.[3] Abduction considered as a matrimonial impediment is the forcible carrying off of any woman, for the purpose of contracting marriage with her. Such was Mylys's intent. Although Florence and his brother Emere were wed, he knew their marriage had not been consummated, as Florence, somewhat vindictively, even for a saintly heroine, told her spouse, "3yt schall ye neuyr in bedde me by,/ Tyl ye haue broght me Syr Garcy" ([her father's murderer], ll. 1000-1). Mylys implies, then, as she is a virgin who has refused to consummate her marriage, that he could "get rid of Emere" and force her to marry him:

> My brodur comyþ neuyr agayne.
> I wyll wedde the yonge bryde,
> He slepyd neuyr be hur syde. (ll. 1068-70)

However, since Florence, even after being falsely persuaded that

Emere is dead, decides to marry not Mylys but Christ, "a lorde that neuyr schall dye,/ That preestys schewe in forme of bredd," (ll. 1100-1101) the scheme outlined above by the knight Egravayne is hatched.

The intent of the law in making abduction an impediment is to assure a woman the freedom which is necessary for the proper contracting of a marriage. Had Mylys succeeded, he would have been subject to the impediment. But once Egravayne explains the conspiracy to the Bishop of Rome, the Pope ". . . gart arme of þe spyrtualte,/ And of the seculors hundurdys thre . . . For to dystroye the false weddyng,/ The matrymony was not fyne" [4] (ll. 1132-37). Clearly the Pope's militant action indicates that he regards detention as tantamount to abduction and had Mylys succeeded in persuading Florence to marry him, the Pope would have invoked the impediment. The present discipline of the church in regard to the impediment of abduction is similar to the legislation of the Council of Trent. There is one important exception, however; the present Code "has assigned the effects of *raptus* to the case in which a woman was not carried off, but was merely detained in one place through violence." [5] Thus, it seems the Bishop of Rome in *Le Bone Florence* was very forward-looking, indeed, in realizing that it is not necessary to change locale to move from a secure and free place to a morally different one.

As for Egravayne's confession to the Pope, it appears to anticipate the ecclesiastical discipline introduced by the Council of Trent, for according to the Council, whether the abduction ends with marriage or not "the abductor with all of his advisers, accomplices, and abettors" were to be "excommunicated and declared forever infamous, incapable of acquiring dignities":

Decernit sancta synodus, inter raptorem et raptam, etiam raptae consensu, quamdiu in potestate raptoris manserit, superveniente, nullum posse matrimonium consistere. Quodsi rapta a raptore separata et in loco tuto et libero constituta eum in virum habere consenserit, cogatur, raptor ab ecclesiastico et saeculari iudice, eam in uxorem habere, et nihilominus *raptor ipse ac omnes illi consilium, auxilium et favorem praebentes sint ipso iure excommunicati ac perpetuo infames omniumque dignitatum incapaces,* et, si clerici sint, de proprio gradu decidant. Teneatur praeterea raptor mulierem decenter arbitrio iudicis dotare.[6] (The italics are mine.)

The right to absolve in a case of excommunication belongs to him who can excommunicate and who has imposed the law. In Egravayne's case, the power would be the Pope's, as he is Bishop of Rome and the crime of *raptus* was committed in his jurisdiction. Hence, the confession to Pope Symond.

Interestingly, Florence is abducted a second time by her persistent brother-in-law Mylys (stanzas 117-27). As there is a woman, a change of locale (this time he carries her off to the woods), and violence ("He bete hur wyth hys nakyd swyrde," l. 1426), the crime of abduction can be said to have occurred again, but the Tridentine impediment could not have been induced as Mylys's intent is no longer matrimonial but sheer desire for vengeance and sexual gratification.[7] In any event, Florence's chastity is saved again, this time by a prayer to the Virgin Mary who makes the persecutor forget his passion—"Hys lykyng vanyscht all awaye" (l. 1499).

The legal aspects of Florence's abduction are of particular interest in as much as one would have expected a totally different treatment of the crime and punishment of abduction in a late fifteenth-century romance. The Decretal *Accedens* of Innocent III (1198-1216) was the prevailing ecclesiastical discipline with respect to abduction up until the sixteenth-century Council of Trent. Innocent's decretal declared that the abducted woman could lawfully contract marriage provided that her prior reluctance and dissent change to willingness, even if the woman continued in the power of her captor.[8] Innocent's decree was so vague that it practically made abduction worth trying. A case in point is the daring abductions of the raven-haired Jewess, Rebecca, and the fair Lady Rowena in Sir Walter Scott's *Ivanhoe*. That novel attempted to recreate the times of Richard *Coeur de Leon*, and, consequently, of Innocent III, who ascended the papal throne during Richard's reign.

Clearly, the poet's treatment of crime and punishment for *raptus* in *Le Bone Florence of Rome* suggests that even before the Council of Trent began meeting in 1545, there must already have been evident in daily life a growing respect for the sanctity of marriage and a woman's right to consent freely to the selection of her mate.

Historically, before Innocent's Decretal, there had been harsh laws with respect to abduction. According to Saint Basil,[9] the church had issued no canons prior to his time. Abduction among Christians was apparently rare before the fourth century. Thereafter, as it increased, the church decreed punishments. Pope Gela-

sius (496) permitted marriage to a consenting woman.[10] *Raptus* did
not appear as an impediment prior to the ninth century. From the
ninth century onwards, the marriage of captor and captive was
forbidden in the West. As the bishops of the Frankish nation felt the
need for severe legislation, many particular councils (e.g., Aix-la-
Chapelle and Meaux) issued stringent canons which continued as
the particular law of the Franks until abolished by Innocent III. The
Capitulary of Aix-la-Chapelle of 817 states that the abductor could
not according to canonical authority contract legitimate marriage
with the abducted woman.[11] The Council of Meaux (845) forbade
the abductor ever to marry the rapt woman, but permitted his
marriage with any other woman after he had performed prescribed
public penance.[12] These strict prescriptions were evidently not fully
observed in practice, for there was a gradual relaxation in the
discipline of the church. The Decree of Gratian [13] inaugurated a
milder discipline which reflects the confused state of canonical
teaching and practice in the eleventh century. Gratian decreed that
an abductor ought to be permitted to marry the abducted, provided
she be willing to have him for a husband. After Gratian's decree, the
milder discipline met with the approval of later popes until Inno-
cent III finally issued his Decretal *Accedens* for the universal church.

NOTES

1. Carol Falvo Heffernan, *"Le Bone Florence of Rome:* A Critical Edition and Study of the Middle English Romance," dissertation, New York University, 1973, pp. 19-20, and 47-48. The dissertation was directed by Professor Hornstein.

2. Ibid., pp. 174-75. All further references to the poem will appear in parentheses within the body of my text.

3. Rev. Bartholomew Francis L. Fair, *The Impediment of Abduction,* The Catholic University of America Canon Law Studies, no. 194 (Washington, D.C.: The Catholic University of America Press, 1944), p. xi.

4. The MED (s.v. *fin* adj. 8) cites this line from *Florence* and defines the word as "an agreement or promise fully ratified, final, binding." The entry also suggests comparison with *fin* n. (2), sense 5: "an agreement or contract, especially a marriage contract."

5. Fair, p. 28.

6. *Concilii Tridentini Actorum Pars Sexta Complectens Acta Post Ses-*

sionem Sextam (XXII) Usque ad Finem Concilii (17 Sept. 1562-4 Dec. 1563), ed. Stephanus Ehses (Friburgi Bresgoviae: Herder & Co., 1924), vol. IX, pp. 684-85. The entry is the result of deliberations which ran from 7 August to 23 August, 1563.

7. Supra, p. 4.

8. *Decretales D. Gregorii Papae IX una cum Glossis Restitutae* (Romae, 1582), Lib. 5, tit. 17 de Raptoribus; cf. Augustus Potthast, *Regesta Pontificum Romanorum* (Berlin: Rudolph de Decker, 1873), vol. I, p. 98, no. 1066.

9. Sanctus Basilius, "Epistola Canonica Secunda ad Amphilochium" in Sancti Basilii Re et Nomine Magni Caesareae Cappadociae Archiepiscopi *Opera Quae ad Nos Latine Pervenerunt Omnia* (Antuerpiae: Apud Henricum Aertssium, 1616), Canon XXII (p. 499) and Canon XXX (p. 501).

10. Sancti Gelasii, "Epistola ad Hostilium" in Phillipus Jaffé, ed., *Regesta Pontificum Romanorum ab condita Ecclesia ad annum post Christum natum MCXCVIII,* 2d ed. (Lipsiae, 1885-88), N. 692.

11. *Capitularia Regum Francorum,* vol. I, p. 279 of Legum Sectio II in *Monumenta Germaniae Historica* (Hannoverae: A. Boretius, 1883).

12. Philippus Labbeus and Gabriel Cossartius, *Sacrosancta Concilia ad Regiam Editionem Exacta* (Lutetia Parisiorum: Impensis Societatis Typographicae Librorum Ecclesiasticorum, 1671), cap. LXIV-VIII, cols. 1839-40.

13. Gratianus, *Decretum Gratiani: Seu Verius, Decretorum Canonicorum Collectanea, ab ipso Auctore Gratiano Primum Inscripta, Concordia Discordantium Canonum* (Lutetia Parisiorum: Apud Gulielmum Merlin & Gulielmum Desboys, 1561), cols. 1575-76, 1591-92, 1597-98, 1967-74.

Chaucer's *fyn lovynge* and the Late Medieval Sense of *fin amor*

Edmund Reiss

Duke University

In the Prologue to the *Legend of Good Women*, as part of his criticism of Chaucer's writings, the god of love tells the poet that he should have written of Alceste instead of women like Criseyde: "Why noldest thow han writen of Alceste, / And laten Criseide ben aslepe and reste?" (G 530-531).[1] He states further of Alceste that "kalender ys shee / To any woman that wol lover bee" (F 542-543). As the G version has it, "calandier is she / Of goodnesse" (G 533-534). Both versions of the Prologue go on to explain,

> For she taught al the craft of fyn lovynge,
> And namely of wyfhod the lyvynge,
> And al the boundes that she oghte kepe (F 544-546).[2]

Strangely, no critic has seen fit to comment on this passage except to note the meaning of "kalender" as guide or model.[3] No one has discussed the kind of love represented here as *fyn lovynge* or noted its apparent identification, or association, with "wyfhod."

The use of *lovynge* or, for that matter, *love* preceded by a qualifying adjective is not common in Chaucer's writings. The only parallel with *fyn lovynge* is "long lovynge" in the *Parliament of Fowls* (454), but this is hardly an exact parallel since *fyn* defines *lovynge* in a way that "long" does not and is not meant to. Closer to *fyn lovynge* are the various uses of the term *love* preceded by an adjective describing it as either good or bad, but even these are not very frequent in Chaucer's works. On the one hand are such pejoratives as "flesshly love," "amorous love," "ardaunt love," and "feynede loves."[4] On the other hand are terms describing an obviously desirable love: "verray love," "trewe love," "good love," "clene love," "chaste loves," and "comune love," as well as scores of references to "Goddes love."[5] Although *fyn lovynge* is cited only once in all of Chaucer's writings,

181

the context of both Prologues to the *Legend of Good Women* makes it clear that this love is to be opposed to the usual objectionable kinds of "amorous love"—like that associated with Criseyde—and to any kind of "foly love."

According to the *Middle English Dictionary, fyn,* as cited here, refers to "persons and their actions," and means "accomplished, expert, skilled; subtle, clever," [6] although elsewhere in the MED *fin love* is noted as having its meaning "in a moral sense: pure, true, genuine, perfect; faithful; constant, unwavering." [7] Apparently *fyn lovynge,* as stated in the Prologue to the *Legend of Good Women,* is to be distinguished from *fin love* as it appears in Middle English, though the compilers of the MED do not give their reasons for making such a distinction. But whatever the precise meaning of *fyn,* the love referred to in Chaucer's poem seems to be distinguished from the "foul delyt, what that thow callest love," cited later in the *Legend of Good Women* (1380). As Raison tells Amanz in the *Romaunt of the Rose,* "som love leful is and good" (5195); and Chaucer's *fyn lovynge* would seem to be precisely this "good" love. In particular, its connection with marriage—"of wyfhod the lyvynge"—would appear to distinguish it from illicit passion and from the love that is destructive, what Andreas Capellanus had referred to as the love that "wickedly breaks up marriage and without reason turns a husband from his wife." [8]

This love is likewise to be distinguished from the *fin'amors* that by and large had permeated the lyrics of the Provençal troubadours and that had marked French and Italian poetry of the twelfth and thirteenth centuries. If we are to believe Moshé Lazar, whose words may be taken to represent a significant present-day view, *fin'amors* is from its origins to be contrasted with marriage: for the troubadours, "l'opposition entre *fin'amors* et amour conjugal est absolue et irréductible." [9] As Lazar states it, *fin'amors* cannot exist between married persons; in contrast with married love, *fin'amors* is "essentiellement inquiétude et suffrance"; and it is "par son essence même, un amour adultère." [10] If the gap between *fin'amors* and married love was indeed so impossible in twelfth-century Provence,[11] such was certainly not the case in late medieval England. By the fourteenth century the "relation between love and marriage" may even have been "an ideal." [12] The eighteen balades that make up John Gower's *Traitié,* for instance, are devoted to "les amantz marietz" and are designed "to set forth by argument and example the nature

and dignity of the state of marriage and the evils springing from adultery and incontinence." [13] As opposed to "fol amour," marriage is "honest amour," even "l'amour parfit en dieu justifié." [14] Moreover, Chaucer's *Franklin's Tale,* for all its possible irony, at least has as its premise the compatibility of love and marriage.[15]

As the late thirteenth-century English romance *Arthour and Merlin* indicates, the term *fyn lovynge* was by this time applicable to marriage. The work describes the marriage of Fortiger and the daughter of Angys as follows: "Fortiger for loue fin / Hir tok to fere & to wiue" (480-481).[16] The term *loue fin* may, however, function as a pejorative here; for, as the text explains, although the lady was "boþe fair & gent," she was still a "heþen Sarrazin" (478-479). In marrying her, Fortiger thereby mixed Christian with heathen blood and thus "was curssed in al his liue" (482). The point is not made explicit that *loue fin* is in itself bad, but it may be significant that this term was chosen by the poet to describe a cursed love.[17] The romance goes on to generalize that "mani þousand," in such "weddeloc," "To the deuel gon an hond" (485-488).

The term *fyn lovynge* was also used by the late thirteenth century to describe God's love for man. The *Love Rune* of Thomas of Hales, written at this time, describes Christ as better than all precious stones: "He is i-don in heouene golde / and is ful of fyn amur" (182).[18] This *fyn amur* that fills Christ is obviously comparable to Christian *caritas* and seems to be opposed to the lesser love ordinarily exhibited by man. This elevated use of *fyn lovynge* is reinforced by a passage in the *Castle of Love,* an early fourteenth-century English translation of the very popular *Chasteau d'Amour* of Robert Grosseteste, that refers to Christ's love of man as greater than that of a father for his child: "Neuer ffader for no childe / Of fyn loue nas so freo ne mylde" (1399-1400).[19] "Freo" (generous) and "mylde" here suggest the qualities to be associated with this love. Grosseteste's original likewise speaks of this love as *fin amor.*[20]

This usage is reinforced by that in *Piers Plowman* C, where *fyn love* is explicitly defined as celestial love: the members of the Trinity are said to "Fostren forth a-mong folke Fyn loue and by-leyue / That alle kynne Crystene clanseth of synne" (C. XX, 175-76).[21] This love, associated with right thinking ("by-leyue"), is precisely what man can learn from understanding the Trinity. It is also that which purifies man, which cleanses him of sin. The usage in *Piers* parallels that occurring earlier in Passus XX of the C version, where the poet

speaks of "fyn hope" (C. XX, 83) and may indicate that the term *fyn* exists in late fourteenth-century England not merely as part of a set phrase but as a separable qualitative term suggesting perfection and purification. As such, *fyn lovynge,* or *fin amor,* would seem to be far from the sensual and illicit associations of the term in twelfth-century Provençal, as well as in related French and Italian lyric poetry.

The overt ambivalence of *fin amor* in the late Middle Ages may perhaps best be seen in Jean de Meun's continuation of the *Roman de la rose.* While the term is used several times in association with earthly love and amorous desire,[22] it also appears as a spiritual ideal of purity. When Raison denounces "amor" as a "maladie de pensee" (4348), she attacks those who pretend to be *fins amanz* but who really love "par amors" and deceive with their lies.[23] It is clear, moreover, that *fines amors* (pure lovers, 5381) are not often to be found in this world. Amanz's point that even Tully could never find more than three or four pairs of such lovers since the world was created, though intended by the speaker as a criticism of this love, is really, of course, a censure of worldly love. This pure love is what Raison elsewhere terms "bone amor";[24] it is linked to "charité nete et pure" (5114); and although infrequently found in the world, it is the ideal that should reign everywhere. At the end of the poem, when Amanz sets out to pluck the rose, he ironically describes himself as being like a good pilgrim ("conme bons pelerins"), that is, like a pure lover ("conme fins amoureus," 21317-21319). Although the love that properly motivates the pilgrim on his pilgrimage, his journey of penance, should be synonymous with *fin amor,*[25] the pilgrim image is here used ironically to describe Amanz's journey to the consummation of his desire: the pilgrim staff and sack are but sexual euphemisms, and *fin amor* appears finally in this poem as being perverted by Amanz's illicit desire and wrongheadedness. Our understanding of the irony here partially depends on our recognizing the gap between the ideal *fin amor* and the inadequate human expression of it.

Without going into the history of *fin amor* here,[26] we may still see that although the term permeates ostensibly secular love poetry of the twelfth and thirteenth centuries, by the end of the thirteenth century it is hardly ever found in this poetry, at least in that written in England, France, and Italy. In France the break may be seen strikingly by comparing the poetry of Guillaume de Machaut, who flourished in the first half of the fourteenth century, with that of

later writers. Although the term *fin amor* occurs frequently in Ma-
chaut's writings as a term pertinent to human desire, it is hardly ever
used by Machaut's followers, Jean Froissart and Eustache Des-
champs, later in the century, even though Deschamps wrote
hundreds of secular balades that would seem to provide a perfect
setting for the term.[27] In his overtly religious balade, "Dictié de
Nostre Seigneur," however, Deschamps has God say to Christ that
he should go, "pour nostre amour fine," and redeem humanity.[28]
This use of *fin amor* as a term appropriate to Christian love is in
accord with what in his *Miroir de marriage* Deschamps terms "l'ardeur
de charité parfaicte." [29]

Fin amor as ideal love is also expressed by Christine de Pisan in the
final lines of her *Dit de Poissy,* written at the turn of the fifteenth
century. Here the author prays that God might grant good life and
finally his paradise to all the *fins amans*—"a tous les gentilz / Vrais
fins amans loiaulz et non faintis / Que vraye amour tient subgiez et
creintis." [30] Just as the first part of this poem describes a movement
from worldly beauties and pleasures to the contemplative life of the
convent of Poissy, so the discussion of love moves from a debate
about the pleasures and sadnesses of worldly love to the realities of a
spiritual love beyond the world and the flesh.[31]

Instances of *fin amor*'s referring to human passion are not easy to
find in late medieval French poetry. The term is not used in either
the *Cent Ballades* of Jean le Seneschal (mid-fourteenth century) or
the poems, English as well as French, of Charles d'Orleans (early
fifteenth century); and it appears only once in the poetry of Jehan-
not de Lescurel (late-fourteenth century).[32] Although John Gower
uses the term several times in his *Cinkante Balades,*[33] this courtly
work—really comprising fifty-four balades—moves from courtly love
to an address to the Virgin whom the narrator serves above all
women (II. 9 ff.). The work ends with *fin amor* presented not only as
"vrai amour" and "bon amour" but as a love that will not be false
(XLVII), that brings health ("santé d'amour," XLVII. 24), and
that is related to marriage (XLIX. 16-17), as well as to love of God
(XLIX. 8-9). Such is also the movement of Gower's massive *Miroir de
l'omme,* which proceeds from an analysis of sin to repentance and to a
celebration of the Virgin and "l'estat de fin amour" that is seen in
her response to Christ's passion (28968).[34]

A development similar to that found in French poetry may be
seen in late medieval Italian poetry. Although the term *fin'amore*

permeates love poetry of the Sicilian school in the duecento, after Guido Guinizelli and the beginnings of the *dolce stil nuovo* in the mid-thirteenth century, it only rarely appears.[35] The term is not used by Dante, and I have been unable to locate it in the works of Petrarch and Boccaccio. When Antonio Pucci in the mid-fourteenth century refers to *fino amor* in the last of the nineteen sonnets that comprise his *Corona del messagio d'amore,* he is consciously imitating Andreas Capellanus and the older application of the term.[36] On the other hand, *fin'amore* is significantly found in the works of the late thirteenth-century mystic Jacopone da Todi. In his *Laude,* for instance, speaking of the love of Christ, Jacopone calls it "amor grande, dolce e fino" (LXXXVI. 10).[37]

From the evidence it seems clear that whatever its original significance, *fin amor* (or *fin' amore* or *fyne lovynge*) was by the fourteenth century—at least in England, France, and Italy—not much used to describe human love and longing; when used, it generally refers to legitimate married love and to Christian charity. Futhermore, every use of the term in Middle English refers to marriage or divine love. When in the *Legend of Good Women* Chaucer links *fyn lovynge* to "wyfhod," his usage is wholly in accord with that of his contemporaries and may suggest a quality comparable to that associated with the "fine love" of the *Love Rune,* the *Castle of Love,* and *Piers Plowman.*

By having this love advocated by the god of love—that is, by Cupid—Chaucer may, however, be purposefully undercutting it and ironically making it seem more like the illicit love laughed at in Ovid's *Ars Amatoria* and Andreas's *De arte honeste amandi* than like anything legitimate or ideal. As Chaucer presents him, the god of love is hardly a manifestation of the Christian God: he blames Chaucer for hindering people in their "devocyoun / To serve" him, and for holding it "folye / To truste" in him (G 252-253). He also regards the *Roman de la rose* as heretical—"an heresye ageyns my lawe," for it makes "wise folk" withdraw from love (G 255-257). Although, especially in the G Prologue, this god of love constantly defends women, referring to them as "clene maydenes," "trewe wyves," and "stedefaste widewes" (G 282-283), the classical and patristic authorities he cites, notably "Jerome agayns Jovynyan (G 281), are hardly pro-feminist.[38] The god of love, who swears "By Seynt Venus, that my moder ys" (F 338) [39] and who puts himself in his consort's hands (F 442 ff.; G 433 ff.), is not an adequate guide to right loving.

Alceste, the god's consort and ideal—she who "taught al the craft of fyn lovynge, / And namely of wyfhod the lyvynge"—would seem to be little better as a spokesman for proper love. Although commonly understood as an ideal wife—because she sacrificed herself so that her husband might live [40]—she is seen here rejecting Chaucer's argument that in telling of Criseyde and of the Rose, his "entente" was "To forthere trouthe in love and it cheryce, / And to be war fro falsnesse and fro vice / By swich ensaumple: this was my menynge" (G 461-464; F 471-474). Her response does not demonstrate a fair, much less charitable, view of love: "Lat be thyn arguynge, / For Love ne wol nat counterpletyd be / In ryght ne wrong" (G 465-467; F 475-477). If her credibility is not helped by her lack of concern with whether love is right or wrong, it is strained by her being associated with such "good women, maydenes and wyves" (G 474; F 484) as Cleopatra, who, according to the command of the god of love, is the first good woman whose story Chaucer is to tell (G 542; F 566).[41]

As "wyfhod," moreover, is referred to by the god of love, it may be considered a "craft" (esp., F 544), that is, an art or skill, something perhaps related to such ironic "arts" of loving as those written by Ovid and Andreas, perhaps even similar to what is made of marriage by the Wife of Bath later in the *Canterbury Tales*. The pejorative use of "craft" as something suggesting the occult or as something opposed to nature may be found in the English language of the late fourteenth century, and the term may also imply "skill or art applied to deceive." [42] In any case, the god of love presented here by Chaucer is not noticeably a god of marriage; and the tales of "trewe" lovers told by the poet are neither the accounts of wives and husbands nor the stories of "pure" lovers such as Saint Cecilia in the *Second Nun's Tale*.

Notwithstanding the ambiguity of the love presented in the *Legend of Good Women*—in both the Prologue and the nine tales—the *fyne lovynge* referred to by Chaucer would probably have been viewed most immediately by the poet and his audience as an ideal love. And although this ideal may not be supported by the words of the god of love and Alceste or borne out by the tales of earthly love and loss that follow, the ideal itself remains to make us aware of the various inadequacies of love detailed in this poem.

NOTES

1. All quotations from Chaucer are according to *The Works of Geoffrey Chaucer,* ed. F. N. Robinson, 2d ed. (Boston: Houghton Mifflin, 1957), and are cited by line number.

2. G reads the same except for omitting "the craft of"; that is, "for she taughte of fyn lovynge, / And namely . . ." (G 534-36).

3. See esp. *The Complete Works of Geoffrey Chaucer,* ed. W. W. Skeat (Oxford: Clarendon Press, 1894), vol. III, pp. 309-10; also Robinson, p. 846.

4. *ParsT* I 203, 942; *Bo* III, m. 12, 13-14; *TC* V, 1848.

5. *MerT* E 2183; *FknT* F 1477; *LGW* 2227, 2542; *RR* 4587, 5793; *SNT* G 159; *Bo* II, m. 8, 23; IV, m. 6, 54-55.

6. MED, III, 566, sec. 9.

7. Ibid., III, 565, sec. 6; cf. *Oxford English Dictionary,* IV, 227.

8. See Andreas Capellanus, *The Art of Courtly Love,* trans. J. J. Parry (New York: Columbia University Press, 1941), p. 196; "Amor enim inique matrimonia frangit et cogit sine causa ab uxore avertere virum," *De amore,* ed. Amadeu Pagès (Castelló de la Plana: Soc. Castellonense de Cultura, 1930), p. 191. See also Parry, p. 100.

9. Moshé Lazar, *Amour courtois et 'fin'amors' dans la littérature du XIIe siècle,* Bibliothèque

Française et Romane, Études Littéraires 8 (Paris: Klincksieck, 1964), p. 60. See also his earlier statement of this view: "L'idéologie et la casuistique de la *fin'amors," Filologia e Letteratura,* 8 (1962), 233-73, 380-407; as well as A. J. Denomy, *"Fin'Amors:* The Pure Love of the Troubadours, Its Amorality and Possible Source," *Mediaeval Studies,* 7 (1945), 139-207.

10. Lazar, *Amour courtois,* pp. 61, 63.

11. Cf. Joseph L. Coppin, *Amour et mariage dans la littérature française du nord au moyen-âge,* Bibliothèque Elzévirienne (Paris: Librairie d'Argences, 1961).

12. Gervase Mathew, "Marriage and *Amor Courtois* in Late Fourteenth-century England," *Essays Presented to Charles Williams* (Oxford: Oxford University Press, 1947), pp. 128-35, esp., p. 135.

13. *The Complete Works of John Gower,* ed. G. C. Macaulay (Oxford: Clarendon Press, 1899), I, lxxxiv. The full title of this work, as given by Gower, is "un traitié selonc les auctors pour essampler les amantz mariez." As one of the Latin marginal glosses explains: "Qualiter honestas conjugii non est libidinis aut avaricie causa" (IV. 1 [I,

381]). As Macaulay points out, in several manuscripts the *Traitié* is attached to Gower's *Confessio Amantis,* "with a heading to the effect that the author having shown above in English the folly of those who love 'par amour,' will now write in French for the world generally a book to instruct married lovers by examples to keep the faith of their espousals" (ibid.).

14. See V. 15 and XVII. 28 (ed. Macaulay, I, 382, 391). See also J. A. W. Bennett, "Gower's 'Honeste Love,'" *Patterns of Love and Courtesy. Essays in Memory of C. S. Lewis* (London: Arnold; Evanston, Ill.: Northwestern University Press, 1966), pp. 113-14.

15. See esp., *Fnk T,* F 791-98.

16. *Arthour and Merlin,* ed. Eugen Kölbing, Altenglische Bibliothek 4 (Leipzig: Reistand, 1890), p. 16. The *fin amor* term is lacking in the poem's source, the Vulgate *Estoire de Merlin;* see *The Vulgate Version of the Arthurian Romances* (Washington, D.C.: Carnegie Institution, 1908), vol. II, p. 23.

17. The related English prose *Merlin,* along with Henry Lovelich's *Merlin,* both dating from the fifteenth century, do not employ the term.

18. *English Lyrics of the XIIIth Century,* ed. Carleton Brown (Oxford: Clarendon Press, 1932), p. 73. As Brown points out, the *Love Rune* was apparently "still remembered and imitated as late as the end of the fourteenth century" (p. 198). Although some alliteration is found throughout the poem, it is not sufficient to be considered a significant determinant of word selection.

19. *The Minor Poems of the Vernon MS,* I, ed. Carl Horstmann, EETS OS 98 (London: Kegan Paul, Trench, Trubner & Co., 1892), p. 390; see also variants, p. 402.

20. See *Carmen de creatione mundi (Chasteau d'Amour),* l. 1377, in *Robert Grossetete's Chasteau d' Amour,* ed. M. Cooke (Caxton Society 15, 1852; reprinted New York: Franklin, 1967), p. 48. See also the Harleian version, l. 1370 (Cooke, p. 185).

21. *Piers the Plowman,* ed. W. W. Skeat (London: Oxford University Press, 1886), I, 511; in the B version "fyn loue" is termed only "loue" (B. XVII, 209).

22. See, e.g., ll. 8391, 10290, 12499, 13655. *Le Roman de la rose,* ed. Félix Lecoy, CFMA, 92, 95, 98 (Paris: Librairie Honoré Champion, 1966, 1970).

23. Ll. 4361-62. Charles Dahlberg properly translates *fins amanz* here as "pure lovers." *The Romance of the Rose* (Princeton: Princeton University Press, 1971), p. 96.

24. E.g., ll. 5109, 5459.

25. Such is found, for instance, in the *Nouvelle complainte d'outremer* of Rutebeuf, a contemporary of Jean de Meun, where the author speaks of the "pelerinage fin" on which the sinner goes to become "pure et fine" (60-62). *Oeuvres complètes de Rutebeuf,* ed. Edmond Faral and Julia Bastin (Paris: Picard, 1959), I, 499. Rutebeuf does not use the term *fin amor,* but in his writings *fine* is obviously not only a qualitative term, it is one properly linked with "pure."

26. I am preparing a detailed study of the development of this term in medieval literature.

27. I have been able to find the term only in CCCCXXXVI. 5 and DCXXIV. 6. *Oeuvres Complètes de Eustache Deschamps,* ed. Le Marquis de Queux de Saint-Hilaire and Gaston Raynaud, SATF 10 (Paris: Firmin Didot, 1880-94), vol. III, p. 308; vol. IV, p. 83. Deschamps's favorite term for love is *vray amour.*

28. L. 27. *Oeuvres,* VII, 142. Deschamps here plays with the adjective *fine* in relation to the verb *finir,* having the sense of end or terminate: " 'Va! et si monde,' / A son filz pour nostre amour fine, / 'Ce pechié, et ceste morte fine,' / Et pour ceste amour qui fin n'a / De no redempcion fina . . ." (pp. 26 ff.).

29. L. 6319. *Oeuvres,* IX, 206. The

Miroir de mariage influenced Chaucer's later writings. See Robinson, p. 844.

30. Ll. 2073-75. *Oeuvres poétiques de Christine de Pisan,* ed. Maurice Roy, SATF 23 (Paris: Firmin Didot, 1886, 1891), vol. II, p. 222.

31. The term *fin amor* in reference to earthly love is not much used by Christine. See *Dit de Poissy,* l. 1148; *Ballades,* IX. 25; *Complaintes amoureuses,* I. 20; *Dit de la rose,* l. 138; *Debat des deux amans,* ll. 1048, 1182, 1268. As with Deschamps her preferred term is *vraye amour.*

32. Jehannot de Lescurel, *Chansons, ballades et rondeaux,* ed. Anatole de Montaiglon (Paris: Jannet, 1855), p. 26.

33. Gower, *Cinkante Balades,* VII. 1; XXI. 5; XXIII, 6; XXXI. 5; XXXVII. 2; XLVII. 2, 15 (ed. Macaulay, I).

34. Macaulay, I, 322. See also the analysis of the term *fin amour* in John H. Fisher, *John Gower, Moral Philosopher and Friend of Chaucer* (New York: New York University Press, 1964), pp. 76-77.

35. Significantly, Guido uses the term only in his *canzoni siciliane.*

36. XXXIX. 16; in *Rimatori del trecento,* ed. Giuseppe Corsi, *Classici italiani* (Turin: Unione Tipografico, 1969), p. 840. The term is not found in any of the writings included in *Rimatori del tardo trecento,* I, ed. Natalino Sapegno, *Testi de*

letteratura italiana (Rome: Edizione dell'Atheneo, 1967).

37. Jacopone da Todi, *Le Laude,* ed. Luigi Gallacara (Florence: Libreria Editrice Fiorentia, n.d.).

38. See Robinson, p. 844; and Francis Lee Utley, *The Crooked Rib. An Analytical Index to the Argument about Women in English and Scots Literature to the End of the Year 1568* (Columbus: Ohio State University, 1944).

39. G reads "By Seynt Venus, of whom that I was born" (313).

40. Besides Chaucer's reference to this sacrifice in *LGW,* G 501-4; F 513-16, see, e.g., Gower's application of her

story to show "the trouthe of wommen and the love" *(Confessio Amantis,* vol. VII, 1946).

41. Scholars have long puzzled over the credibility of such "saints of love" as Cleopatra, Dido, and Medea; see, e.g., Harold C. Goddard, "Chaucer's Legend of Good Women," *Journal of English and Germanic Philology* 7 (1908), 87-129; 8 (1909), 47-112; and Robert M. Garrett, "Cleopatra the Martyr and Her Sisters," *JEGP* 22 (1923), 64-74.

42. OED, I, 1128, sec. 4a. See also sec. 2c (ibid.), and MED, II, 699, secs. 2b and 3c.

A Vocabulary for Chaucerian Comedy: A Preliminary Sketch

Paul G. Ruggiers
University of Oklahoma

I

I am attempting in this essay to lay out a vocabulary for handling the complex subject of comedy in Chaucer. I have leaned heavily on Aristotle's definitions of character in the *Nicomachean Ethics* and the *Rhetoric,* upon the Coislinian *Tractate,* and upon Lane Cooper's attempt to recreate an Aristotelian theory of comedy.[1] It has been fairly clear that we are generally more comfortable with the vocabulary for romance and tragedy than we have been for comedy, perhaps because of formalistic tendencies in these modes of experience and because there has been a more definable tradition for them. I have wedded several schemes: one a series of headings under general rubrics representing the categories needing illustrations; another, a system resulting from Aristotle's suggestion in the *Rhetoric* about the sources of laughter, and finally, a series of topics borrowed from the Coislinian *Tractate.*

I will restrict my discussion mainly to considerations of plot and character,[2] trying to avoid the complicated question of Chaucer's ironical point of view regarding the human condition, and avoiding as much as possible considerations of the larger movement of the *Canterbury Tales* as a whole, the placement of the tales in the frame, and the relations between tellers and tales.

Much of what we suggest here will seem obvious to sensitive readers of Chaucer; it seems justifiable on the grounds that definition of the terms of comic technique for Chaucer is sparse and that such an attempt as this one may serve to point up areas of research for others. If it does nothing more than to demonstrate that there is a universal language of comedy and that there are affinities between comic writers of any age, then nothing will have been lost. There is always a danger that a theory of comedy will aridify the subject more than can be justified. In all classification there is the inherent sin of imposing system upon art and therefore of making that art

appear mechanical. Clearly no system can do justice to any of the great geniuses of comic writing, their wit and irony, the special flavor of license, their power to challenge staid opinion, that peculiar innocence that allows them to escape defilement even in the relating of the obscene. This said, let us move on.

II
THE PROBLEM OF DEFINITION

There are certain critics who believe that it is not possible to define comedy on the ground that no definition will in any way illuminate our experience of it. There is not much point in repeating the terms of the debate. Yet, Chaucerian comedy, which everyone takes for granted, rarely finds its way into discussions of comedy, the omission being explained away on the ground that theory of comedy is mostly dramatic anyway. What, in fact, is there to explain? Accepting the tradition of the comic tale, what are the criteria by which to understand it? And what tales in Chaucer's canon shall we generalize from?

If we set aside the prose tales, the saints' lives (*Man of Law's Tale, Clerk's Tale, Prioress' Tale, Second Nun's Tale*), the clear romances (*Knight's Tale, Squire's Tale, Franklin's Tale,* though the latter qualifies as comic in some of its elements, and the *Wife of Bath's Tale,* a romance with strong comic infusions that need to be taken into account) what remain are comic structures of one sort or another: the *Miller's Tale, Reeve's Tale, Cook's Tale, Shipman's Tale, Merchant's Tale, Friar's Tale, Summoner's Tale, Canon's Yeoman's Tale,* and the *Pardoner's Tale.* To these we must add the *Nun's Priest's Tale* and *Sir Thopas* as burlesque or parody, and the *Wife of Bath's Tale* as a mixed form. Obviously these are not all the same kind of structure; laughter is not the key to all of them. Some of them are more "serious" than others, having weight given them by the presence of thought provoking matter in them; some seem lighthearted, others manage to convey either by their position in the *Canterbury Tales* or their assignment to their narrator certain unpleasant levels of emotion.

The definition of comedy given to the Knight, the result of a long historical tradition going back to Theophrastus, developed simultaneously with tragedy as an action beginning in misery and ending in prosperity.[3]

> As whan a man hath been in povre estaat,
> And clymbeth up and wexeth fortunat,
> And there abideth in prosperitee.
> Swich thyng is gladsom, as it thynketh me. . . . (B 3965-3968)

The definition leaves something to be desired. No one can object to the general term "gladsom"; it implies an entire attitude towards experience—one intends something to be received as happy; or to put it another way, one is predisposed by clues of character, tone, ambiance, and language to accept the view of experience as non-serious, to see the good things of life trivialized.[4]

The definition is thus useful largely as making a simple distinction between what is basically serious and nonserious, weighty and lightsome. But the definition as given does not fit Chaucer's practice entirely, as we may see from a consideration of the closures of his tales: A protagonist outwits an adversary, arriving at a curious stalemate in the *Nun's Priest's Tale;* a lover triumphs at the expense of another and with considerable pain to himself in the *Miller's Tale;* the most likable character of the *Shipman's Tale* remains duped at the close, and though the wife triumphs, she too has been duped. The summoner of the *Friar's Tale* is carried off to perdition; the rioters of the *Pardoner's Tale* are damned in their own self-annihilating way; the long complications of the *Canon's Yeoman's Tale* must be seen in the context of a losing art; and the knight of the *Merchant's Tale* is blind and deceived, even with eyesight. In short the definition can be made to apply only by expansion of its basic terms into considerations of tone, character, and plot; I question whether we find Chaucer's comic tales uniformly "happy" except in their total effect of producing in the audience or reader the general sense that the ending "should be so."

III
PLOT

We will make a distinction at the outset that is obvious to everyone but needs to be set forth early: (a) Half of the comic tales are about conflicts in which the reprisal is a sexual triumph over a conventional, older person. Of these tales, i.e., those of the Miller, Reeve, Merchant, and Shipman, only the *Shipman's Tale* does not tell us about the relative ages of the agents except to imply by the age of the Monk the general age of all. (b) Half of the tales, those of the

Friar, Pardoner, Summoner, and Canon's Yeoman, are nonsexual tales, comedies without lighthearted humor; these are, more frankly, unmaskings. They each have some quality of the sinister about them that raises ethical considerations in a way that the first group does not; they describe ugly actions in the process of raising questions about the kind of society that allows them. They are comedies that frankly face up to serious human concerns: good and evil, life and death. The comedies about adultery, it should be pointed out, may also raise criticisms of a society that tolerates the marriage of youth and age; the *Shipman's Tale,* for example, or the *Merchant's Tale,* both have the capacity to challenge us at levels we have not anticipated. Seriousness is always an implied quality in Chaucerian comedy.

In both types of comedy, the whole tendency of Chaucerian comedy is to move from an old law, stated at the outset (usually as an enchaining marriage or family order in the tales of the Miller, Reeve, Merchant, and Shipman), to a wily escape from its bondage into momentary freedom from its constraints; or in the darker comedies (those of the Friar, the Summoner, the Pardoner, and the Canon's Yeoman's Introduction) to tear away illusion and hypocrisy by building the *agon,* not around the opposition of youth and age, but around demonstrations of conspiratorial behavior destined to be exposed as hypocritical, thievish, or mendacious.

These two types are quite different in their emphasis, the first kind being aimed largely at giving satisfaction through cleverly arranged episodes, suspense, and a sense of something being carefully nudged toward surprise and an unexpected conflation of happenings, like the episode of the misplaced cradle in the *Reeve's Tale,* or the cry of "water, water" in the *Miller's Tale,* which tops all previous surprises. The closing barrage of puns at the conclusion of the *Shipman's Tale* enables the level of comic statement to soar immediately into the dimensions of verbal wit.

In the second kind of tales, those of Friar, Summoner, Pardoner, and Canon's Yeoman, the emphasis is largely upon describing the ethos of a society or group: something more communal, perhaps a community of demon types, mostly hypocrites and liars, persons wearing masks of one sort or another, who are either exposed or destroyed. In the *Pardoner's Tale,* for example, in the enveloping sermon a scapegoat is made by his own words to unmask himself and to undergo the threat of expulsion (only to be restored in Chaucer's comic generosity); and similarly in the exemplum, the three rioters, one of whom serves as a scapegoat, get what they deserve, being

shown as thieves and murderers. It might be noted that the figure of a scapegoat may make for pathos—a mood that Chaucer manages to avoid here—which can destroy the comic tone if carried too far.[5]

In at least two of the tales, the *Friar's Tale* and the Pardoner's exemplum, where the intention is clearly preacherly, the thematic statement is overtly moral and self-righteous; and there is also an elevated moral appendage to the *Canon's Yeoman's Tale* which somewhat distresses a purely comic impulse.

The distinction that may be made between the two kinds of comic structure has to do with a deeper, more serious view of things, a willingness to make comparison between higher and lower norms in the manner of satire and irony. Both types of tales yield their special satisfactions: the closed garden of the *Merchant's Tale* has been successfully invaded, the upward mobility of the Reeve's snobbish family has been damaged, the unwise marriage of unlikes in the *Miller's* and *Merchant's* tales has been given its "just" due and the guileless simplicity of the merchant of the *Shipman's Tale* has been confirmed (but he seems no worse off than before; the other characters seem faintly shameful). In the others, perhaps because of their stronger moral and social concerns, the satisfaction derives from seeing conventions, theological and moral, vindicated.

A writer who vindicates or defends piously held beliefs is writing comedies of a limited range; but they are not to be dispraised for being so. For the Christian poet, stripping off the disguises and masks of villainy precisely in terms of religiously defined norms and writing comedies about damnation demonstrates that comedy may derive its materials from anywhere; attitude and tone are all. And obviously comedy does not exclude suffering; it makes capital of it but uses it for its own ends and with the right tone and attitude.

These two broad types of comedic structures in Chaucer thus confirm that double perspective which is implicit in comedy generally. One cannot know the merely existing without testing it against essence, the factual without the ideal, the life of instinct without the life of reason, body without soul. The norms which are vindicated in Chaucer's comedies about adultery are clearly those of nature; in the others, the tension is clearer in terms of good and evil men and women. Chaucer does not pretend that his protagonists are not bad men and women; they are shown to be so, and one has the feeling that their predictable destruction has been part of a larger justification of law.

Chance, trickery, and improbable possibilities may be the laws of

the first kind of comedies; from the perspective of the other type, these laws dwindle before an inexorable law. In the first type, things turn out well for the agents; in the second, for the audience.

I do not know whether Chaucer's comic structures can be placed on any scale. Irony of various sorts invests them all. But of the tales of license and the "adultery" tales, the *Miller's Tale* is the "happiest," the *Reeve's Tale* less so, because the somewhat morose and dispeptic disposition of the miller of the tale tends to cast a large shadow over the action; and he has something of the humor about him. The *Shipman's Tale* even less so, perhaps because of the age of the persons involved: they should not behave so lightheartedly, or perhaps we feel that in the tale nothing is held sacred. They are lightweight alongside the *Merchant's Tale*'s somewhat more grandiose style and manner. Essentially, in formal ways they are the same; but they are all different in tone, in characterization, in kind of structure, and in the amount of the serious that has been added to the plot.

The others are ironic-comedies, built around the basic theme of unmasking. In these it is society at large that has profited from the unmasking. If the villains will not mend their ways, then they must go. And their going is justified when we consider the demonic values which they had hoped to impose upon the world. In the outer frame, the Pardoner and the Yeoman stay, the Canon goes; in the tales, the friar is carried off to hell; the rioters die.

Chaucer's range is considerable in its effects: there are tales in which considerations of moral responsibility are totally absent; others in which the question of rightness and wrongness somehow springs into our minds *(Shipman's Tale*—at least it disturbed earlier generations of scholars); still others in which the agents are frankly described as bad persons and so are calculated to rouse feelings of indignation in us.

<div align="center">

IV

SOME ELEMENTS OF PLOT

</div>

Complex Plot: Discoveries and Reversals. In Aristotle's sense, Chaucer's comedies are generally complex; they are actions attended by discoveries and reversals of fortune arising from the structure of the plots. But the plots themselves are built up out of ludicrous incidents upon which the discoveries and reversals depend. Prime examples are afforded by the *Miller's Tale*'s clever alternations of success and failure for Absolon and Nicholas, the deception of

Absolon at the window on two occasions and his carrying out of revenge; the swift discoveries and reversals for Absolon and the reversal of fortune for Nicholas when he is smitten by the coulter afford three obvious instances in which laughter is elicited by ridiculous actions. The conclusion of the tale, in which the old husband, fallen and injured, fails to gain an audience for his side of the story, is also a major reversal. In the *Reeve's Tale,* the loosing of the horse leads to a major reversal for the young students; and the positioning of the baby's cradle leads to a series of discoveries (by false inference) and reversals of fortune for the various agents. Similarly, in the *Shipman's Tale,* the wife's fortunes are threatened with a reversal from good to bad fortune when her husband inadvertently reveals to her that she has been duped by the monk; her quick wit produces a reversal for the better, and a threatened continued bad fortune for the unwitting husband.

Comic Incidents. Such discoveries and reversals are part and parcel of absurd or comic incidents: a blind man suddenly regains his eyesight and sees his wife in a tree with her lover; a would-be lover is deceived into kissing his love's nether eye and on a subsequent occasion is farted upon by her lover; a young student, thinking he is getting into bed with his fellow student, gets into bed with the father of the girl he has just swived; a wife bargains her body for quick money from a monk which he subsequently borrows from her husband; a summoner and a demon each demonstrate separately what is legitimate prey, each incident being attended by its own discoveries and reversals of fortune; a friar has his hand farted upon; three rioters find gold and in the process find death; a feckless, gullible priest participates in successful experiments to make silver; a rooster-hero "sings" for his enemy. These are of course only the major incidents from the tales, attended by discoveries and reversals of fortune. There are others.

Seriousness and Cognition. Though Chaucer divides his work into serious and nonserious forms, he has the often noted tendency to inject serious elements into comic forms as well as the opposite tendency to make jests within the romances. It should not be surprising to discover that Chaucer's comedies always contain something serious against which we measure the absurd. The *Miller's Tale* has its parody of romance, its biblical allusions; the *Reeve's Tale* has its gnomic wisdom, etc. As many critics have noted, everything in a comedy need not be laughable. But what is serious in Chaucer's tales

enables us to see the themes in the largest context; we "learn" something in the evolution of the plot, and the cognition confirms what is pleasant to us. Although the *Tractate* states that comedy "has laughter as its mother," serious cognition may transcend the laughter, as in the *Nun's Priest's Tale,* where one has the sense of a sublime Presence laughing at the follies of mankind, and before which mankind shrinks to smallest dimensions; or as in the *Franklin's Tale* where one has a sense of swirling upward out of the confines of a romance into the loving and indulgent view of the human condition, a view that escapes from the latitudes of mere comedy into those of a high moral stance.

Too, some of Chaucer's comedies are "dark" comedies, in which the comic retreats from lightheartedness before the weight of truly serious considerations. The *Merchant's Tale, Franklin's Tale, Pardoner's Tale,* and even the *Summoner's Tale* with its horrid exempla of power casually used, have the capacity to adduce serious matters for the sake of making heavier kinds of statement. The theology of marriage, the relation of penance to salvation, considerations of destiny, and the betrayal of kindness may all be seen as various levels of serious thematic statement throughout the entire gamut of Chaucerian comedy.

Suffering. In Chaucerian comedy we may expect elements of suffering, either physical or mental, but offered to us in such manner that it will seem ludicrous; or we will not be overly conscious of the pain or ugliness of the situation because of the tone of presentation. The comic tales have a large share of violence, suffering, and discomfiture: broken arms, threats of death, burnings, assaults, beatings, blindness, and mental anguish; all demonstrate that comedy uses what may seem at first glance be matter not suited to it. Obviously they are not dealt with seriously but are seen as arising out of causes and situations that are established in various ways as comic. Absolon is chagrined and discomfited after the fateful kiss; the merchant's wife in the *Shipman's Tale* has a shock of surprised indignation from which she quickly recovers; and the worse physical effects, the old husband's broken arm in the *Miller's Tale,* the beaten pate in the *Reeve's Tale,* and the threat of death in the *Nun's Priest's Tale,* are treated lightly. Generally husbands remain deceived; the deceivers go free.

In the *Friar's Tale* and the exemplum of the Pardoner, their cautionary preacher's gambit makes death and damnation highly

desirable; our satisfaction arises as much from the fate meted out as from the surprise and wonder in watching the plot work out to its conclusion.

Agon. The comic *agon* has been a comic necessity since at least the time of Aristophanes, as a balance to the phallic element which is the "other" content of comedy generally. Though all the tales have an *agon* in the generalized opposition of the main agents of the story, there are several instances of a proposition being debated in a "classical" way: Justinus and Placebo in the *Merchant's Tale* take the sides respectively of the old and new law; Chauntecleer and Pertelote in the *Nun's Priest's Tale* debate the truth of dreams; the old hag of the *Wife of Bath's Tale,* to become more general, offers arguments against the issues of moral recalcitrance in the debating manner; Dorigen weighs the merits of death and dishonor; and there is, too, the great *agon* of the *Canterbury Tales* debated by the narrator in several places, on the question of prudence versus morality, and artistic responsibility versus artistic freedom.

Laughter from Content. The *Tractate* suggests two sources of laughter for comedy, from the "things" depicted and from the diction. The section on action or "things" (roughly content) divides into considerations of plot devices of one sort or another and of ways of depicting the characters as "worse than average" or ludicrous and absurd. These categories pertaining to plot are as follows (the others will be given in the section on character):

Deception. Deception is one of the staples of comedy, along with surprise. All of Chaucer's "clever" comedies exemplify the ingenious, elaborate deceptions, lies, tricks, and stratagems by which husbands are taken in. But deception may be seen equally well in the others, when, for example, the Summoner is tricked into damnation by the demon of the *Friar's Tale,* or the friar of the *Summoner's Tale* is duped into putting his hand down the back of Thomas, or the poor priest in Part II of the *Canon's Yeoman's Tale* is deceived into thinking he can make silver. Some of the deceptions have a quality of the sinister, being allied to the deeper considerations of salvation and death, not only in the *Friar's Tale* but in the *Pardoner's Tale* where the two rioters plot to kill the third, do so, and meet their own unforeseen demise. One thinks also of the elaborate duping of the Wife of Bath's three old husbands, and the fox's deceiving of Chauntecleer in the *Nun's Priest's Tale.*

It is difficult to separate deception from the next category, that of

the *unexpected*, since the major deceptions often come to us with an element of surprise. And clearly too, in word-play there is always an element of the unexpected and of surprised wonder as we take in a clever conclusion. But here we have in mind that sequence of events held together by comic probability by which the poet leads us through sometimes labyrinthine complications to a conclusion that elicits from us a burst of laughter, or a flash of intuition, or a sense of approval. In this category of acts rather than of language belong all the tricks and outwittings, dupings and pretenses, without which comedy cannot exist.

The unexpected is, however, dealt with as a separate category in the *Tractate*, and we see it as one of the chief ingredients of comedy, along with deception and surprise. The verbal agility of the wife at the close of the *Shipman's Tale;* the loosing of the stallion, perhaps; the aftermath of the misplaced cradle in the *Reeve's Tale* when the wife gets into bed with Alan and John gets into bed with the miller; the swift deaths of the Pardoner's exemplum; the demon of the *Friar's Tale* carrying off the summoner with the line, "Thou shalt with me to helle yet to-nyght"—the result of the old woman's statement of repentance as necessary to salvation; the shout of "water, water!" and its aftermath in the *Miller's Tale;* the coupling in the pear tree in the *Merchant's Tale;* the fart exploding in Absolon's face, as well as that other in the friar's hand—all may serve as examples that fit this category.[6]

Starkie thought that the *impossible* should include "all degrees of unreason, illogicality, unintelligibility, intended to excite laughter," to which Cooper adds only the phrase, "violating the laws of natural sequence." [7] More in keeping with Starkie and Cooper's definition, and linked both to garrulity or disjointed narrative, may be the old man's night spell in the *Miller's Tale* and the elaborate descriptions of processes and lists of elements in the *Canon's Yeoman's Tale*. The whole study of illogic for comic purposes in patterns of rhetoric is surely worthy of further study.

It is simpler to include here only those obvious examples that enable us to see how much comedy depends upon our willingness to move beyond the factual, plausible world we ordinarily inhabit into considerations of persons or devices that either do not exist in everyday life or that do exist but are put to absurd use in comedy. Such examples include the "magic" removal of the black rocks in the *Franklin's Tale,* the urbane and articulate demon of the *Friar's Tale,*

the physical encounter with Death in the *Pardoner's Tale;* the belief in the alchemist's power in the *Canon's Yeoman's Tale* to convert base metals into gold and silver; the challenge to the young clerics of the *Reeve's Tale* to make by their "philosophy" a large room of his cottage; and—I am tempted to add here—the daring acrobatics in a pear tree of the *Merchant's Tale,* along with a surer example, the marvellous partition of a fart at the conclusion of the *Summoner's Tale;* and that of the old man's belief in a possible repetition of Noah's flood in the *Miller's Tale.*

Loose Structure. The long *confessio* of the Wife of Bath (including the two interruptions by the Pardoner and the Friar-Summoner altercation), along with its connection with the tale she tells; that of the Pardoner with its somewhat free, associational coherence; much of Part I of the Canon's Yeoman's criticism of the profession of his master; and the slowly developed display of the friar's personality in the *Summoner's Tale* all manifest something of the improvisational loose structure that is the ancient inheritance from Greek and Roman comedy, both in dramatic and narrative forms. Not only is the total structure of the *Canterbury Tales* episodic or mechanical; but the tales themselves show a tendency toward developing the comic topic in segments: the lengthy complaint of Dorigen in the *Franklin's Tale,* Chauntecleer's exhausting recitation of dreams, the long discussion of marriage at the outset of the *Merchant's Tale,* even the exempla on wrath in the *Summoner's Tale* and the portraits of Alison and Absolon in the *Miller's Tale* provide fairly obvious examples.

Chaucer was not working inadvertently towards the effects of disconnectedness. Gothic aesthetics offered a sympathetic option of the processional and sequential as much as the consequential and logical, which goes well with Chaucer's cool reportorial stance and enables him to break the mood of narration, to interrupt its flow, forcing our own increased distance as he calls attention to a particular episode or tells us baldly he is moving on to something else. Robert Jordan calls such moments "recurrent disruptions of illusion." [8] We thus have a double satisfaction—that of participating in a mimesis as a product as well as that of participating in the process of making the illusion work.

Related to the general category of disjointed narrative is that of garrulity. No one would accuse Chauntecleer, Dorigen, the Wife of Bath, the Pardoner, the Canon's Yeoman, or even the Reeve in his Introduction, of being short of wind. In each of these instances,

interesting talk, sometimes for its own sake, becomes discursive and associational, and therefore contributes to the general impressions of disconnected narrative.

V
THE DIANOETIC FUNCTION

Comedy may be seen as a contest between opposing value systems: i.e., between any systems that serve as the two aspects of the *agon;* and struggle for dominance or survival may be regarded as the thematic skeleton of the plot or, more conventionally, its intellectual element. The *Tractate* gives names to the opposed sides: *gnome* or opinion, and *pistis* or proofs and persuasions by which the strength of the *gnome* is tested or opposed. Opinion belongs generally to the older or more conventional members of society, though not always; proofs and persuasions are encumbent upon the opposition. These latter jibe with the forms of proof given by Aristotle in the *Rhetoric* I, 15: oaths; compacts or conspiracies; testimonies or witnesses; tortures or ordeals; and finally, laws.[9]

Opinion

Here we must place all maxims, *sententiae,* extended discussions of values and the worth of things, or descriptions of the qualities of life, etc. One thinks immediately of the set speeches of Arcite and Palamon, those of Theseus, the long speech of the hag in the *Wife of Bath's Tale,* Dorigen's disquisition on evil, as well as the definition of love and friendship earlier in the *Franklin's Tale,* among the romances; among the comedies, the proverbial element of the *Reeve's Tale,* the Summoner's definitions of wrath, the Pardoner's sermon statements (not the exempla, which fall under the heading of testimonies or witnesses), the speeches of Placebo and Justinus in the *Merchant's Tale,* the defenses of the values of marriage in both the *Wife of Bath's Introduction* and the *Merchant's Tale,* the merchant's discourse on luck in the *Shipman's Tale,* the quotation from Cato in the *Miller's Tale,* to name a few obvious examples. More generally we may see the opening propositions of the *Shipman's Tale* and the *Merchant's Tale* as the *gnome* which the remainder of the tale either illustrates or challenges.

Proofs or Persuasions

 1. *Oaths:* There are so many oaths in Chaucer that we shall have to content ourselves with only a few examples. They have a range from

swearing by the name of God, his bones, his blood, of saints real and imaginary, by Mary, by Jesus, and to more generalized expressions like "so may I prosper." They are especially numerous in the *Miller's Tale.* They may serve on a mundane level as fillers in comic discourse; more seriously they serve the ends of irony by pungent innuendo especially when they are part of a compact or conspiracy, or when the oath itself has a special aptness to the situation.

2. *Compacts and Conspiracies:* Chaucer is replete with various kinds of collusion. Nicholas and Alison in the *Miller's Tale,* the two clerks of the *Reeve's Tale,* the Wife and Monk of the *Shipman's Tale,* the canon and yeoman in the *Canon's Yeoman's Tale,* the three rioters of the *Pardoner's Tale,* May and Damian of the *Merchant's Tale,* the summoner and demon in the *Friar's Tale*—all provide examples of the conspiratorial part of a comic plot. Much of the satisfaction of comedy arises from watching the evolution of the compacts, in language rich in irony, by which the allegiances are crystallized among the dupers. We remember, too, that the whole *Canterbury Tales* depends upon the compact laid out for the pilgrims by the Host; the compact or agreement is made much of in the links.

3. *Testimonies and Witnesses:* Aristotle allows, for ancient testimony, the citing of poets and the use of proverbs, to which we may add exempla like those of the *Summoner's Tale,* illustrating sudden wrath, or those of the *Nun's Priest's Tale,* to support one or the other side of the *agon* on the worth of dreams. There are, too, many instances of calling upon the authority of old writers, Solomon, Cato, etc.—the *Wife of Bath's Tale* and that of the merchant is especially rich in such witnesses. In a more legal sense, we recall that Nicholas and Alison witness for each other in putting down the protestations of the old husband; Pluto and Proserpine are witness to the episode in the pear tree, each swearing an oath, though not called to give testimony; the canon's yeoman's testimony against his master comprises virtually all of his tale.

4. *Tortures, Ordeals, Tests—mental or physical, by mechanical or other means:* The cartwheel of the *Summoner's Tale* is the most obvious example of a mechanical testing device. The other examples that come to mind are ordeals in the more common sense: Absolon's mental anguish and the use of the hot coulter of the *Miller's Tale,* the weary chasing of the loosed stallion in the *Reeve's Tale,* the Wife of Bath's inquisition of her three old husbands, the merchant's inquisition of his wife at the close of the *Shipman's Tale,* the challenge to May by January in the *Merchant's Tale* which produces her "sin-

cere" protestation of fidelity. We may adduce, too, the long ordeal of Dorigen resulting from the unfortunate compact with Aurelius, the various "tests" in the *Canon's Yeoman's Tale;* the various "ordeals" described in the exempla of the *Summoner's Tale;* Chauntecleer's ordeal of nightmare and the subsequent ordeal of being carried off by the fox; the resting of the three rioters of the *Pardoner's Tale* against the cleverness of death; and lastly the two ordeals, that of the carter and that of old Mabely that make up the structure of the *Friar's Tale.*

5. *Laws:* Chaucerian comedy of adultery begins with an absurdly observed convention of marriage or family held by an older person which the subsequent action subverts. To these we might add other tyrannies inherent in "humorous" comedy, such as that of the dominant passion in the nature of the Pardoner, for example the hypocrisy of the Friar, the *idée fixe* of the friar of the *Summoner's Tale,* and that of the old knight in the *Merchant's Tale.* Chaucer's *Canterbury Tales* is full of references to law, both in the serious and nonserious tales, from proverbs that proclaim it is lawful to put off force with force in the *Reeve's Tale* to the law of Arthur's court in the *Wife of Bath's Tale* against rape, and the other law imposed upon the young knight by the queen, that he find what it is that women most desire. The *Concordance* to Chaucer gives many instances of "law" in the comic tales alone.

VI
COMIC CATHARSIS

We may make an initial assumption based on Aristotle that something like equanimity is the soul's natural state, and that pleasure is what one feels when one is restored to it. Aristotle says *(Rhetoric* I, 2) that pleasure is "a certain motion of the soul, and a settling, sudden and perceptible, into one's normal state." Among the activities of mind that produce this settling into one's natural state are wonder and learning, more particularly the latter, when wonder has been fulfilled in learning. At the close of the chapter he writes: "Since amusement and relaxation of every kind are among pleasant things, and laughter too, it follows that the causes of laughter must be pleasant—namely, persons, utterances, and deeds," though he does not say anything here about the kind of pleasure afforded.

A second assumption we may make is that every kind of art has its

own special pleasurable effect; obviously the effect of comedy will not be that of tragedy, though in both some kind of "learning" is going on; and learning is associated with pleasure. But the pleasure yielded by comedy is associated with the worthless, the ridiculous, and the ugly without pain. It is accompanied by laughter often, though laughter is not the only available response, for there is also some sense of satisfaction or elation which serves as well; in the close of the *Odyssey,* for example, though the suitors all die, Odysseus and Penelope are restored to each other, or at the end of the otherwise tragic *Iphigenia Among the Taurians,* all the agents make their escape without mayhem or bloodshed.[10]

Before Aristotle, Plato had pointed out in the *Philebus* (48-50) that in both comedy and tragedy, pleasure and pain are mysteriously intermingled; we laugh while we experience untoward or painful emotions, like envy, desire, sorrow, fear, love, emulation, etc. Both philosophers hold in common a view that the emotions are burdensome and that they can be deliberately brought in excess to the surface of the mind by various arts. Aristotle's famous and problem-ridden statement in the *Politics* and the *Poetics* goes farther, making the function of tragedy the arousal and catharsis of specific emotions. The state of mind that remains is presumably one of relaxation, of salutary distance, or a sense of things turning out as they must, the process being a psychological/physiological one rather than a moral one.

I am reasonably sure that the contribution of depth psychologists enables us to make application of such a process intelligently to Chaucer's comic structures. If the psychologists are correct in their opinion that we are all guided by deep-seated psychic drives over which we exert little conscious control, we may add to the consciously perceived emotions a whole array of suppressed aggressions and desires, many of them painful and ugly, thronging in the unconscious, which comedy may allow to surface and to be dissipated. The distortion and exaggeration, as well as a deeper instinct for destruction, desecration, and the vile that we see when we put on the distorting spectacles of comedy, enable us to reach down into truths about ourselves.[11] Freud saw this process as fundamentally cathartic, a release, not a stimulant, and cathartic specifically of matter in the soul regarded as obscene.

I do not know whether it is possible to define precisely the emotions that are released in comedy. Lane Cooper was of the tentative

opinion that "if you succeed in making an angry or envious man laugh with pleasure, he ceases for a time to be angry or envious. Thus anger and envy might be said to be purged away by comedy . . . by something very unlike them." Frye offers the view that sympathy and ridicule are the emotions that comedy purges. It might be argued more generally, however, that comedy, being vicarious, gives innocent release to the untoward pleasure that attaches to even so-called painful emotions, like anger accompanied by the confident expectation of revenge. Translated into feeling, consider with how much satisfaction we watch the discountenancing of arrogance, want the "bad" characters driven out or chastened, with what joy we participate in unmasking the knave, in ferreting out the scapegoat, gratifying our cravings for the trappings of wealth in film presentations, losing ourselves in fantasy of whatever sort. Consider our satisfaction and mingled wonder in the working out of certain Chaucerian plots: the carrying off of the vile summoner to hell and the mutual murder of the three rioters, the grimly satisfying "revenge" upon the lying hypocrisy of the pardoner at the hands of the host—from which Chaucer redeems us by the kiss of peace; the ugly satisfaction of watching the Manciple play games at the expense of the drunken cook. In short, comedy makes capital of the emotional endowment we have. Laughter gives us the necessary distance, the ability both to see things from a very low vantage point of human failing and to know by contrast what may lie at the opposite extreme.

Chaucerian comedy has the capacity to make us laugh for a while, indulge pleasure, particularly *unworthy* pleasure and excessive laughter, after which we settle back into equanimity or a sense of well-being. We have the satisfaction of license, trickery, foolishness, even cruelty in punishing a scapegoat or wishing someone dead, or feeling that death was deserved. We have the privilege of making attacks on many piously held moral conventions, of watching the plot work out such attacks on convention, as in the *Miller's Tale* and in the *Merchant's Tale;* or on human stupidity, as in the *Canon's Yeoman's Tale;* or arrogance and hypocrisy, as in the *Summoner's Tale.*

The elaborate stratagems of plot, character, and vocal utterance all coerce us—as we go willingly—into indulgence. For Aristotle, and I believe for Chaucer, this activity, a surrender to lower faculties, is salutary in its ability to give vent to what is deleterious to the serious affairs of life. Chaucer lets us see what is to be affirmed and rejected

in the course of the *Canterbury Tales;* what should be rejected must be seen, as in the Palinode of *Troilus and Criseyde,* against the backdrop of eternity and its imperatives,[12] or at the very least as a necessary contrast to the values of romance.

I am led to believe, therefore, that the *Tractate* may mean what it says: that pleasure and laughter are the emotions to be purged in comedy and that there should be a due proportion of laughter in comedy. Such a statement must inevitably sound strange to our ears. Are there really unworthy and excessive degrees of pleasure and laughter? [13] My affirmative answer, admittedly inferential, rests upon Aristotle's discussion of pleasure, which I read differently from those who do not see a kind of restorative power in art of whatever sort and that art can serve the larger ends of civic morality generally. Chaucer, given to making frequent references to self-control, might have felt considerable sympathy towards Aristotle's views on the educative and purgative powers of art.

As we have said, the pleasure of participating in the forms of art is of a special innocent sort; it arises from learning something, from contemplating, and from wonder. Beyond amusement, which Aristotle says (in the *Politics* 1137b 41-133a 21) is as a medicine to the soul (for the emotion created in the soul "is a relaxation, and from the pleasure we obtain rest") lies the higher, intellectual pleasure of music (and of the verbal arts), from which one learns during the complex psychological processes of emotional release. He writes (1340a 17): "Since then music is a pleasure and virtue consists in rejoicing and loving and hating aright, there is clearly nothing which we are so much concerned to acquire and to cultivate as the power of forming right judgments, and of taking delight in good dispositions and noble actions." And in a canny insight he adds (1340a 24): "The habit of feeling pleasure or pain at mere representations is not far removed from the same feelings about realities," reminding us that one benefit from representations of music is purgation (1341b 37), a process by which the soul is "lightened and delighted" (1342a 16).

By way of summary, then, I infer the following:

(1) The effect of comedy is pleasure, specifically the pleasure of learning something. (a) This pleasure is a higher pleasure than that of mere amusement, though even mere amusement relaxes and delights. (b) The emotions attached to such representations are very close to

the emotions arising from real things and occurrences, and therefore we learn something about ourselves in life.

(2) There is a second kind of pleasure which it is the function of comedy to purge; the pleasure arising from participation in ugly, untoward admixtures of emotions arising from watching the trivialized actions of inferior characters.

(3) Comedy thus yields two kinds of pleasure, of which the second kind alone is to be relieved or dissipated.

(4) A "highest" kind of pleasure specifically attaches to attainment of the life of virtue, the realm of "what is intermediate and best," in which we acquire the ability to make right judgments and experience "delight in good dispositions and noble actions." One of the benefits of art is to enable us to see ourselves in relation to the life of virtue.

The whole matter is, of course, a vexed question: whether we see in Aristotle (and subsequently in Freud) a justification for a theory of catharsis in comedy is of less moment than our realization that the whole movement of the *Canterbury Tales* is purgatorial, inclining finally to a redemptive closure in which the excesses and disproportions of the comic tales are seen from a cooler aesthetic distance, a model of what catharsis should produce in us in the dynamics of the poem itself.

VII
READER RESPONSE

Chaucer "banks heavily on the sanity of his audience," to borrow a phrase from Eric Bentley,[14] their moral sanity as well as their common sense, and the closures of the tales may be attended by a generalized moral tag *(Friar's Tale, Canon's Yeoman's Tale, Pardoner's Tale)* as a constant reminder that human beings live in two worlds, that above and the purgatorial state below. In the one above they will be judged according to virtue; but in the one below, they are interesting for their vices. To throw off the shackles of conscience, to enter into a world with few restrictions, as Lamb puts it, yields us plain pleasure in the sexual tales and releases us from the law court; while in the other unmasking tales, the conscienceless are punished, giving us assurance of an overwhelming presence of law. Thus, it is the interaction between the two worlds (that of instinct and plain pleasure, and that of conscience and the norms of morality) that provides a range of comic response from joy to the larger satisfactions of learning something about the relation between the two, or

having something confirmed. At one end of the spectrum the characters verge on the demonic as in the *Canon's Yeoman's Tale* and the *Pardoner's Tale;* at the other, as in the *Franklin's Tale* and the *Wife of Bath's Tale,* on the morally transformed (but the latter view of humanity, as Dante complained, is offered by few); and the fact is that we are more comfortable with the former than the latter.

Until his last years—or at any rate until the period of the *Canterbury Tales*—Chaucer seems not to have shared Plato's assumptions [15] that the audience is to be guarded against its tendency to indulge in real life the emotions aroused by literature, though he debates the issue for his own purposes in several places. It is true that some members of an audience are always platonic in their attitudes towards comic experience, and are apt to be distressed by violence, sexuality, and aggression; they are apt to react too sympathetically to hot coulters, broken arms, bashed heads, perhaps because the illusion is too real for them.

But Chaucer demands a surrender to the illusions of a comic world down to the level of buffoonish action and the pratfall, without excessive concern. The conventions of comedy demand such surrender, posit the element of suffering, and do not shrink from ugliness; and if we have been given the clues properly, have the illusion broken for us often enough by one means or another, and have thus learned the proper attitudes of detachment that are part of comic response, we can see the difference between the world of fantasy and the world of action.

If we see this difference, then we can accept the irony that holds up a bad marriage or the union of youth and age, for that special scrutiny which comedy affords: an unblinking look at hypocrisy.[16] Or we may take a more detached view of the son-father rivalry, which is clearly visible in disguised form in Chaucer's sexual comedies. Chaucer avows through the mouth of the Man of Law that he wrote no tales of incest, though there is ground (provided for us by Freud) for seeing the competition for Alison, the Miller's wife, May, and Dorigen as a displaced expression of a perennial theme. This statement must not be taken to mean that the tales in which these agents figure do not involve other thematic considerations, but only that they contain a topic anchored in a tradition going back through Roman to late Greek comedy, a topic so popular it has never gone out of style since Menander. It may be seen at a glance which tales are, in a sense, Roman comedies built around the theme

of a senex and the successful rebellion against his rule. Sex triumphs; yet, where it does not completely, it is adroitly welded to another drive—money, and thus becomes more "social" in its implications, as aggression moves over from one arena to another. In either case, the themes touch upon universal concerns of the audience of whatever age and time.

The tales that seem more social give this impression because of the emphasis placed upon a single agent, as in the *Summoner's Tale,* or the *Merchant's Tale,* in both of which there is a fairly subtle debate between secular and theological values centralized in a single "humor" upon whom the audience may center its amused animosity. The debate is given a firm secular conclusion which the audience approves no less than the conclusions of the comedies without the quality of good nature, those of the Friar, Pardoner, and the Canon's Yeoman, in which not instinct to survive but will to damnation becomes the prime instrumentality. In either case, the audience experiences a psychic need which the ending gratifies.

VIII
COMIC CHARACTERS

I once offered the view that one may distinguish comic characters from other types on the grounds of their impenitence: if the agents remained recalcitrant, did not change for the better in the course of an action, remained stupid and deceived, or clever and deceiving, continuing in a single-minded course of action, we were dealing with comic characters in a comic structure. These were agents we could not take seriously; they were "no account" deceivers or dupes who figured in complicated stratagems.

A surer way of classifying comic characters is through Aristotle's *Nicomachean Ethics, Rhetoric,* and the *Coislinian Tractate,* the reservoirs out of which, for comic theory, a cast of comic characters may be formed. It may be seen from these authorities that the pilgrims of the *Canterbury Tales* evince comic qualities in remarkable conformity with ancient description: pretentious boasters and liars, garrulous men and women, ironists both modest and mock-modest, learned men, buffoons and clowns, boors, men of touchy and choleric dispositions, rude and churlish men, quarrelsome and flattering types, witty and scurrilous speakers—both in the *General Prologue* and links and within the tales. And with the various types go various clues to social level: the humor and laughter of "gentle" persons being

different from that of the churls; kind wit being opposed to unkind; and obscenity and license opposed to innuendo. The names of pilgrims in Chaucer's parade of characters leap to mind even as we enumerate the classic characters.

These characters may be subsumed under the headings drawn from our authorities as the impostor *(alazon)*; the ironical man *(eiron)*; and the buffoon *(bomolochos)*, names we would do well to retain as part of the vocabulary of comic theory. These may be modulated to include a number of other types for which names have evolved: the straightforward man or plain-dealer, the various kinds of fools and clowns, a rustic type called by Aristotle *agroikos,* and the scapegoat or *pharmakos.*[17]

Examples are not far to seek, although we must recognize always that the types merge with each other in accordance with the poet's intuition of them. The host, for example, may be seen as a buffoonish type whose task it is to be master of revels, who functions virtually as a chorus in the links, recalling by his summons to a feast the ancient lineage of comedy from *komos.* But he is also something of an ironist in the links, taking various stances vis-à-vis the pilgrims; and as an impostor, he unmasks himself in a well-known confession about his virago wife. Similarly, the pardoner may be seen as an impostor who manages to speak with ironical contempt for his audience, and who, in the process of demonstrating his great skills as an entertainer, becomes the scapegoat threatened with full disclosure. His role is paradoxically that of mixed blessing: he nurtures in us a kind of quest for truth, while at the same time he functions as a scourge of society. The Manciple, who is depicted as a sly ironist in the *General Prologue,* emerges in his tale as something of a plain-dealer who turns into a malcontent and complainer, railing at hypocrisy in language and in society. The Reeve, an *eiron* to the Miller's posture as loud boaster, is something of a rustic, a refuser of festivities, grouchy and churlish in response.

Within the tales the oppositions of *eiron-alazon* types are clear: Thomas-friar; demon-summoner; canon-gullible priest; old man-three rioters; May/Damian-January; miller-students, etc. But merely to pin such tags upon the various agents does injustice to Chaucer's art. In the dynamics of his poem, both the pilgrims of the outer frame and the characters in the tales become fleshed out in all their variety and values. Particularly in the "serious" comedies they evince, along with their grotesqueries, the capacity to move out of

stereotypes into full moral stature. The Wife of Bath, the Pardoner, the summoner of the *Friar's Tale,* and even the Canon's Yeoman have the capacity to raise truly disturbing questions, to challenge us at unexpected moments in the flow of statement or event. Who would have expected from the young scheming Wife of the three good, old husbands the later strain of melancholy courage, the "surprise" of the Canon's departure from the community, the decision of the Yeoman to remain, or the compelling strain of a beneficent religion that flows in a deep substratum beneath the treble of the Pardoner?

Chaucer will not allow his impostors (dim relics of the *miles gloriosus*) to remain comic stereotypes, but rather gives them a complexity far beyond simple role-play. The impostor exists to be unmasked, and part of the interest of the Wife's character, for example, is the result of her steady shedding of earlier roles and masks, and of her realization of the loss of youthful radiance in the passage of time. In the process of unmasking appear the subtler tones of self-depreciation, the implied serious questions (What should one want? What is love? What is honest in human dealings?) of the ironist, the "other" to the *alazon.* The Wife, who has made a travesty of marriage, has profaned a rite, in Cornford's terms, and must kill off the old self. If later in the tale she tells we see something of the wise fool or of the sibyl speaking far more philosophically than we had anticipated through the mouth of the hag, we can estimate something of Chaucer's complex art. Like the clown of later literature who gets slapped, she is the fool who, though beaten, somehow emerges unscathed.

It is not merely psychological acuity that enables Chaucer to make his characters lifelike. He has, to an uncommon degree, the camera eye that sees clearly at various distances. There is always in his descriptions what Virginia Woolf called "the hardness and the freshness of an actual presence." [18] It is obviously people that interest him. He speaks of them unself-consciously, particularly on matters that later ages came to think shameful, and so retains that open candor so necessary to comic license; and his attention to visual physiological detail is part and parcel of that directness and plain utterance essential to the comic mode.

It is Chaucer's clear eye for hard detail that works towards character that dominates plot rather than plot formations to which character is merely subordinate. In general, comedy tends not to be

concerned about the relations of plot to character in the same sense as tragedy, where plot becomes the working out of "necessity" or some other law that gives form to human actions. There, character becomes subordinate to the working out of that plot, although the hero's ethos gets revealed in the process of it. But comedy may display character for its own sake, outside the pressures of an inexorable plot movement, as in the *Summoner's Tale.* Thus, too, the characters of the General Prologue are presented, in a sense, as free-standing, operating by the flimsiest of imperatives, to tell tales for a meager prize. Similarly within the tales, character is sometimes presented with directness and flair, often as though each person were a portrait (particularly in the Miller's and Reeve's tales) before being released into actions that are forms of play, chance, and unexpected fortune. We may see a relationship between Absolon's fastidious, squeamish nature, and the surprise blast in his face, but it is not inevitability that produces the blast but the comic spirit, and it is not necessitated by his character.

Thus, unlike tragedy, which in Aristotle's view subordinates character to plot, comedy tends to place its largest emphasis on the characters to the extent that plot may seem merely the showcase for them. Chance, improbability, mischief, what Sypher calls "a tidy arrangement of improbable possibilities" [19] by means of which a character is brought to triumph or is exposed as an impostor, are the casual imperatives, alternates to tragedy's law.

Several of the categories in the *Tractate's* division of "laughter caused by things" have to do with the various ways in which the characters of comedy may be made to appear inferior or ridiculous. They are as follows:

1. *From comparisons (implicit or explicit) to what is better or worse:* It will be remembered that comedy tends to represent men, in Aristotle's phrase, as worse than they commonly are. Men and women may be compared downward in the scale of being, to chickens in the *Nun's Priest's Tale,* to denizens of the barnyard and meadows in the *Miller's Tale,* to sparrows, to geldings or mares, to rabbits, to butcher-birds, to snakes and scorpions, all the way down to the demonic world, where they are seen as working devilish actions. The subtle rapprochement between stallion and human being in the *Reeve's Tale* is one of the subtler comparisons, less overt. There is also the assimilation of the Canon to trickster in the *Canon's Yeoman's Tale,* that of the friar of the *Summoner's Tale* to greedy cheat; even an implied

comparison of better and worse in the haughty clerical tone that criticizes secular values in the *Merchant's Tale*. The Wife of Bath compares herself to vessels of gold and those of wood, the implied comparison of the wife of the *Shipman's Tale* to Ganelon; of the summoner of the *Friar's Tale* to Judas, to a shrike, and to a juggler; of the fox of the *Nun's Priest's Tale* to Judas, Ganelon, and to Sinon; the use of such terms as "popelote" and "piggesnye" to "lower" the character of Alison in the *Miller's Tale*—all demonstrate the ease with which Chaucer assimilates character to the worse. It may be noted that the humor here is frequently linguistic as well as comparative.

The comparisons are frequently those of worse to better: as in the Wife of Bath's comparison of her "wood" to gold, that of Alison's face to the newly forged coin; the comparison of the softness of the weasel, perhaps, and to apples laid up in the hay, bring the beauty of nature into the human sphere. There is a subtle interplay between the two kinds of movement in such comparisons, that upward and that downward.

In the largest context of such comparisons, between truth and falseness, for example, consider the satisfaction we feel in the *Manciple's Tale*, in getting things straight: a whore is only a whore, not a dear lady, and a brigand is a brigand, not a great captain; or between honor and dishonor in the *Merchant's Tale*, when the wife defends herself (just prior to her assignation with Damian) as being a woman of honor; or between higher and lower loves in the implied relationship of Pardoner and Summoner in the General Prologue.

In some of these examples, the effect is not always that of laughter, but rather that of irony and occasionally ethical import, particularly in the parodies of high style strewn throughout Chaucer's work; for example, when Pertelote is compared to the bereaved wives of Roman senators, and when Dorigen compares herself with the various wives and virgins of antiquity. Something of a a more casual, more insolent comparison is inherent in naming the Pardoner "beel amy."

2. *Debasing the Personages:* This category is related to the previous one in which there is a comparison either implied or stated with things above and below in the scale of being. Cooper's translation of the Greek phrase makes the distinction clearer: "fashioning the personages in the direction of the worthless." [20] Thus, depicting the husband of the *Shipman's Tale* as obtuse, the wife as conniving and sexually irresponsible, and the monk as opportunist demonstrate the

poet's practice of debasing not the total person, but only one aspect
of his character, the one necessary to plot. Similarly, Nicholas's
handiness, Absolon's squeamishness, the Reeve's admission of the
vices of old age, the miller's (in the *Reeve's Tale*) defensiveness and
angry nature, his wife's stupid haughtiness, the daughter's resem-
blance to her father, the headstrong nature of the two young clerics,
Damian's crouching in a bush, May reading her billet-doux in the
privy, the closing line of the *Cook's Tale,* the summoner's vicious
control of the young of the diocese, the Wife of Bath's scorn for her
first three husbands and her anti-intellectual battle with Jenkin—all
provide examples, from one vantage or another, of debasing the
persons. It should be noted that though comedy requires the lower-
ing of character towards the worthless, the characters may be seen as
likable and therefore as drawing our sympathies. Equally they may
be seen as despicable. In any event, what happens to them is to be
felt by the audience, at the close, as psychologically satisfying.

3. *Having a Choice and Choosing the Worthless, Passing by What is
Worthwhile and Fastening upon What is Trivial:* I am tempted to say that
all comedy depends upon the deliberate trivializing of experience or
upon reducing the view of experience from graveness; and that the
choices made by the agents in the course of any action must support
the inner law of trivialization. Thus, the characters of comedy
habitually choose courses of action displaying mean-mindedness,
malice, bad nature, or more simply make choices that bring about a
sequence of increasing complications. The badinage between the
Miller and Reeve in which the Miller provokes the Reeve, then
offers a disclaimer, may be seen as a kind of bad choice that
demonstrates sly malice. The Reeve subsequently makes a firm
decision to requite the Miller, though earlier he avows only that he
could, if he wanted to, tell a story about a Miller. Even his platitudes
on old age have a somewhat trivial air, though raised up by powerful
imagery.

Absolon's decision to go back to Alison's house (in the *Miller's
Tale),* the miller's release of the clerics' horse (in the *Reeve's Tale),* the
wife's reliance upon the monk (in the *Shipman's Tale),* old January's
determination to marry and his subsequent willingness to believe his
wife's protestations (in the *Merchant's Tale),* the rioters' resolve to seek
out Death (in the *Pardoner's Tale),* the summoner's assumption of a
profitable alliance with the demon-yeoman (in the *Friar's Tale),* the
friar's belief that he has talked Thomas into giving him money (in

the *Summoner's Tale*)—all serve to demonstrate the dependence of comedy upon bad decisions as a source of comic satisfaction.

There are good decisions, too, that raise comedy to a more thought provoking dimension: that of the Canon's Yeoman not to go off with his master, and that of the young knight of the *Wife of Bath's Tale* to leave a major decision to his wife. This latter example may test for us, in part, the degree to which the *Wife of Bath's Tale* is predominantly a romance, with comic overtones.

IX
PROBABILITY

The final test by which we come to know an artist's skill is in his handling of the probable and necessary. We almost never question probability unless violations are so bald as to elicit either mild anger in us or a laugh at ineptness in developing the inner coherence of a literary form. In tragedy, where we come into the action close to the end of a previous sequence of events (in which there may have been elements of the fortuitous or the merely sequential), we expect the final action, regardless of the number of complications it contains, to be the consequence of all the antecedent actions, including those recalled by the protagonist as memories. The tragic writer thus in depicting the final act of a larger action reaching far back in time enables us to see an inexorable order or law working itself out both in terms of events and character, this law overriding all the accidents and chance occurrences that might have intervened between cause and effect. We may have thought the events were merely sequential, but now we see that, far from being so, there are parts of a pattern rooted in character or fate.

But Chaucer, even in his serious tales, allows the accidental and the merely sequential into the actions as normal means of developing both his serious and nonserious plots. The more the accidental and fortuitous become parts of the presented actions, the closer we are to the accepted norms of comedy and realism, where we are interested less in the ways in which human beings are made to conform to law or obey an inexorably developing pattern, than in the quixotic, the unforeseen, the merely sequential, and the frankly absurd.

The opposition of the vocabularies of providence and fortune tells us a good deal about the experiential mode in which Chaucer is writing, and often about the degree of irony in the manner of

presentation. It is instructive to look at such verbal practices in the *Concordance* to help penetrate the mystery of that peculiar largeness of mind and complex world view which deliberately conflates modes usually kept separate from each other (at least in the classical Greek drama that has come down to us).

Chaucer's humorless comedies, particularly the Pardoner's ex-emplum and the *Friar's Tale,* imitate the rigorous "law" of the most serious forms of literature: character is made clear as fate, and an unsmiling presence is felt overseeing the inevitable catastrophe which comes as the necessary consequence of character-in-action, a preacher's conviction about an inevitable relationship between morality and action. There is a similar alliance with the serious tonalities of probability in both the *Merchant's Tale* and the *Nun's Priest's Tale* where a host of imperatives from dreams to destiny are playfully brought to the foreground, left momentarily to reverberate their potentially tragic overtones and then withdrawn in favor of codas stating existential truths, not of a corrected ethos but only of a manipulative rationality.

And this manipulative rationality is what is left in the "pure" comedies: Absolon and Nicholas working to solve problems of gratification and revenge as quickly as possible by immediately available means; Alan and John moving in obedience to plot trick-ery into actions controlled by chance and misunderstanding; and the merchant's wife and best friend wittily squeezing personal ad-vantage out of their circumstances, casually buying and selling love, solving problems seen finally to be as trivial as the blast of hot air which is the catastrophe of the *Summoner's Tale.*

If thus we eliminate from human actions the larger considerations of an inevitable relationship between micro- and macrocosms, cut off so to speak from the transcendental dimensions of love, fidelity, and truth-to-word, what is left is man-in-a-middle-world, with the limited possibilities therein, in which providence gives way to for-tune and the penalties of temporality: lineality, witty judgment, and the warp of time. And so, when we are dealing with inferior agents whom we watch moving through their designed stratagems, the imperatives we see demonstrated are not those of the human race's moral nature, but rather those of their mere humanity: survival, gratification, and winning.

What does one do to win? To put it simply, anything, in the order the poet deems best. And will we "believe" in the sequence in which

the events are made to occur? Of course. We know from tragic tales about inevitability and necessity; comedy conditions us to take satisfaction either in the parody of their function or in the outright suspension of their function, substituting for them gratuitous choice and absurd results, the possible with an inconsequential sequel.[21]

And therein lies the clue: Chaucer, like any comic writer, invents the degree of plausibility or probability which we define here as the relation of events entirely internal to the work. Though the entire tale may be a mimesis of a clearly improbable or impossible action (as in the *Nun's Priest's Tale* and *Friar's Tale*) the events within the tale have their own relatedness. Even when a cause-and-effect sequence is interrupted by what appears to be accidental, we do not question that it could happen so. The coherence imposed upon it is that which the character or the situation necessitates. Thus, a Chaucerian comic action, even when sequential as in the *Reeve's Tale,* is not *merely* a sequence of events imitating the events of history, but evolves under the imperatives of an entirely inner probability and convinces us precisely because of our understanding that given the microcosm of the poem, the events might have taken place just so. They make, not any sense, but the sense that only this concatenation yields, a mimesis of what might be. This is not to be taken to mean that life is being imitated in a mechanical way, but rather that the poet's plastic power imposes a pattern equally upon the absurd or accidental and upon the factual, thus demonstrating a relationship between life and art by making intelligible wholes of life's great range of possibilities.[22]

Chaucer's genius, as many scholars have pointed out, sees both sides of human nature, the lower as well as the higher imperatives. Both sides of human nature can be made to produce convincing depictions in literature because both are human, and because, in the final analysis, we believe in both.

NOTES

1. Lane Cooper, *An Aristotelian Theory of Comedy With an Adaptation of the Poetics and a Translation of the 'Tractatus Coislinianus'* (New York: Harcourt, Brace and Company, 1922). A classic study that has influenced much comic theory is Francis Macdonald Cornford's *The gin of Attic Comedy* (new York: Doubleday, 1961), and that of Northrop Frye, *Anatomy of Criticism* (Princeton: Prince-

ton University Press, 1957).

2. I have omitted "laughter arising from diction" from this paper for reasons of length, though much needs to be done in studying the ways in p Chaucer manipulates language for the sake of laughter or special effects. His comic style is an interesting mixture: he bristles with similitudes and metaphors, along with other devices which have received good treatment by Janette Richardson, *Blameth Not Me: A Study of Imagery in Chaucer's Fabliaux* (The Hague; Mouton, 1970); and two dissertations have given considerable insight into Chaucer's imagery, that of Elizabeth Rudisill Homann, "Kinesthetic Imagery in Chaucer" (Berkeley: University of California, 1948) and William A. Tornwall, "Studies in Chaucer's Imagery" (Baton Rouge: Louisiana State University, 1956). Verbal as well as dramatic irony has been given ample treatment in numerous works, notably the pieces of Earle Birney, and doubtless there will be more articles on the subject with regard to individual topics and loci; level of delivery has received good impetus from E. T. Donaldson's "Idiom of Popular Poetry in the *Miller's Tale," English Institute Essays,* 1950 (New York, 1951), pp. 116-40.

Puns have been collected and their role assessed in a number of articles, notably Paull F. Baum, "Chaucer's Puns," *PMLA,* 71 (1956) 225-46, and *PMLA,* 73 (1958), 167-70; and Helge Kökeritz, "Rhetorical Word-Play in Chaucer," *PMLA,* 69 (1954), 937-52. Chaucer's familiar names, his Latin and French terms sprinkled through the comic tales, the pertinence of oaths, word-play (homonyms, synonyms, paronyms), periphrases and circumlocutions, euphemisms, the occasional nonce word, distortions of words, and the Chaucerian habit of style of compounding, particularly nouns and adjectives, all need further investigation.

In omitting the most tempting aspect of diction, style, I am passing by an important consideration of ascents and descents into grandiloquence, apostrophes, jargon, garrulity, travesty, etc., which are part and parcel of the texture of Chaucer's comic style, and these, of course, involve considerations of manner of delivery and gesture.

3. J. W. H. Atkins, *English Literary Criticism; The Medieval Phase* (Cambridge: Cambridge University Press, 1943), p. 32.

4. Susanne Langer, *Feeling and Form: A Theory of Art* (New York: Scribner's Sons, 1953). She writes, p. 331, that the comic vision deals with man's capacity to triumph "by art, luck, personal power, or even humorous, or ironical, or philosophical acceptance of mischance."

5. Elder Olson, *The Theory of Comedy* (Indiana University Press, 1968), pp. 52-54. It happens that these two classes of tales jibe loosely with a part of the scheme evolved by Olson for dramatic forms. The second group represent his "plots of folly ... in which the agent acts in error," for whatever reason; the first group corresponds to his "plots of cleverness ... in which the stratagems of the agent produce the comic action." The agents are rewarded or punished according to their deserts; according as the agent is well or ill intentioned, we respond. The agents themselves, those that fall into the class of the ridiculous, may be of three types: (a) morally sound but intellectually deficient; (b) morally deficient but clever; and (c) deficient both intellectually and morally. Moreover, the agents may act from good or bad motives.

Olson's scheme, illustrated from a simple archetype (p. 53), is as follows:

Plots of Folly: well-intentioned fool; outcome must be successful.

Plots of Folly: ill-intentioned fool; outcome must be failure.

Plots of Cleverness: well-intentioned cleverman; outcome must be successful.

Plots of Cleverness: ill-intentioned cleverman; outcome must be failure.

In this scheme the friar of the *Summoner's Tale,* the summoner of the *Friar's Tale,* the three rioters of the *Pardoner's Tale,* and the Canon of the *Canon's Yeoman's Tale* may be seen as ill-intentioned fools, for whom the outcome must be failure; in the cleverness plots, the wife and monk of the *Shipman's Tale,* the pairs of young men in the Miller's and Reeve's tales, Damian and May of the *Merchant's Tale,* because they succeed in their various ways, must—to preserve the scheme—be seen as well-intentioned. This constitutes a definition of terms that strains our belief in the applicability of the theory to Chaucer's tales. Obviously much hangs upon our defini-

tion of "well-intentioned."
One has to adopt a rather
special perspective to see the
agents in this light, that is, as
well-intentioned with refer-
ence exclusively to their own
interests.

6. Cooper, p. 243: ". . . every
ludicrous accident to which
an author carefully leads up
with a view to surprising us
into laughter has the nature
of a deception; and similarly
the outcome of deception is
unexpected."

7. W. J. M. Starkie, *The Achar-
nians of Aristophanes* (London:
Macmillan & Co., 1909), p.
lxiv; Cooper, p. 224.

8. Robert M. Jordan, *Chaucer
and the Shape of Creation* (Cam-
bridge: Harvard University
Press, 1967), p. 8.

9. Northrop Frye, p. 116. Frye
defines the opposition as
roughly "the usurping and
the desirable societies respec-
tively," the action of comedy
being like "the action of a
lawsuit, in which the plaintiff
and defendant construct dif-
ferent versions of the same
situation, one finally being
judged as real and the other
as illusory. This resemblance
of the rhetoric of comedy to
the rhetoric of jurisprudence
has been recognized from
earliest times." It should be
reiterated that opinions and
various proofs may be uttered
or offered by *any* characters in

any situation. The descrip-
tion given above is arche-
typal.

10. Cooper, pp. 60-62.

11. Wylie Sypher, *Comedy* (New
York: Doubleday, 1956), p.
222: "Tragedy has been
called 'mithridatic' because
the tragic action, inoculating
us with large doses of pity and
fear, inures the self to the
perils we all face. Comedy is
no less mithridatic in its
effects on the self, and has its
own catharsis. Freud said
that nonsense is a toxic agent,
acting like some 'poison' now
and again required by the
economy of the soul. Under
the spell of this intoxication
we reclaim for an instant our
'old liberties,' and after dis-
charging our inhibited im-
pulses in folly we regain the
sanity that is worn away by
the everyday gestures. We
have a compulsion to be
moral and decent, but we also
resent obligations we have
accepted. The irreverence of
the carnival disburdens us of
our resentment and purges
our ambivalence so that we
can return to our duties as
honest men." And he adds:
"From license and parody
and unmasking—or putting
on another mask—come re-
newed sanity and responsi-
bility, a confidence that
we have looked at things
from a lower angle and there-

fore know what is incorruptible." See also Cooper, p. 67 and Frye, p. 177.

12. I have explored elsewhere what the moral implications of the position are for Chaucer: *Art of the Canterbury Tales* (Madison: University of Wisconsin Press, 1965), pp. 23-41, 34-40, 146-47, 248-49.

13. Elder Olson writes, p. 45, "Why anyone should want to get rid of pleasure or be pleased by getting rid of pleasure, or how he can get rid of pleasure and still have it [the *Tractate*] fails to say." And earlier, p. 36, [comedy] ". . . has no catharsis, since all kinds of the comic—the ridiculous and ludicrous, for example—are naturally pleasant." But see in particular, Cooper, pp. 70-78, on the dual effects of comedy.

14. Eric Bentley, *Life of the Drama* (New York: Atheneum, 1964), pp. 221-22.

15. "Poetic representation . . . waters the growth of passions which should be allowed to wither away and sets them up in control, although the goodness and happiness of our lives depend on their being held in subjection." *Republic* X, 606.

16. Chaucer is without interest in the family and its vices or virtues; Virginia of the *Physician's Tale* comes to mind, as does the love-hungry Molly of the *Reeve's Tale*, the little girl under the "yerde" of the merchant's wife in the *Shipman's Tale*, the various levels of domesticity in the *Clerk's Tale*, the *Summoner's Tale*, and even the gracious atmosphere of upper class households in *Troilus and Criseyde* in which Criseyde is ensnared and victimized. In none of these is the family itself the subject under comic examination; perhaps his instinct told him that the family generates "drama" rather than comedy. But his view of marriage will serve to demonstrate the range from bemusement to something like sardonic contempt.

17. A full discussion of these types is to be found in Frye, pp. 171-76.

18. Virginia Woolf, "The Pastons and Chaucer" in *The Common Reader*, 1st series (Hogarth Press, 1925), p. 26.

19. Sypher, p. 209.

20. Cooper, p. 250.

21. Several remarks by Cooper are of interest here: "It is clear that the sequence of incidents in comedy must often run counter to the laws of necessity and probability. Yet it is equally clear that the comic poet must keep in mind the law of a necessary or probable sequence, and must suggest it, in order to depart from it in the right way for the ends of comedy, showing that he observes the law by his

method of violating it. . . . the stress [for Aristophanic comedy] clearly must be, not the relation of one incident to another. . . . [Aristotle] thinks of "probability" less (as we commonly and vaguely do) with reference to things in general, and more with reference to specific antecedent and consequent within the limits of a particular play or tale. In other words, the poet is not a historian" (pp. 187, 191). And finally: "Comic incidents affect us most when we are not expecting them, if at the same time they are caused, or have an air of being caused, by one another; for we are struck with more amusement if we find a causal relation in unexpected comic occurrences than if they come about of themselves and in no special sequence; since even pure coincidences seem more amusing if there is something that looks like design in them. Plots therefore that illustrate the principle of necessity of probability in the sequence of incident are better than others" (p. 194).

22. Eva Schaper, *Prelude to Aesthetics* (London, 1968), pp. 93-101.